THE REVENGE OF HATPIN MARY

PETER LANG
New York • Washington, D.C./Baltimore • Bern
Frankfurt am Main • Berlin • Brussels • Vienna • Oxford

Chad Dell

THE REVENGE OF HATPIN MARY

Women, Professional Wrestling and Fan Culture in the 1950s

PETER LANG
New York • Washington, D.C./Baltimore • Bern
Frankfurt am Main • Berlin • Brussels • Vienna • Oxford

Library of Congress Cataloging-in-Publication Data
Dell, Chad.
The revenge of Hatpin Mary: women, professional wrestling
and fan culture in the 1950s / Chad Dell.
p. cm.
Includes bibliographical references and index.
1. Wrestling—United States—Social aspects. 2. Sports spectators—United States.
3. Women—United States—Social conditions. 4. Feminism—United States—
History—20th century. 5. United States—Social life
and customs—1945–1970. I. Title.
GV1196.4.S63D45 796.812'082—dc22 2005023781
ISBN 0-8204-7270-0

Bibliographic information published by **Die Deutsche Bibliothek**.
Die Deutsche Bibliothek lists this publication in the "Deutsche
Nationalbibliografie"; detailed bibliographic data is available
on the Internet at http://dnb.ddb.de/.

Cover design by Lisa Barfield
Cover photo of Hatpin Mary appears courtesy of Phillip A. Harrington

The paper in this book meets the guidelines for permanence and durability
of the Committee on Production Guidelines for Book Longevity
of the Council of Library Resources.

Peter Lang Publishing, Inc., New York
29 Broadway, New York, NY 10006
www.peterlang.com

Printed in the United States of America

For Eleanor

Contents

Illustrations

Acknowledgments

The authorship of any book is shared by countless contributors who deserve the writer's thanks. First and foremost, I am eternally grateful to the fans, collectors, wrestlers, announcers and promoters who agreed to share their insights and experiences with me. There would have been no book without their participation. Thanks in particular to Tom Burke, who shared his collection of fan club bulletins that served as a foundational element for the book. Thanks to my friend Dan Wolf for his help negotiating the Library of Congress, and to Phil Maass, my fellow wrestling fan, who joined me at the start of the journey.

Folks at the University of Wisconsin–Madison who trained and mentored me from the beginning of this project include Jackie Byars, who encouraged my first steps, and John Fiske and Michele Hilmes, who encouraged me to fly. I'm grateful as well to Julie D'Acci, Jack Kugelmass, David Morley, and Bob McChesney, and my fellow "Telecommies"—particularly Pam Wilson, Steve Classen, Aniko Bodroghkozy, Daniel Marcus and Matthew Murray—who helped shape my thinking and intellectual growth along the way. Linda Henzl was nothing less than heroic in transcribing most of the interviews.

As the book neared completion, Henry Jenkins III, Richard Butsch and Kathy Newman contributed their perspectives and thoughtful insights, challenging me to add richness to the manuscript, as did the anonymous reviewers. I am grateful to my colleagues at Monmouth University, particularly to John Morano for his counsel during preparation of the manuscript. In addition, I am grateful as well to Barbara Bernstein at Hampton Press for her support.

Many thanks go to my editor Damon Zucca, who "got" the idea for this book from the moment he heard it and patiently guided the project. Thanks as well to the staff at Peter Lang USA for their hard work and careful attention to detail.

Thanks to my family, my mother Carol Carr Dell, my father Ed Dell, and my sisters Heather and Sara for their love and support.

Finally, this book would not have been possible without the encouragement, patience, wisdom and guidance of Eleanor Novek, my wife, partner, fellow scholar and soul mate, to whom this book is dedicated. Your intellectual courage and passion is an inspiration to me.

Chapter three appeared in a different version as "'Lookit that Hunk of Man!': Subversive Pleasures, Female Fandom, and Professional Wrestling," in *Theorizing Fandom: Fans, Subculture and Identity*, edited by Cheryl Harris and Alison Alexander (Cresskill, NJ: Hampton Press 1998).

Photographs of Hatpin Mary, the Wolf Man, and fans at ringside in chapter three appear courtesy of Phillip A. Harrington. Chicago Daily News photographs of the 1911 wrestling match between Frank Gotch and George Hackenschmidt at Comiskey Park (SDN-009543; SDN-057265; SDN-009546) appear courtesy of Chicago Historical Society.

This project was supported in part by a generous Grant in Aid to Creativity from Monmouth University.

CHAPTER ONE

"My Grandmother Was a *Huge* Fan"

Growing up in Philadelphia in the late 1960s, I watched a lot of wrestling on television. Like many boys my age—scrawny, rail-thin, not much good in a fight—I found the image of muscular, powerfully built men with a clear sense of right and wrong very attractive. For a time, Bruno Sammartino was my hero and the hero of nearly every other young wrestling fan in the Northeast. With a broad, rippling chest, thin waist and rugged good looks, Bruno battled the likes of Toru Tanaka and George "the Animal" Steele, an Otto Preminger look-alike with a bald head, a gross hairy body and a twisted gleam in his eye (had I known that in real life, "the Animal" taught high-school history, I might have hated him even more). Every Saturday afternoon my buddy Phil and I would arrange the couches in his rec room into a makeshift ring, reenacting the skirmishes on his television.

Years later, when I would describe my research on "historical broadcast audiences" to better understand how viewers engaged with television in the past, the eyes in my own audience would glaze over. "That's nice," someone might mumble, looking around disinterestedly. But as soon as I mentioned the particular audience I was researching, my listeners would light up: "Female fans of pro wrestling? In the 1950s?" Some would betray their wrestling ignorance by leaning forward to ask conspiratorially, "Isn't it *fake?*" Then I'd know they were a "mark," in wrestling parlance as in others, a sucker.

But someone else might crack a smile, shake his head and say, "My grandmother was a *huge* wrestling fan." It didn't matter whom I spoke to: waiters, executives, mechanics, even academics—*especially* academics. They all had a die-hard wrestling fan somewhere in their family tree, and usually it was a woman.

The connection was mysterious. What was it about professional wrestling that women found so attractive in the 1950s? What was it about women that drew them to wrestling? Why women, and why wrestling?

Television sitcoms from the 1950s offer few answers. Take *Father Knows Best*. Margaret Anderson was the perfect wife and a model for her times. Pretty, unflappable, a supremely talented cook and housekeeper, Margaret (played by Jane Wyatt) was a supportive wife and mother to her children Princess, Bud and Kitten. Cast in the same mold as her television colleagues June Cleaver, Harriet Nelson and Donna Reed, Margaret Anderson exemplified idyllic, wholesome familial contentedness.

Thanks largely to television's endless reruns, the image of the suburban middle-class white family remains etched in our cultural consciousness. In that family, each member knew his or her prescribed role, and life was economically sound, simple and carefree, save for the weekly minor adolescent crisis. *The Adventures of Ozzie and Harriet, The Donna Reed Show* and *Leave it to Beaver* endure as symbols of a bygone era we fondly imagine as one of gendered clarity and suburbanized domestic bliss.

Yet the postwar era was also a time when millions of women throughout the United States defied gendered expectations by practicing their fandom of wrestling. Women of all ages—young girls, adolescents, single wage-earners, housewives and grandmothers—and of all classes, races and ethnic backgrounds attended matches at sporting arenas and local halls or watched the weekly events on television. Real-life characters such as Hatpin Mary in Manhattan, Ringside Rosie in Pittsburgh, and others in cities across the country cultivated their hard-earned reputations as "dangerous" women through their attendance at professional wrestling events and their antics at ringside. On the home front, women commandeered the television set for hours at a time to watch well-developed men in swim trunks wrestle; other family members dared not disturb the lady of the house when it was time for her show. In towns like Dayton, Ohio, Meadowlands, Pennsylvania and Benicia, California, enterprising women began small communication empires, fielding queries from thousands of women and men, and sending out monthly or quarterly publications to hordes of hungry fans on the subject of their favorite wrestlers. While they may have shared similarities in appearance or dress, these women bore little resemblance to June Cleaver, Harriet Nelson or Donna Reed, even though they, too, were products of the postwar era.

Rewriting 1950s Scholarship

This book joins a growing body of work that challenges long-held notions of the postwar era as a period of clearly defined gender roles and familial tranquility. In the representation of the postwar era carefully constructed by government missives and the mass media, women returned contentedly to the position for

which they alone were ideally suited (housewife and helpmate to children and husband), Americans of all races lived happily in their separate-but-equal communities, and all classes reveled in an age of consumer bliss. While this image retains its nostalgic allure even today, it is not wholly grounded in fact. There was turbulence beneath the smooth surface ideology of peace and simplicity, innocence and consensus: women, people of color, gays and lesbians, and other repressed groups were starting to make their discontent known.

Considerable research has emerged that puts the lie to the persistent clichés of the 1950s. Joanne Meyerowitz argues that while early historians' focus on postwar conservatism tended to downplay women's agency, more recent case studies have highlighted the work of "significant groups of women who questioned and loosened postwar constraints." This new social history, Lary May suggests, strips away the consensus model to reveal the "conflict and diversity [that] informed the work of public and private life, as gender, populist protest, and minority tension repeatedly surfaced."[1]

Part of the blame for the persistence of the postwar ideology can be laid at the feet of those who sought to change it. Betty Friedan's pioneering work, *The Feminine Mystique*, first published in 1963, marks a towering contribution to the revitalization of the women's movement for millions of Americans. However, one of its unintended consequences was the stereotyping of the postwar era. Meyerowitz contends that while Friedan gave a name and a voice to the discontent of American housewives, she also "reinforced the stereotype that portrayed all postwar women as middle-class, domestic and suburban." This homogenization of women's postwar experiences and ideology is carried over in many of the historical treatments of the period.[2]

There is much evidence of gendered discontent and activism in the postwar era.[3] The 1950s are the origin of the women's movement that resurged a decade later in what Foreman describes as an era of "nascent rebellion and liberation." Though there was a slowing of women's activism regarding gender issues following World War II, there *was* an active movement nevertheless, as Rupp and Taylor establish. Organizations such as the National Federation of Business and Professional Women's Clubs, with over 160,000 members, were able to use the language of the cold war to subvert conservative gender norms, promoting gender-role changes and facilitating women's participation in the public arena. Despite a decidedly antifeminist social climate, Eugenia Kaledin maintains that the postwar era was an active period of consciousness-raising for many women, "when [they] first confronted the reality that American society made no concessions to their problems as wives or mothers or divorcees or underpaid workers."[4]

Some adolescent girls expressed their dissatisfaction with domesticity and suburban life by aligning themselves with the bohemian life of the Beats. Though primarily male, Beat subculture provides another example, Wini Breines suggests, of the opportunities to rebel against social norms in the otherwise staid 1950s. Girls and women could defy—or threaten to defy—sexual rules simply by

indicating their attraction to males they could not possibly marry. In doing so, they challenged the social standards employed to contain them.[5]

Women were not the only group in the postwar era whose discontent was starting to bubble over. African Americans were more successful than any other group in the postwar era in publicly voicing their grievances, though at considerable cost. In addition to overt forms of protest, evidenced by actions (and repressive reactions) throughout the country, blacks found more subtle, yet far-reaching, methods of articulating their alienation. Erenberg's work on postwar jazz suggests that black musicians engineered a stylistic shift in popular culture by moving away from the dominant paradigm of swing and into the more challenging and innovative bop music that challenged the "minstrel stereotype required of black entertainers." Through bebop, musicians like Dizzy Gillespie and Miles Davis fashioned a sound that gave voice to their disgust with the racist culture that privileged black music but excluded and marginalized black people.[6]

While the 1950s are correctly thought of as particularly hostile to gays and lesbians, with the government witch-hunt against them in full swing, there was notable resistance nevertheless. The war years facilitated the rapid growth of a gay subculture, and as the work of D'Emilio and Freedman points out, this continued virtually unabated into the postwar era. Lesbian bar culture, first established in many port cities during the war, remained and thrived after the war. In California, several gay organizations—under the "homophile" rubric—emerged in support of a legitimated gay culture. These examples point to the real if inchoate efforts of lesbians and gays, successful at times, to redefine definitions of sexuality in America.[7]

American adolescents were also increasingly unsettled, and juvenile delinquency was on the rise. Like women, teens were pushing against social norms and the mind-numbing sameness of suburban life. Teenage boys in particular were chafing against what Richard Flacks describes as cultural incoherence: a range of contradictory values such as discipline and indulgence, self-denial and self-expression that resulted in a growing cohort of alienated, disaffected young men. And as George Lipsitz has suggested, the new music that swept the country gave expression to adolescent feelings of rebellion and sexual tension, as well as a growing acceptance of racial and class differences. Young white audiences' interest in rock and roll, with its roots in blue collar and African-American cultures, further suggests the cultural changes that were afoot in the 1950s.[8]

Definitions of masculinity were being renegotiated on other fronts as well. While many men returning from the war actively sought out marriage and domestic stability, by the mid-1950s, even that ideological frame was under attack in some quarters. The introduction of Hugh Hefner's *Playboy* magazine in 1953 sparked a new construction of masculinity, leading some men to rebel against marriage and domesticity entirely in favor of a more publicly articulated, fantasy-infused lifestyle. Similarly, William Whyte's *The Organizational Man* signaled masculine dissatisfaction with the corporatization of the workplace. Even

among the male patriarchs who benefited most from postwar ideology, there is evidence of dissention and disaffection.[9]

It is within this recent outpouring of compelling historical research and within this context of challenge and conflict, of evolving identities breaking through conservative ideology, that I situate this study. What motivated millions of women to break with the dominant construction of femininity and attend professional wrestling in such numbers that they at times outnumbered their male counterparts at the arena? Who were these women? What meanings and pleasures did they find? What purposes did women's attendance and fandom of wrestling serve? I will argue that, far from a marginalized activity, women's fandom of professional wrestling is central to our understanding of the 1950s and of women's pivotal role in the decade.

The Life Cycle of Professional Wrestling

To better understand why women and wrestling converge in the 1950s, we need to consider the history of professional wrestling in the larger context of women's struggles in twentieth-century America. In one form or another, wrestling has played a role in most societies.[10] On the North American continent, wrestling was a part of many Native American cultures, and variations were imported by white European colonists from both England and France. Still, wrestling did not come fully into its own as an established sports entertainment in the United States until the beginning of the twentieth century. It has since undergone cyclical stages of popularity. Wrestling reached its first peak in 1908, in a pair of what are often characterized as "epic" matches between Iowan Frank Gotch—then the American titleholder, known for his skill and trickery—and George "the Russian Lion" Hackenschmidt, renowned for his precise, scientific technique. Nearly 40,000 people flocked to newly constructed Comiskey Park in Chicago for their second match in 1911 (Figure 1.1), at which Gotch prevailed.

Following Gotch's retirement in 1913, the industry went into a period of decline

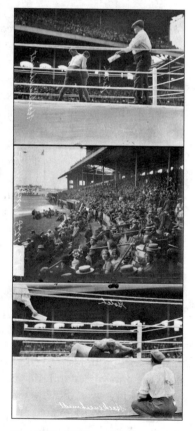

Figure 1.1 Gotch and Hackenschmidt at Comiskey Park. (Courtesy of Chicago Historical Society)

amid complaints that a "wrestling trust" existed—that the results were fixed. Some alleged that the championship belt was being passed among a small group of performers each season.[11] Declining public interest was also attributed to the sport's dullness, as the subtleties of the "scientific" wrestling style were lost on large crowds. Wrestlers would often remain fixed in holds for long stretches, attempting to wear down an opponent—a technique equally effective in wearing down the audience.

One competitor who overcame this problem in the late 1920s was Gus Sonnenberg, an All-American football player from Dartmouth. Sonnenberg's "flying tackle," borrowed from his gridiron experiences, demonstrated that an emphasis on action over artistry would increase audience interest. Many writers, however, complained that the result was "harmful" for wrestling as a whole.[12] As one journalist described it in 1935:

> Wrestlers began hurling one another out of the ring, slapping one another's faces, butting heads, kicking, scratching and gouging. They roared imprecations, screamed with pain, bared their teeth in fearful snarls, and on occasion aimed wild swings at the referee. It wasn't wrestling, but no one cared about that; the departure of refinement signaled the return of prosperity.[13]

With the effects of the Depression gripping the country in the early 1930s, wrestling thrived more on its ability to entertain than on its legitimacy as a sporting event. In fact, wrestling was heralded as the third largest "sports" industry in the country, behind only college football and major league baseball, posting estimated grosses of some five million dollars annually.[14]

Interest in professional wrestling slumped again in the late 1930s, as many daily newspapers dropped wrestling from the sports page because of the genre's increasingly theatrical performance style. Magazines such as *Time* and *Newsweek* denigrated the genre, taking repeated opportunities to expose wrestling as "fake," ignoring its largely accepted status as a *performance* of sport.[15]

It was not until after the conclusion of World War II that wrestling's fortunes took a dramatic turn for the better, with a new manifestation of electronic media: television. Radio broadcasting had proven to be ill-suited to transmitting wrestling events. As Morton and O'Brien point out, it is extremely difficult to verbally describe a wrestling performance, with its "approximately three hundred basic routines and up to one thousand terms for the estimated three thousand wrestling holds, moves and positions. Such a rich vocabulary would tax both the announcer and the audience."[16]

Wrestling was, however, extremely well-suited to television, which the industry quickly discovered and exploited. It had been included in NBC's earliest programming experiments when television was introduced commercially in 1939 and continued to be offered periodically throughout the war years. As the country began to negotiate the economic transition from wartime to peacetime,

the exploits of such characters as Wladek "Killer" Kowalski, Maurice "the French Angel" Tillet, Hans "the Horrid Hun" Schmidt and Ivan "the Russian Hangman" Rasputin became known in households across the country. So, too, did the exploits of Ann "Ringside Rosie" Buckalew of Pittsburgh and Mrs. Eloise Patricia Barnett of the Bronx, better known in the press as "Hatpin Mary." The men were the emerging postwar stars of professional wrestling in the United States, while Hatpin Mary, Ringside Rosie and other colorful characters like them were signs of the genre's sudden popularity among American women.

In 1945, one of the first weekly wrestling programs had its debut on KTLA in Los Angeles. Shot on a Paramount sound stage, the program was so successful that within two years it was moved to the 10,096-seat Olympic Auditorium. Here the program enjoyed a thirty-six-year syndicated run. By 1948, wrestling was a weekly feature on three of the four national television broadcast networks.[17]

If television benefited from its relationship with professional wrestling, the reverse was also true. Estimated annual attendance at professional wrestling events in the United States surged 800 percent in eight years—from three million in 1942 to twenty-four million in 1950—and insiders attributed the newfound prosperity to television.[18] *Business Week* reported in 1950 that "even the top wrestling promoters will tell you that television is directly responsible for this lush success."[19]

While television and wrestling had developed a symbiotic relationship in the immediate postwar era, television was not solely responsible for wrestling's success. Wrestling's performance style was moving toward still greater theatricality and showmanship. Even before the war ended, wrestlers such as George Wagner, known in the ring as "Gorgeous George," were remaking the image of wrestling, bringing an unprecedented level of antics, color and spectacle to the ring. Soon wrestling dazzled with the athleticized acrobatics of stars like Antonino Rocca and Andre Drapp; the nationalistic villainy of Ivan Rasputin, Killer Kowalski and Mr. Moto; and the body-beautiful imagery of Buddy "Nature Boy" Rogers and Gene "Mr. America" Stanlee. Each contributed to the heightened spectacle of professional wrestling, moving it ever further from its roots as a "pure" sporting event.

Another element contributed as well to the latest success of the genre: the increasingly dominant presence of women in the audience, both at the wrestling arena and watching on television. In 1950, an article in *Business Week* looked beyond the conjunction of television and wrestling to inquire what was behind its recent success, asking: "What made wrestling such a big TV feature? Mainly it was due to the fact that its most ardent fans are women. One big eastern promoter estimates the home wrestling audience to be 90 [percent] women."[20] In arenas across the nation, women were upstaging men at ringside; many more were viewing the event on television. By most accounts, as professional wrestling

in the 1950s grew in popularity both at the box office and on the television screen, it drew more women than men.

Wrestling had evolved from a sporting event—a ritualized test of strength, endurance and ability—into a performance of sport, with added theatricality borrowed from the stage. It had become a passion play of good and evil, hero and villain, right and wrong, with an occasional reprieve of clownish humor or carnival grotesquerie, transmitted by the increasingly powerful medium of television.

Defining Femininity

What was it about the condition of American women at this particular historical moment that made wrestling so attractive to them? In the latent social turmoil of the postwar era, definitions of gender roles were one of many contested areas. In fact, the role of women in American society had been a cultural battle for much of the century.

The first half of the twentieth century was marked by considerable activism and negotiation of the status of American women. Significant early events included World War I, during which women experienced new employment opportunities, albeit limited in scope; the passage of the Nineteenth Amendment, which granted women the right to vote; and the Roaring Twenties, specifically the emergence of a new definition of femininity in the image of the "flapper," an openly liberated, independent woman. Soon after, however, Depression redefined gender roles yet again, restricting women's access to the workplace (particularly that of married women) in favor of their male counterparts and reinforcing conservative definitions of femininity. As Rupp and Taylor document, in the aftermath of the successful passage of the Nineteenth Amendment, feminism had lost much of its forward momentum and entered a period of retrenchment.[21]

America's involvement in World War II forced a radical change to women's employment prospects, and their position in American society, for the first time since the turn of the century. Rupp and Taylor point out that the war drew millions of women into the paid labor force for the first time, while employed women shifted into millions of jobs previously reserved for men. In response to the war, over six million women took jobs, increasing the size of the female labor force by 60 percent by 1945. Historian William Chafe suggests that during this period, wages for women grew, the number of wives holding jobs doubled, and the unionization of female employees skyrocketed. Many women experienced job mobility for the first time, with African-American women benefiting more than any other single group.[22]

Just as importantly, some public attitudes concerning women's employment changed. In order to satisfy the wartime demand for workers, government agencies vigorously campaigned to encourage women to enter the work force. Just a few years before, married women had been criticized for taking jobs away from men,

but now they were specifically urged to take on "men's jobs" in support of the war effort. Chafe argues that "in the eyes of many observers, women's experience during the war years amounted to a revolution."[23] Some prominent women leaders noted that women workers had gone from being "socially inferior" to becoming "first class citizen[s] whose contribution was recognized by everyone as indispensable to national survival."[24] Others asserted that women would never again be economically dependent on men. Most importantly, public attitudes toward women's employment changed, at least for a time, "from outright condemnation to tolerant sanction."[25] As the demands of the war effort led to an unprecedented change in the economic status of American women, no doubt some felt that an ideological change in the status of women was not far behind.

On the other hand, plenty of indicators of gender inequality remained. During the war, popular literature and politicians frequently reminded women of the temporary nature of their employment status, urging married women to return to their domestic roles and single women to give up their jobs and find suitable husbands once the war was over. In the workplace, the tradition of gender-based wage disparity continued unabated, and most women were prevented from advancing into management and professional positions. Many others faced a lack of community assistance in household and child-care duties.[26] The challenge of balancing domestic responsibilities with increased outside employment led to high absentee and turnover rates for industries, hampering wartime production. Not surprisingly, stories in the media covered some of the more dramatic results of this unresolved tension, such as children locked in cars in war-industry parking lots, penned in basements or packed off to neighborhood cinemas. One journalist claimed that children trapped in homes without constant care "are the troublemakers, the neurotics and the spiritual and emotional cripples of a generation hence."[27]

Prevailing attitudes regarding appropriate roles for women in society, visible in press reports, and in government and industry policies, continued to relegate women firmly to the domestic sphere. But the status of women suffered great internal tension. Unlike any other time in the twentieth century, women in significant numbers—married and single, of all races, ages and class backgrounds—were beginning to taste economic independence and real opportunity. More women were employed in paid positions than at any other time in the nation's history; some experienced economic autonomy for the first time, while others enjoyed job mobility and improved employment status, many at higher rates of pay than ever before. And despite continuing job discrimination, wage disparity and public sentiment regarding the eventual return of women to the home, 80 percent of the women interviewed in a Women's Bureau survey indicated their desire to remain employed after the war ended.[28] The ideology of traditional gender roles was contravened by women's behavior and experiences as wage earners, a trajectory of change on which many women wished to continue permanently.

With the end of the war, a rash of uncertainties and insecurities found public expression when eleven million servicemen returned to their jobs and families. The cessation of hostilities meant the closure of the wartime manufacturing machine, which in turn raised fears of a depression like the one that had enveloped the country in the 1930s. For many women, this meant renewed uncertainty about their employment status, and with good reason. Repeating the pattern established after World War I, the end of World War II spurred the effort to move women out of their new jobs to make room for returning veterans, into lower-paying (or unpaid) occupations.[29]

By and large, the new employment opportunities offered to women during the war had been grounded in arguments of patriotism, altruism and self-sacrifice, all of which implied the positions were temporary, thus setting the stage for the layoffs that would come. But while women comprised 60 percent of all workers released from employment immediately following the war, an appreciable number of women retained their positions in the labor force. Only a small percentage of the six million people predicted to lose their jobs remained permanently out of work; the majority of women who had left their wartime jobs rejoined the labor force at a later date. And while the number of employed women aged twenty to thirty-four dropped substantially, their departure made room for older women to enter the workplace, many in the expanding "pink-collar" section of secretarial, clerical, service and teaching positions. Consequently the actual number of women in the labor force continued to rise after the war.[30]

Nevertheless, government discourse, media debates and industry practices made the workplace an even less hospitable context for women in the 1950s. Women retained many of the economic gains they established during the war, albeit at lower wages, but not without an ideological cost. Wartime social acceptance of independence for women was replaced by calls for a return to domesticity and subordination for women. Hartmann points to politicians who used the rhetoric of cold-war competition with the Soviet Union to argue for women's traditional roles as wives and mothers. Some viewed women's employment as a contributing cause of childhood neglect and teenage delinquency, urging women to return to their domestic roles lest the stability of the nation's social institutions be threatened. A darker image of femininity was also cultivated by Hollywood through film noir, which suggested that unchecked, selfish female drive represented a powerful and dangerous force.[31]

The theme of a return to domesticity was echoed on numerous fronts in American culture. Mary Beth Haralovich shows how consumer manufacturers and advertisers, suburban home designers and builders, market research firms and television programmers worked to redefine white middle-class women primarily as homemakers and consumers, rather than as members of the paid labor force. In this way, images of domesticity were used to renegotiate the definition of femininity in part to better serve the needs of postwar patriarchal capitalism.[32]

And as I detail in chapter 3, the definition of female sexuality was also undergoing a cultural change. On one hand, women were treated to heightened messages of feminine sexuality in the media, in advertising and in movies, suggesting a more permissive attitude toward women's sexuality and sexual display. On the other hand, prohibitions against girls and unmarried women acting on their sexuality increased. As Wini Breines suggests, the 1950s were for women "a time when liberating possibilities were masked by restrictive norms."[33] Constructions of appropriate sexuality for women were everywhere in conflict.

A battle began between the conservative ideology of the feminine role, which was situated firmly within the confines of the domestic sphere, and the changing reality of women's lives, which increasingly occupied social space, in the employment arena and beyond. In fact, as Mary Ryan's work suggests, women's considerable public activity in the 1950s was simply a continuation of their work in the public arena for the past two centuries.[34] This ideological pull between public and private evolved into what some called the "woman problem," a subject of national debate and controversy, even in the mainstream press. A 1947 feature article in *Life* magazine titled "American Woman's Dilemma," for example, argued that a growing number of contemporary women were frustrated by the dichotomy between traditional conceptualizations of a woman's role and her actual experience outside the home. *Life* weighed in again in 1949, observing, "Suddenly, and for no plain reason the women of the U.S. were seized with an eerie restlessness." Whereas women in previous decades had only one major decision—choosing a husband—*Life* posited that American women in the postwar era had to balance their wish to marry and have children against a desire to participate in the world outside the domestic sphere, especially after their children had sufficiently grown.[35]

This ongoing tension provoked significant discontent. A survey appearing in *Fortune* in 1946 noted that 25 percent of women polled would prefer to be men, given the choice.[36] One reason for this dissatisfaction lay in the limited choices available to women who had given up or curtailed their careers and personal interests to take on the burden of household tasks and child-rearing. Another factor for predominantly white middle-class women was the increase in migration to the expanding suburbs, and the sense of isolation that resulted from it.[37] Compared to the relative economic and social freedom many women experienced during the war years, the postwar era was characterized by lowered expectations for some and heightened disappointment for others.

In the clash over "appropriate" femininity, women sought out new venues in which to explore and express their identities. Professional wrestling provided a perfect synthesis, offering women a classic story of good and evil, morality and immorality, performed by burly, athletic men in abbreviated attire. In the postwar boom of consumer culture, wrestling extended its reach to the local tavern and to the homes of a growing audience of television viewers. On the wave of publicity garnered by television, wrestling engagements were moving from the

smoky confines of the gymnasium into larger, cleaner sports arenas. As wrestling's promoters and performers became aware of the changing composition of the audience, they began to gear their performances to women. And women took to it in record numbers. As I argue in this book, women exercised considerable social, cultural and economic power in the 1950s through their fandom of professional wrestling—in the public arenas, in millions of private homes across the country and in the pages of countless publications. Women's interest in wrestling evidences a growing sense of empowerment and resistance to gender boundaries in the postwar era. It is no wonder that dominant ideology was spoken with such firm and unrelenting resolve in the 1950s: the foundations on which it was erected were particularly unstable.

Outline of Chapters

This book examines the places where women's fandom of wrestling was most visible. The most obvious place to see women was at the wrestling arena; thus, chapter 2 examines televised wrestling programs from the 1950s. As a constructed event, the wrestling program reveals assumptions television producers made about the audience. There is clear evidence that some producers were creating a program that would appeal to both male *and* female viewers, despite wrestling's construction as a masculine sports entertainment. The recordings of these matches also reveal the multitudes of women at the margins of the screen, and the many ways they engaged with the performances in the ring. Finally, women found ways to use television's recording apparatus to share their pleasures with the larger community of women watching at home.

In chapter 3, we study female audiences from the viewpoint of the mainstream print media. The perspective of that era's newspapers and magazines also affords a view beyond the immediate proximity of the wrestling ring, allowing a peek at less accessible spots, such as the wrestlers' dressing and hotel rooms. The press speculated about the nature of wrestling's appeal for women, though the conclusions reporters drew were not nearly as persuasive as the evidence of pleasurable objectification and physical confrontation they presented. We also look into the home space, where women watched wrestling on television, sometimes holding the television hostage for hours at a time, and where families often watched their wives, mothers, sisters, daughters or grandmothers engaging with the program on the screen.

A number of commercial wrestling magazines emerged in the 1950s to capitalize on wrestling's surging popularity, and these specialized publications are the focus of chapter 4. There we find a more defined portrait of the male and female fans who flocked to wrestling and clashed over its meaning in the pages of the wrestling press.

Chapter 5 examines the fan club, an even more intimate space for wrestling's female fans. Hundreds of fan clubs were formed in the 1950s around

the star image of a featured performer, and most were run by women. Many clubs published a regular fan club bulletin, a mimeographed publication featuring news and commentary on their favorite wrestlers. These bulletins, which contained artwork, poetry, photography, stories, social commentary and more, offer a fascinating perspective on some of wrestling's most dedicated female fans and the efforts at self-definition that underlie their fandom.

Chapter 6 views women and wrestling through the lens of memory, based on my interviews with men and women who worked in the wrestling industry as wrestlers, announcers and promoters, as well as with those who were fans in the 1950s. Their stories confirm many of the perspectives offered in the previous chapters and help explain what drew women to wrestling and what they took away from it.

Wrestling's fortunes declined in the 1960s, as both the television networks and much of its female audience went elsewhere for entertainment. Chapter 7 examines the significant lessons to be learned from this transition, perched on the doorstep of the feminist movement that would sweep the nation in the decade to come.

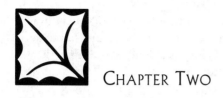

Wrestling with Television

George Wagner may well have been the greatest television appliance salesman in Southern California in the 1940s. Yet I don't think he ever worked retail a day in his life.

Long after television was first introduced to the Los Angeles area, set dealers were tormented by the lack of sales. Despite two active stations in the metropolitan area, sets were languishing on the shelves. Dealers grumbled that the programming available wasn't sufficiently attractive to new purchasers.[1]

But a change had already begun. KTLA had begun broadcasting wrestling from its studios in 1945, and two years later the station moved its operation to the spacious Olympic Auditorium, where the wrestler George Wagner, better known to fans as Gorgeous George, was fast becoming a box-office phenomenon.[2] Suddenly, interest in television sets exploded, and dealers credited the wrestler with spurring more sales than any other individual. Soon "the Gorgeous One" was performing his sales pitch across Southern California, and his message was echoed on billboards outside hundreds of bars and restaurants, advertising "Gorgeous George, Television, Here Tonight."[3]

While he may have drawn a crowd, Gorgeous George was anything but a favorite once inside the ring. A featured match between Rito Romero and Gorgeous George[4] broadcast on *Wrestling from Hollywood* in the 1950s demonstrated the wrath he inspired in his audiences. Like many other wrestling performances, this one featured large groups of women in attendance, women who were unrelenting in their verbal attacks on the wrestler. Midway through the first of three falls, a woman can be seen and heard urging Romero on, yelling out her advice: "Break his arm!" Other women around her laugh approvingly at her brash performance.

The barrage of verbal abuse by the women in the arena continued through the rest period and increased markedly after George lost the second fall to even the match. A few minutes into the break, George suddenly looked directly at a large, boisterous group of women in the front row and yelled, "Aw, shut up!" The women responded gleefully with laughter and applause; they had succeeded in rattling "the Gorgeous One" with their verbal onslaught and clearly relished their hard-won victory.

The newcomers thronging to wrestling matches were first introduced to the performance genre through television. Wrestling was ideally suited for television: unlike sports such as baseball or football, wrestling's confinement to a well-lit ring meant that one or two cameras could easily cover the action. And because the ring was centrally located in the sports arena and surrounded by the audience, the crowd contributed both a visually attractive backdrop and a ready-made sounding board for the narrative unfolding in the ring, dramatically underscoring the performance.

Finally, unlike boxing, another popular sport that was located in a ring and well suited to television, professional wrestling's status as a theatricalized genre based on the *performance* of sport made wrestling a much more predictable television commodity. A first-round knockout in boxing would leave broadcasters with unfulfilled advertising commitments and unfilled airtime; likewise, extra innings in a baseball game could run up costly additional wire expenses. But wrestling performances suffered no such problems; performers could easily and predictably fill the time between advertising breaks, concluding matches quite literally on cue. As one wrestler explained, "When the announcer picks up a piece of paper, we know it's time for the commercial and we go into a slow stall on the mat—the sponsor's gotta live, too."[5] Thus it is not surprising that each of the four commercial networks featured prime-time wrestling programs between 1948 and 1954. Televised wrestling could also be seen in syndication across the country, and a host of local stations met with early success by televising local (and later syndicated) wrestling matches in their areas.

This chapter analyzes sixteen wrestling programs produced by ten different production companies originating from Chicago; Washington, DC; Buffalo, New York; and southern California. Though few, if any, surviving copies of these programs contain explicit air dates, all but two of the broadcasts can be dated to the early and mid-1950s by cross-referencing the careers of the performers. Of the sixteen tapes, *Lou Weiss Presents: Wrestling Night at Hollywood Legion Stadium* was copyrighted in 1941, while an episode of *Wrestling from the Capitol* was likely recorded in the late 1950s or early 1960s. *Wrestling from Chicago* was distributed by a network (DuMont); *Wrestling from Hollywood* with Dick Lane was distributed nationally via syndication during the early 1950s.

To provide additional context, I also examined a collection of thirty-three wrestling-specific episodes of Hearst Metrotone newsreels dating between 1929

and 1961, with the majority originating in the 1950s (UCLA Archive, Los Angeles, CA). Finally, I examined scripts and filmed episodes of a Pittsburgh news program entitled *The Pitt Parade,* which was televised locally from 1949 through 1959 and included regular features on professional wrestling.[6]

Many media historians working within cultural studies seek to uncover and emphasize repressed fragments of evidence that can be used to counter official histories. This chapter uses evidence of broadcast audiences to explore the multiple, fragmentary and often conflicting voices and perspectives at the margins of a television broadcast. The analysis specifically emphasizes those aspects of the wrestling presentation that attracted women fans to the genre and examines the performances of many women in attendance at the events.

From Arena to Living Room

The technical requirements for broadcasting a wrestling match did not change significantly from the first wrestling matches aired in 1939 to the genre's newfound popularity a decade later. However, wrestling's performance style underwent a pronounced shift during that period, a shift caused in part by a change in the audience. Early broadcasts, such as the 1941 match between Dean Denton and Dick Raines featured on Lou Weiss' *Wrestling Night at Hollywood Legion Stadium,* had tended to emphasize an athleticized wrestling performance, highlighting displays of strength and wrestling technique.[7] But in the post–World War II era, wrestling performers increasingly employed visual and dramatic spectacle.

Michael Ball argues that wrestling's theatrical roots can be traced to its transition at the start of the twentieth century from a participatory event—in which wrestlers would take on local challengers—to a spectator event, in which audiences paid to watch professional athletes meet one anther in the ring. This professionalization of wrestling, Ball suggests, is largely responsible for the "thespian nature of wrestling."[8] With the development of a symbiotic relationship between wrestling and television, this theatrical style thrived.

Heightened theatricality is readily apparent in wrestling's changing cast of characters, and particularly in the increasingly complex construction of its villains, or "heels," as they are known within the industry.[9] As historian Graeme Kent argues, prior to World War II, the character of the villain in wrestling "had always been depicted in the ring as [an] unshaven, scowling brute," a persona based largely on the uncomplicated display of excessive strength and unseemly behavior.[10] But as wrestling moved to television in the late 1940s, newer, more nuanced types of villains emerged. The complexity and depth of these new characters may not have traveled easily to spectators in the top rows of a live arena but were effortlessly communicated through television. Among the most crowd-pleasing was Gorgeous George, whose stage persona balanced prissiness, arrogance and ostentatious display. George wore his hair long, dyed

blond or other colors to match his costume, and set in a marcelled permanent at a local beauty parlor prior to each match. He traveled with an impressive array of lavish robes and gowns that he wore into the ring, accompanied by his valet Jeffrys.

Many of wrestling's most popular (and infamous) characters adopted other elaborate stage personas, including "Nature Boy" Buddy Rogers, Gene "Mr. America" Stanlee, the Golden Superman, the Black Panther, the Thing and Elephant Boy, along with a plethora of German, Japanese and Russian villains, Indian chiefs, British royalty and the like. It was clear to those in charge of the wrestling industry, Kent suggests, that "the fans they sought would have to be wooed with bigger and more rousing spectacles."[11] Television, with its ability to bring the elaborate costuming and characterization into sharper relief and distribute them to a much wider audience (dominated by women), was instrumental in wrestling's increased popularity.

It is appropriate to pause a moment and reflect on the historical status of women's culture—or that which is ascribed to women at a particular historical moment. Women have long been associated with spectacle, from melodramatic theatricals to romance novels, as well as with mass culture more generally, and they have been roundly criticized in the association. Huyssen argues that nineteenth-century women were often castigated for their consumption of "inferior" literature and "inauthentic" mass culture, while men were similarly praised for their devotion to real or authentic culture, that is, "high art." Kibler demonstrates how early cultural critics disapprovingly associated women with a saccharine culture, rather than one of educational and civilized uplift. Professional wrestling's status was considerably lower than its more male-oriented sporting equivalent—boxing—and sunk even lower in the 1950s. It is no surprise, then, that professional wrestling would be further denigrated for being popular with women.[12]

Before television interceded, many women wouldn't have been caught dead at a wrestling match, in part due to the locations in which the matches were held. Wrestling events, particularly in smaller cities and towns around the country, were consigned to small venues, such as gymnasiums, second floor meeting halls and converted dance halls. These spaces reeked with liniment, sweat and the ever-present cigar smoke that sometimes obscured the action in the ring.[13] Still, as Butsch argues, promoters of popular forms of public entertainment have often remade both the place and the performance to attract female consumers. Vaudeville and movie theaters were marketed as safe and educational spaces, some even outfitted with child-care facilities, in order to lure women into public amusement venues.[14] In the case of wrestling, television sanitized the performance by resituating it within the home, thus eliminating the odors and humidity of the gymnasium or arena. Television also offered an intimate perspective on the action, a close-up previously reserved for those privileged fans who could afford ringside tickets. The spectacle of

wrestling was now sweet-smelling, in focus and fully available to anyone with access to a television.

Scrutinizing the Wrestling Performance

Scholars have extensively analyzed the wrestling performance, generally concentrating on three key elements: the choreographed battle between combatants in the ring; the morality play that makes up wrestling's grand narrative; and the exaggerated body of the wrestler himself.

The first element, the actual contest between combatants, represents the *performance* of sport. It focuses on wrestling at its most basic and elemental: the context between individuals. The wrestling match would seem to target a male viewer most directly, with its emphasis on athletic performance, competition, victory and defeat—the components of sport. Yet as Roland Barthes observed in 1952, "Wrestling is not a sport, it is a spectacle," as much as any other theatrical form.[15] John Fiske argues that wrestling is more a performance of ritual than the skill of sport, a ritual that is "excessively physical . . . whose meaning is the clash of flesh on flesh."[16] The meaning of wrestling, from this perspective, is not sport, but rather, in Fiske's words, a parody of sport. It exists not as true competition, but as the performance of competition between ritualized characters who know their roles and deliver what is expected of them. The masculine viewing position privileged by any reference to wrestling as a sporting contest is obviated by its performative excess.

The second element of wrestling, drama, is infused into the individual match by the narrative implications of the outcome and by the overarching and ongoing story. Wrestling, particularly televised wrestling, is much more than a collection of individual contests. Each match is a mini-morality play of good versus evil played out between two combatants, each of whom brings an elaborate history to the context, a lineage of past events, accomplishments, allegiances, wins and losses. And each brings the promise of the future, though usually one will take the setback that comes with loss. Thus each individual match is set within the play of a larger, serial narrative structure: each win or loss implies new battles, new obstacles and new meaning.

Wrestling's exposure via television in the 1950s made this genre available to a large group of women who were previously unexposed to the form. Its strong roots in melodramatic tradition meant that wrestling's narrative structure was very familiar to women, even if wrestling itself was not.[17] Furthermore, the added visibility provided by television, both in its transmission of the form to a wider public and in its concentration on close-ups, which brought the action and the larger narrative structure closer to the casual viewer, permitted wrestling to extend its narrative emphasis even further than previously possible. In addition to more subtle and sophisticated character development, television incorporated backstory through between-match segments in which announcers interviewed

wrestlers and their managers about past matches, conquests and slights, and future plans. These interviews gave the viewer even more narrative information. Television also introduced the idea of a commentator or announcer, adding another layer of narrative complexity. Thus television enhanced wrestling's larger narrative structure, a genre steeped in the melodramatic tradition with appeal for both male and female viewers.

The final element of wrestling is the body itself, athletic or excessive, muscled or flabby, toned or bloated, hidden or exposed. Certainly the exaggerated male body as an object of spectacle was an important component of wrestling in the 1950s, as it is today. What we have come to know as the grotesque male body of current wrestling is a construction that began in the 1960s with the increased availability of steroids. Growth-enhancement drugs made possible the emergence of the cartoonish "super-hero" bodies typified by Hulk Hogan, Randy "Macho Man" Savage and "The Ultimate Warrior" in the 1980s and 1990s (as well as by film stars such as Arnold Schwarzenegger). However, back in the 1940s and 1950s, the typical body image for wrestlers, particularly for the heroic figure, was modeled after the body builders of the time. These were men whose body weight averaged closer to 200 pounds—at least 75 to 100 pounds less than current wrestlers—with less of the muscle definition currently in vogue.

The appeal of the male body on public display, both on television and on stage in the context of the late 1940s and 1950s, strongly suggests the targeting of a female viewer. Comments from some of the women in attendance, as we shall see, certainly demonstrate that the eroticized male body on display was of considerable appeal to many women in the audience, and thus to many viewing on television as well.

When considering the body of the male wrestler in the 1950s, it is appropriate to consider the racial aspects of such appeal. It would be easy to assume that the body of the 1950s wrestler was largely a white body. While many male African-American wrestlers were active during the early 1950s, only a handful, like Bobo Brazil and Woody Strode, achieved national prominence.[18] However, looking beyond a bifurcated definition of race, professional wrestling has long relied on performers from a wide range of racial and ethnic backgrounds. While the majority of the performers were identified racially as being of white, European descent, performers such as Don Eagle (Native American), Antonino Rocca (Italian/Argentinian), Miguel Guzman and Rito Romero (Hispanic) were but a few of the featured players in the parade of attractive, eroticized male bodies that filled the television screen in the 1950s.

Each of these three central features of the wrestling performance—spectacle, melodrama, and physique—points to a range of pleasures available to women. The growing emphasis on the theatrical and sensational in wrestling of this period, along with the display of performers' muscled bodies on television, created a genre that was increasingly attractive and accessible to a female audience.

"Now Hear This"

The presence and performance of the television announcer contributed significantly to bridging the gap between wrestling and its female audience. Wrestling programs typically were narrated by male announcers, who would offer a play-by-play interpretation of the events unfolding on the screen. Personalities such as Steve Allen and Dennis James, actor Dick Lane, and sports commentators Jack Brickhouse and Harry Carey were among the better known hosts of wrestling programs in the 1940s and 1950s. The role of the announcer as a mediator and interpreter of the wrestling performance was something of an innovation. While audiences were used to hearing most sports genres described in mediated form, either by radio announcers or via the daily newspaper, wrestling had previously enjoyed no such attention. The inclusion of a commentator in the wrestling broadcast demystified the performance to the uninitiated viewer. Brooks and Marsh give the example of DuMont's Dennis James, one of wrestling's most famous television announcers, noting that his "simplified explanations and infectious enthusiasm made the sport palatable even to little old ladies."[19]

As in so many sports genres, a wrestling announcer's descriptive patter included a litany of terms unique to the performance type. Wrestling jargon was particularly flamboyant and creative, especially when describing the many maneuvers or "holds" specific to individual wrestlers. While many amateur-wrestling holds had long been included in the lexicon of wrestling, descriptions of new techniques unique to the professional ranks were rampant. Announcers would regale the television audience with descriptions of holds such as the "Gorgeous George Flip," "flying scissors," "back-breaker," "Boston crab," "Japanese head twist," "Cobra hold," abdominal stretch and the potentially lethal "pile-driver," said to be banned in several states.

While most moves would be identified by the announcer as the match progressed, in some cases announcers would have to invent names on the spot. In the program *At Ringside* from Hollywood Legion Stadium, in a match between Andre Drapp and the Bushman, Drapp suddenly grabbed the fingers of his opponent, and the pair flopped to the canvas on their bellies. The announcer was taken quite by surprise, remarking: "Well, that's a new one. I don't know what I'd call it! You can call it any . . . [laughs] Sgt. Benjamin, who is with me from Armed Forces Radio, says, 'Call it a flapjack.' That's as good as any, Ben!"[20] Announcers were often similarly challenged to coin terms for a profusion of new wrestling moves. This widening array of specialized tactics is further indication that wrestling was becoming increasingly theatricalized.

Despite these innovations, most wrestling maneuvers were well known to the aficionado. Knowledge about the holds used in wrestling was part of a fan's "cultural capital,"[21] to use Bourdieu's term, and was important to many of the female fans I interviewed.[22] Of course, familiarity with specialized, genre-specific

knowledge is a common attribute of most sports fans. Devoted baseball fans, for example, pride themselves on their intricate understanding of strategy and the ability to recall and contextualize an enormous, always shifting sea of statistical information. But command of cultural capital is equally important to genres like the soap opera, where detailed knowledge of the history of characters and story lines can place the smallest detail in sharp relief. Similarly, an in-depth knowledge of the growing array of wrestling maneuvers meant that fans could easily interpret the application of a wrestler's signature hold, for example, as a hint that the conclusion of a match was near, and the outcome clear.

Both wrestling and boxing matches began in the same manner, with the introduction of the combatants by the ring announcer or matchmaker at the center of the ring. This was followed by a description of each wrestler by the television announcer, who would provide additional pertinent information, such as the color of his trunks—a particularly useful piece of information to the television audience watching the broadcast on a black-and-white screen. Yet unlike boxing announcers, who perfunctorily mentioned the color of a boxer's trunks only as a means of identification, wrestling announcers often went into remarkable detail in describing the wrestler's costume. In the program *Wrestling from Hollywood*, Dick Lane began his characterization of a match between Ali Pasha and Mr. Moto with the following description: "Ali Pasha, wrestling out of the white corner, in black trunks, removes his robe, which is a wine red lined in chartreuse, and the black fez. In the black corner, Moto has removed his rather sporty pictorial [robe], a fishing motif in the brocading, and off with the gaiter, the elevator shoes, and the toppy, the little white mitten-like booties."[23] Lane offered this description of wrestler Gorgeous George: "The simulated pockets with the peplum design at the hip are very flattering, wearing five buttons at the top of each pocket. There are forty-two of those buttons."[24] Such descriptions suggest the producers assumed that the television audience had a sophisticated appreciation of color and design. Decorative techniques such as brocading (a heavy fabric interwoven with a rich, raised design) or peplum (a short overskirt or ruffle attached at the waistline) would have been lost on most men in the audience, but were familiar to most women.

Color, too, is vividly described to viewers watching at home on black-and-white sets. Instead of the primary colors traditionally offered by boxing announcers, commentators across the country described the wrestlers' color choices in vibrant detail: wine red, chartreuse, canary yellow, Irish green. From *Western Main Event Wrestling* comes this portrait of wrestler Gorgeous George, offered by host Allin Slate: "Color or no color, this would be a beautiful costume. It's an amazing red—he should be a fashion expert for this—it's a red, a persimmon red color with sequins in large and small circles in and out, a beautiful gown, or robe, or whatever it is."[25] While Slate couldn't decide if George's outfit was a robe or a gown, the fashion-literate in the

broadcast audience likely knew. That it was "persimmon red" added detail unavailable on a black-and-white screen. It also provided a level of meaning that went beyond simple identification for those in the audience who were sensitive to the subtleties of color.

This attention to descriptive detail served a number of functions: at one level, it played on class tensions, angering and inciting viewers with a stream of information that highlighted the class position of the wrestler's character and the disparity between him and the audience. Still, for many of the men in the audience, interested primarily in the contest between combatants, the announcer's focus on seemingly irrelevant costuming detail was a reminder of the increasing influence and incursion of the female spectator in a previously male-oriented performance genre. Such details offered viewers a level of description accessible to anyone with knowledge of fashion and style.

While I do not wish to essentialize fashion as a subject area of interest exclusively to women, there is certainly precedent for linking fashion to a female audience. In her discussion of 1950s situation comedy, Patricia Mellencamp argues that gendered categories of programming were quite prevalent during the postwar era: "Apparent in the early 1950s was the 'gender base' of television, with sport and news shows for men, cooking and fashion shows for women, and 'kidvid' for children."[26] The salience of such gendered distinctions, and the identification of fashion shows as principally a women's genre, indicates that the heightened interest in fashion detail among wrestling's announcers was an explicit strategy to attract a female audience for the program. Women were an important constituency for producers of wrestling programming, and producers were willing to offer them significant pleasures in exchange for viewing. Thus the announcer played an important role in bridging the gap between the wrestling performance and its growing female audience base.

Watching the Audience

Any television program is comprised of a variety of influences or "voices" in the text, including writers, producers, directors, actors, and station and network management. Each contributes to the formation of the television text and to the conceptualization of its audience. Television programs staged before a live audience, however, offer the potential inclusion of additional voices and inflections. They made a second level of wrestling performance available to viewers watching at home (and now to historians): the performance of the audience itself. For among the increasing numbers of women attending wrestling events, some were staging performances of their own. Some acted for their own enjoyment, while others acted specifically for the cameras and microphones and for the viewing audience at home.

The presence of the arena audience gave the producers of wrestling programs a lively visual and aural backdrop surrounding the action taking place at

center stage. This audience told television viewers that the contest was "real" rather than a staged, scripted performance (though for the wrestlers it was that as well). Thus the performances of the fans are incorporated into the television text, authenticating the program for viewers.

Still, the presence of the audience, particularly those fans who were within range of the cameras and microphones near the stage, had some unpredictable results. Many audience members in attendance, particularly women, made active use of the margins of the screen, brazenly inserting themselves more fully into the program. Women were poaching broadcast time under the noses of the producers, colonizing the edges of the broadcast for their own cultural performances. This demonstrates an interesting tension: on the one hand, television producers sought to incorporate the voices of the audience at ringside, turning the discourses of fans into a commercialized product that could be used to attract viewers, which in turn could be sold to advertisers. [27] On the other hand, as will become apparent below, the voices of audiences at live events can never be entirely contained, restrained or channeled solely into a dominant text. They semiotically overflow their boundaries, offering a multiplicity of meanings that at times challenge dominant norms. The voices of active women at ringside articulated the challenge to patriarchal norms of femininity, demonstrating the turmoil below the calm ideological surface of the 1950s, while simultaneously serving the commercial needs of the producers. Like other television events staged before an audience, wrestling programs offered viewers alternative voices which operated both within and against the dominance of the planned performance.

A Crush of Bodies

The most unmistakable aspect of the live audience for home viewers is simply bodies: women in evidence in large groups. Many tapes of wrestling matches clearly showed numerous gatherings of women in the first few rows, laughing, clapping, cheering, yelling, chatting amongst themselves, taking in and sharing the performance as a group. These tapes and films also reveal the variety of women in attendance; elderly women, girls in their early teens, working women in their twenties, and middle-aged women were all clustered near the ring. While most of the faces at ringside were white, African-American and Latina women were also visible. In California, one shot showed three generations of women—grandmother, mother and adolescent daughter—sitting together. Some women in furs and resplendent dresses were present, but just as many women appear in the simple, neat attire of a different class.

At times the groups of women took up entire rows within view of the camera, particularly at various arenas in California. These were not women who attended with husbands or male suitors in tow; they were women in their twenties intent on indulging their own pleasure, including the pleasure of each

other's company. Furthermore, these women had gathered in public—outside the isolated domestic world considered the most appropriate place for the feminine body, and outside their relationships to men—to take up a collective, active position at the center of the auditorium. At the same time, they were actively taking in male performers as *objects* of spectacle, momentarily denying the men their customary role as *definers* of "appropriate" gendered roles. In doing so, these women defied the feminine roles set out for them by conservative forces in 1950s America.

The program producers noticed their attendance. For example, during a break in a match between Leo Garibaldi and Wild Red Berry at the Long Beach Auditorium, the camera sweeps the crowd from floor level, revealing nine women sitting together in the first row. The camera then pans and tilts up to reveal a close-up of the muscular Garibaldi standing above them in the corner of the ring, a few feet away. The presence of such a large group of women in the front row was a spectacle worth demonstrating to the television audience, but it was Garibaldi, and not the group of women, who ultimately became the object of the shot: Garibaldi was the principal spectacle on display.[28]

Through this shot and many like it, an important message was being sent to television viewers. The image of women in the front rows of the arena stands as a commentary on the shifting composition of the audience, signaling that women now represented an important part of the audience for professional wrestling. To some, the dominating presence of women in the arena proved that, despite its past reputation, wrestling was now an entertainment form suitable for women.

The image of groups of women objectifying male performers is unsettling for male viewers used to seeing men as the subject, rather than the object, of the gaze.[29] And this image speaks to the social power women were claiming at ringside. There are several useful precedents that support this. In her examination of vaudeville performers and audiences, Kibler highlights the popularity of strongman (and some-time wrestler) Eugene Sandow—whose muscular displays and fig-leaf costume were of particular appeal to female audiences in the early 1900s—suggesting that his dependence on the female sexual gaze had a feminizing effect on his masculinity. She also cites Miriam Hansen's work on Rudolph Valentino to argue that "when men become the object of a sexualized gaze, their masculinity is destabilized."[30] In each instance, sexual and power relations are reversed, with women playing the controlling part. In addition to demonstrating their sexual power in this instance, women were making visible what sports culture tends to deny: the sexual appreciation of the athlete. This has a further destabilizing effect on the relationship between audience and performer, when defined in strictly masculine terms, which typically denies any sexual dynamic. By acknowledging the sexual aspect of an athlete's performance, women were asserting their power—through their control of the gaze—to be public consumers of male sexuality.

Acting Out

Beyond showing the sheer number of women in attendance, the camera also captured individual women close to the stage who were participating directly in the broadcast. Many women took great pleasure in their engagement with the entertainers before them. In a match between Freddie Blassie and Baron Michele Leone,[31] for example, a woman in a neat dress with a white collar can be seen sitting in the front row. She stands up and moves towards the wrestlers. Seeing that Blassie has the Baron incapacitated in a wrist-lock, she takes a puff of her cigarette, blows it forcefully at the Baron, and sits back down again. The woman seated next to her laughs. They smile at each other, and the woman with the white collar shakes her head triumphantly in mock bravado, then dissolves into peals of laughter. Her uncontainable mirth breaks the façade of her initial bravery, but it does not refute the power expressed in her behavior and validated by her companion.

Later in the match, Blassie wins the second fall against the Baron, to the delight of many in the crowd. A middle-aged woman, a wide smile on her face, approaches the ring and slams her hand on the mat a dozen times, mimicking a referee initiating the three-count slap of the mat that decides the victor. The performance is a pointed, gleeful reminder to the temporarily vanquished Baron of his failure to perform. Yet her four-fold elaboration of the ritual is also an authoritative commentary on the performance of the official in the ring: a message to the male referee, the representative of authority in the ring, to do his job and mete out justice.

This kind of disgusted response to the referee is not uncommon among wrestling fans. Justice is regularly thwarted in a wrestling ring, and the women in the arena are often quick to express their displeasure. In a tag-team match pitting Sandor Szabo and Warren Bockwinkel against villains "Wild Red" Berry and "Sockeye" Jack MacDonald,[32] the villains win the referee's decision for the third and deciding fall, much to the chagrin of the fans. One woman in the front row throws a bag at Berry, prompting announcer Bill Welch to observe, "Look out! Red's got somebody after him! Got a bunch of wild-eyed fans here tonight and they're *most* unhappy about the final outcome of things. A few of them getting eager to get in the ring and try to settle things with Wild Red Berry a little bit more." Interestingly, it is the women in the crowd—the "wild-eyed fans," in Welch's estimation—who are most assertive in signaling their displeasure, focusing their anger on Berry and the two referees: "And the referees are also getting a bad time from the fans also. This is certainly one of our more unpopular decisions here at the Hollywood Legion Stadium." Since women are no strangers to inept and faulty decisions by men in power, it may be that the context of the wrestling arena allowed women to fully express their contempt for such outcomes, and perhaps to rehearse their responses for the future, should they be faced with similar incompetence in their daily lives.

Women can also been seen acting out when they are seated together with men in the audience. At a match between Mr. Moto, a Japanese wrestler, and Ali Pasha,[33] a young girl and boy in their mid-teens sit at ringside. During an intermission, the girl extends paper and pen to Mr. Moto, hoping for an autograph. Her companion sits back, a stoic expression on his face. Later, during the match, the girl repeatedly jumps up and down as the action heats up; her date remains pinned to his chair. Throughout the performance, she is active, he is passive.

Sometimes announcers tried to trivialize the actions of female fans. In a match between villain Hans Schnabel and Australian champion Pat Mehan,[34] Schnabel has forced Mehan to the mat illegally, unbeknownst to the referee. An elderly woman with glasses walks into view at the edge of the canvas and throws an object at Schnabel in disgust. She then slams her purse onto the mat. The crowd roars in approval at her performance, but the announcer comments: "A fan comes in, to speak her little piece." Despite the condescending attempt by the announcer to minimize her actions, the elderly woman's performance captured the crowd in attendance and, likely, the television audience, eluding the announcer's attempt at containment.

In these fragments and in thousands like them, the aggressive performance of a female fan is inserted into the telecast at the edges of the frame, and confirmed and celebrated by others nearby. Some of the pleasure of public performance came through the creation of self-image. Wini Breines points to the rising importance of image in the 1950s, particularly for women, arguing that the notion of creating an image that could be validated by others was a critical element of social life. Of course the mass media emphasized the importance of being seen by *men*, using constructed desirability as a mechanism for attracting a husband. Still, the value of being seen can be extended to other contexts as well. While image-construction and validation from others were often framed in terms of what a woman lacked, Breines' larger argument centers on the double message women received regarding identity and sexuality, a dualistic imperative to be active and passive.[35] In that context, I argue that the validation given to women who demonstrated the instability of gender norms can be seen in a positive light. As wrestling's popularity grew with women, the wrestling arena increasingly became a place where women could indulge in and demonstrate new constructions of identity, rewriting the social rules of gender in ways increasingly validated by her peers. Seen on television night after night, vignettes like these demonstrated the ability of female fans to act assertively and physically and confirmed the instability of the norms of white middle-class femininity. While they may have been precluded from doing so in other contexts, these women—teenagers, middle-aged housewives, grandmothers—turned the wrestling arena into a space where they could *act out*, aggressively and publicly, for themselves, for those around them, and, through the television cameras, for the viewing audience at home.

Vocal Participation

Figure 2.1 Bobo Brazil

Many women felt free to contribute vocal, in additional to physical, performances. One interesting manifestation in the taped matches is the differing gendered responses wrestlers received upon introduction. In a match between Italian-American Army pilot Leo Garibaldi and the arrogant, self-aggrandizing "Wild Red" Berry, Garibaldi's introduction is met with a chorus of wild cheers from the women and boos from the men.[36] Likewise, when African-American wrestler Bobo Brazil (in a jacket adorned with a patriotic array of stars) takes on white wrestler Hans "the Horrid Hun" Schmidt in a match in Buffalo, New York, Brazil (see Figure 2.1) draws high-pitched cheers from the women and low-pitched boos from the men in the crowd.[37] In these instances the audience is clearly divided along gendered lines. Brazil's race and Garibaldi's ethnicity were likely catalysts, combined with their exceptional physicality, which may have appeared a threat to male masculinity; but the women in the audience vocalized loud public support of their wrestlers, regardless of what the men in the audience thought.

Audience members regularly operated as the voice of conscience in wrestling's morality play, and in doing so, women's voices dominated the chorus. In many matches where the referee turned a blind eye to villainy, women acted as the collective eyes and ears of justice. In matches in Los Angeles and Chicago, women call attention to each villainous act in unison by bellowing "Hair!" "Trunks!" and the like. At one point in a match between the Bushman and Andre Drapp,[38] the Bushman begins mangling the fingers of Drapp out of view of the referee. A high-pitched call goes up immediately: "Fingers!!" The announcer adds his own explanation, observing for the benefit of the viewers: "He's pulling the fingers apart on Andre Drapp!" Responding to the chorus, the referee moves in to stop the illegal action.

Throughout the match between Drapp and his opponent, as in many similar matches, the referee is serenaded with wave after wave of audience commentary, as hundreds of sharp eyes and high-pitched voices draw attention to the tactics of the villain. In most cases, the referee is compelled to act on the complaint, interceding on behalf of the incensed and vigilant crowd, and bringing to a halt, however temporarily, the wrong-doing in question. In this arena, at least, vocalizing women could point out the sins of injustice and force the less-than-observant representative of authority, however reluctantly, to take action.

Other women chose to speak out individually, and their words are clearly audible in the gaps between the announcer's banter on the tapes. There were some typical suggestions. In a match between Baron Michele Leone and "Sockeye" Jack MacDonald,[39] individual women in the crowd regularly shout encouragement, intoning: "C'mon, Baron!" "Fight 'im!" "Fight it!" and "Hit 'im in the back!" The aforementioned match between Rito Romero and Gorgeous George produced equally pointed commentary; one woman loudly yells to Romero: "Pull his hair!" Another woman implores: "Break his arm!" She and the other women sitting with her then laugh uproariously.

One role often assumed by an individual woman in the audience was that of a cultural critic, who would offer the crowd her own running commentary on the activities in the ring. In a match in Chicago between Frenchman Marcel Bucette and Ivan "the Mad Russian" Rasputin,[40] a woman in the crowd provides analysis of Bucette's physique, yelling repeatedly how much Bucette looks like "a big old teddy bear." Her vocal appreciation of Bucette's good looks is shared by many of the women around her. Later in the match, with Bucette taking the upper hand, the woman looks at Rasputin's clean-shaven pate and loudly observes: "Hey, his head's turning purple!" Many in the crowd chuckle their agreement. This woman's pleasure is derived in part from her ability to share her critical expertise with the fans around her, direct their perceptions, and receive the reward of their affirming response.

Others in the arena directed their comments specifically to the television audience. The tapes show some women standing in range of the cameras and waving directly to the viewing audience. Others locate the microphone and yell greetings to friends watching the television broadcast. Interestingly, most of the women yelled out the names of *female* friends, establishing connections with women who could not attend in person.[41]

The calls of these women in the audience to their counterparts in the media audience suggest that the pleasure of acting out at the arena was shared by quite a few watching the broadcast. In each instance, the women clearly relish their parts in the wrestling narrative as upstarts and miscreants. Their laughter signals their pleasure at the impact of their words, the sound of their voices, and the significance of the roles they are playing. It functions as a self-aware acknowledgment that their behavior is clearly at odds with their proscriptive identity as women, but it is entirely consistent with the types of challenges that were increasingly being mounted in the postwar era against such social limitations.

Whether purposefully or not, professional wrestling after World War II was increasingly tailored to the tastes of a female audience. Within the standard construction of morality play, the characters became more sophisticated. Television added announced descriptions that made the entertainment more accessible to inexperienced audiences. As it gained in popularity through its exposure via television, the staging grounds of wrestling moved to venues that

were more inviting to women. And women began to arrive, in dramatic numbers. Television transported the growing pageantry and active performances of women at ringside to viewers watching at home, in restaurants and bars, and outside hardware stores across the country. Women could be seen gathering in large numbers, accompanied or not, acting out before the cameras, ogling and objectifying the wrestlers' bodies and their sexualized, athleticized performance.

These women had little in common with June Cleaver or Donna Reed; they were more in tune with Lucy Ricardo, whose weekly attempts to escape the drudgery of homemaking catapulted *I Love Lucy* to the top of the ratings in the early 1950s.[42] Yet unlike Lucy, who at the end of each episode obediently returned to the domestic space, the televised women of wrestling remained at ringside to the end, asserting themselves happily within the friendly confines of the arena. Their performances force us to revise our conservative notions of gender construction in the 1950s, showing the postwar era to be one of active challenge and change, rather than domestication and passivity. The reactions of the mainstream press, detailed in the next chapter, would bear this out.

CHAPTER THREE

Wrestling with the Mainstream Press

If you were flipping through the newspaper in the late 1940s or early 1950s, you might be surprised to come across a photo of an elderly woman in a neat dress, standing at ringside, menacing a police officer with a baby's bottle, or a story of a woman who leapt into a wrestling ring in front of thousands of her peers, beaning a wrestler in the head with a large black purse or a soft drink bottle. Story after story appeared in the local papers and in nationally circulating magazines, telling graphic tales in words and pictures of women "gone berserk" at the wrestling arena. For those without access to television sets, the mainstream press provided many women with their first introduction to the world of professional wrestling and its fast-growing popularity among women of all ages.

This chapter examines the ways in which mainstream print publications represented the phenomenon of women's fandom of wrestling. While the tongue-in-cheek writing style adopted by many writers covering wrestling minimized both the subject matter and the women fans, their performances and pleasures still shine through the text and shed light on why they were drawn to wrestling.

The businesses of sports and professional journalism have long been intertwined, though not always happily. While sports stories began appearing in the American press as early as 1733, Adelman points out that prior to 1820, "the American view of sport was shaped by a Puritan legacy of ambivalence and suspicion." While participation in some sport endeavors could refresh the mind and body, Puritans feared they could as easily lead to idleness, or worse.[1] Furthermore, Steven Reiss suggests, "Antebellum newspapers were usually expensive and primarily served readers who were interested in business and politics."[2] Thus it is not surprising that while leisure-class sporting interests such as golf or

boating gained periodic coverage, working-class interests such as prizefighting or animal baiting were either ignored or handled with disapproval.[3]

It was not until the rise of the penny press in the 1830s that sports underwent a gradual process of legitimization. Urban leaders and writers increasingly saw sport as a curative to the ills brought on by city life, while the editors and publishers of major urban newspapers recognized that sports coverage could boost circulation.[4] Over the course of the century, a symbiotic relationship between media and sport was forged. Sports provided an endless source of stories with a capacity to attract readers—without the political or ideological baggage that might alienate advertisers. By the 1920s, daily newspapers had consolidated into a formidable collection of major media chains, while sport had emerged as a centerpiece of American culture.[5]

Along with professional baseball, football and boxing, professional wrestling was one of the sports that garnered regular coverage by daily newspapers. But the so-called Golden Age of Sports in the 1920s saw more exclusion of wrestling from the daily papers, with the gradual realization that professional wrestling was a performance of sport, and not a sporting event in the traditional sense. There was, for example, the (perhaps apocryphal) story of a besotted press agent who accidentally released the results of a wrestling match in advance of its staging. And as wrestling historian J. Michael Kenyon maintains, wrestling coverage by daily newspapers went into serious decline when some sportswriters discovered that promoters were paying their competitors to promote the game.[6] By the 1930s, coverage in the major dailies withered, while articles in national magazines playfully questioned the legitimacy of wrestling as a sport, inevitably asking the question, "Is it on the level?" An article appearing in *Esquire* in 1935 went even further, asking: "Are Wrestlers People?"[7]

Despite its tongue-in-cheek coverage, the press couldn't ignore wrestling's rising fortunes in the post–World War II era. Newspaper and magazine articles in particular took note of the rapidly expanding estimates of audience size. The *New York Times Magazine* noted in 1949 that wrestling was experiencing a "startling spurt in popularity." Observing that nightly "[a]udiences of 12,000 or 15,000 are not uncommon, even in comparatively small towns," the article concluded that the wrestling industry was anticipating its "most profitable season in the last twenty years." The *American Mercury* estimated the nationwide attendance for wrestling at twenty-four million people in 1950, combining for an estimated gross of thirty-six million dollars in revenue.[8] Eight years previously, attendance estimates had been only three million.

Nor could the press ignore the women who had become the largest segment of wrestling's audience. In 1950, *Ebony* observed that wrestling had been transformed from a second-rate attraction into a booming business, largely because of television and "a huge female following." A year earlier, *Collier's* stated: "Nearly 60 percent of [wrestling's fans], surprisingly enough, are women." This estimate was corroborated by *Cosmopolitan* in 1953, which

argued that women "comprise 60 percent of the paying customers." The subject was even addressed in *Business Week,* which asked: "What made wrestling such a big TV feature? Mainly it was due to the fact that its most ardent fans are women. One big eastern promoter estimates the home wrestling audience to be 90 [percent] women."[9]

Still, the observations of the mainstream press were less than celebratory. Rather, its treatment of women's interest in wrestling was consistent with its larger campaign to convince women to leave the paid workforce and return to the domestic sphere. This is in keeping with the mass media's role as a social institution, one of a select group of loosely allied legitimated institutions such as government, business, education and religion that seek to influence public behavior. Because media outlets depend on these institutions for access to a steady stream of information and story material, news organizations legitimate the authority of those that hold power: bureaucrats, politicians, social and business leaders, and so forth. News organizations are institutionally linked to other facets of the power-bloc, and thus they are generally committed to reproducing social mores.[10]

Utilizing accepted institutional news practices, reporters strive to turn occurrences into discernible events, using "frames" to organize and transform everyday reality into news stories. Robert Entman describes framing as a process of "selecting or highlighting some facets of events or issues, and making connections among them so as to promote a particular interpretation, evaluation, and/or solution." Those frames that have the most "cultural resonance" with readers—those that are, in Entman's words, most "noticeable, understandable, memorable, and emotionally charged"—will have the greatest potential for influence.[11] By limiting the type and amount of information told within a story, and by framing that information in a purposeful way, writers and reporters create meanings that work to reinforce social institutions and social norms.[12]

The framing device used to "make sense" of these women's stories was based at least in part on patriarchal assumptions about the role of women in contemporary society. As I established in the introduction, an ideological campaign was underway in the postwar era to redefine constructions of femininity in increasingly conservative ways, largely in an attempt to redirect women away from the workplace and back to the home environment. These strategies of containment are apparent in the discourse used by the mainstream press in discussing the female audience for professional wrestling. (The editor of *Wrestling As You Like It,* Dan Axman, uses the same strategy of containment in his magazine, discussed in detail in chapter 4.) Articles subtly and playfully disparaged women's cultural taste, aligning it with lower-class choices; marked women's behaviors as aberrant; and identified the women themselves as largely outside the mainstream readership, defining them as "not us." At the same time, I argue that the very frame used by writers, and their emotionally charged, tongue-in-cheek descriptions, served to highlight the challenge women were mounting

through their performances. These articles demonstrated just how thin the ideological façade of femininity in the 1950s had become.

Cultural Taste

In 1954, *TV Guide* offered a sampling of the female fans it believed to be typical of professional wrestling audiences in the postwar era. Entitled "Lo, The Lady Wrestling Fan!" the article also suggested the significance of the phenomenon of women's fandom of wrestling at the time. The article began:

> To the female American television fan there is apparently nothing quite so beautiful as a 350-pound wrestler swan-diving into the ropes. At least that's the impression 30,000,000 American husbands, brothers and sons must have after watching their womenfolk ogle the big fellows two or three times a week on TV. Hundreds of disgruntled males can testify that this year alone wrestlers received thousands of upside-down cakes, shoo-fly pies, bouquets of flowers and marriage proposals from supposedly normal schoolgirls, housewives, maiden aunts and grandmothers.[13]

At one level the article demonstrates how significantly wrestling resonated with women across the country in the 1950s. The author conjures up a powerful image of women insisting on watching wrestling "two or three times a week," while thirty million men can only sit back and watch.

At another level, the tone of the article delivers a humorous critique of the cultural taste of these women. Sociologist Pierre Bourdieu describes taste as a process through which economic, social and cultural distinctions are made. "Taste" can be identified when an individual or group appropriates a set of objects or practices as a means of defining lifestyle.[14] These choices become a form of "cultural capital" the individual accumulates and utilizes to make alliances with a particular class and to identify social differences. Among the distinguishing oppositions between the dominant and dominated class are the notions of "form" over "function" and "distance" over "participation." Bourdieu maintains that these oppositions are especially apparent in the expression of popular and bourgeois art and entertainment forms:

> The most radical difference between popular entertainments—from Punch and Judy shows, wrestling or circuses, or even the old neighborhood cinema, to soccer matches—and bourgeois entertainments is found in audience participation. In one case it is constant, manifest (boos, whistles), sometimes direct (pitch or playing-field invasions); in the other it is intermittent, distant, highly ritualized, with obligatory applause.[15]

These oppositions are also evident in each group's conceptualization of the body, which Bourdieu argues is the most indisputable materialization of class taste.[16]

Typically, then, dominant-class taste in art places emphasis on form over function, appreciating, for instance, the precision of a performance over its evocation of emotion. Their preferences in cultural performance-forms tend toward opera, ballet, classical music and the like, and are marked by a critical distance between audience and performers. The appearance and motion of the performers' bodies are carefully controlled and rigidly disciplined, emphasizing through formal characteristics the properties of health, restraint and control. Correspondingly, the response of the audience is equally restrained, with appreciation—usually in the form of polite applause—valued over participation.

Conversely, working-class taste generally privileges the functionality of the art work, preferring content over form. Their preferences in performance genres tend toward the participatory and the spectacular; rock concerts, sports events and professional wrestling all invite intensive vocal and bodily audience involvement and participation. Finally, the working-class conception of the male body emphasizes strength, physicality, plentitude; the typical wrestler's body is simply an exaggeration of these norms.[17]

It is this active, participatory engagement of wrestling's performers and fans that is viewed disparagingly by the excerpt cited above. The article begins by subtly questioning the attraction women find in a "350-pound wrestler *swan-diving* into the ropes" (emphasis added). Given Bourdieu's schema of class concept of the body, the weight reference is an easy marker of working-class values; a 350-pound body is conceptually outside middle-class ideals. Further, the image of a wrestler "swan-diving" into the ropes is playfully disparaging. The dichotomy between the sport of diving and a wrestling performance is clear: the former, a generally middle-class activity, with its emphasis on lithe bodies executing controlled movements, is antithetical to the latter, which emphasizes precisely the opposite qualities, namely, the body physically and performatively out of control. By conflating the two disparate images, the writer establishes the perceived working-class positioning of wrestling's performers and its female fans, marking both as "not-us" in a playful act of containment.

Categorizing Female Fans

Class taste is not the only marker in evidence in this excerpt. The article is quick to identify not simply *female* fans, but particular *categories* of women: "supposedly normal school girls, housewives, maiden aunts and grandmothers." Each of the four categories is first modified by the qualifier "supposedly normal," questioning the credibility and balance of the members of each group. Furthermore, each category is suspect in one manner or another: schoolgirls are not yet adults, and thus not yet women; maiden aunts are not yet (and not likely to be) married, and thus are not "truly" women; and grandmothers are elderly (and thus enfeebled), and presumably know better than to be attracted to such indecorous entertainment. The category of housewives is the most threatening of the four;

their marital status and occupation mark their participation as highly questionable, not to mention unnerving, given the context. Thus the collectivity of women being described is subtly disparaged from the start.

Finally, the response of these women to professional wrestlers is playfully berated. The writer argues that none of these women has any business acting amorously towards these burly performers, who, the author reports, have received "thousands of upside-down cakes, shoo-fly pies, bouquets of flowers and marriage proposals." Certainly the *least* eligible women mentioned are the housewives, the primary area of concern for both the article's author and the millions of "husbands and sons," whose descriptive titles define their domestic relationships to these women. It is clear from the article that these wives and mothers actively pursuing wrestlers are transgressing their domestic roles. The author marks the actions of these women as outside the bounds of normal behavior, and thus strives to contain the women in a category marked "other." The enthusiasm with which these women responded, the assertiveness of the act of looking in which they engaged (as they "ogle the big fellows"), and their spirited pursuit of the wrestlers with gifts and proposals marked these women as members of a working-class faction, and thus outside desirable dominant norms.

Bourdieu's description of the use of taste as a mechanism to privilege dominant norms and marginalize others is useful, but not without its limitations. While cultural capital is aligned with material wealth, which is to say that dominant cultural capital justifies and naturalizes those with an excess of material capital, the two are different in important ways. Taste originates in the arena of meaning-production, which is much harder to control. Fiske argues that "power is less effectively exerted in the cultural economy than it is in the material."[18] While mainstream writers in the 1950s attempted to use references to cultural taste as a method of disparaging and containing women's fandom, they also gave expression to it by their very reporting. The meanings and pleasures of female fans at ringside overflowed that restrictive frame. This is also why I argue we can and should take these articles seriously as data, despite their playful and mocking tone. They are evidence of the real tension that existed in the postwar era over appropriate constructions of femininity, and serious attempts—to my mind, *failed* attempts—at containment. The existence of this discussion of women's fandom of wrestling is evidence of the central challenge this posed.

The Transgressive Female Fan

There is ample evidence of the ways in which the many women in attendance interacted with the performance, and the meanings they made of the wrestling text. An analysis of the articles reveal three categories of women's fan responses to professional wrestling that are particularly striking: oral confrontation, physical confrontation and assertive sexual engagement.

The *New York Times* reported at some length about the behavior of female fans at wrestling events. One article published in 1949 highlighted women's oral engagement with wrestling: "A wrestling show doesn't reveal a great deal about wrestlers, but it does reveal a very great deal about their audience. People burst out in real anger as the villain of the piece apparently is crunching the hero's neck to bits. Women who would be as gentle as lambs shake their fists and cry out wild curses at wrestlers. Others mutter at them as they enter or leave the ring."[19] The author notes with bemused wonderment that audiences responded to this constructed entertainment with "real anger," as if deluded into believing that the violence before them is also authentic. Women in particular, who otherwise would act only in the most gentle fashion, are transformed by the experience, emitting profane expressions while threatening physical harm. At minimum, the performance causes women to mutter under their breath what can only be imagined to be unseemly thoughts. In each of these descriptive images, the women are observed to be stepping outside their "normal" roles.

An extended feature in the *New Yorker* provided an in-depth look at the "mutterings" and curses of one female fan in particular, when noted cultural observer A. J. Liebling reported his experience attending a wrestling match at Madison Square Garden in New York.[20] Liebling's encounter at the arena was dominated by the repeated vocalizations of a middle-aged woman sitting behind him, and while his description of her is consistently if playfully demeaning, her words and actions can also be read quite differently. He introduced the reader to his subject by observing:

> [She] had the look of Germanic well-to-do-ness that I have always associated with small holders of stock in large breweries. She reminded me of a woman my mother used to call Mrs. Immaculate; she was wearing two pearl earrings that precisely matched her two eyes—large round pearls, small round eyes, small round face. It was a study in juxtaposed circles. Her lips were thin, tight and straight, and the semicircle of frizzled gray hair visible under her hat was precisely matched by the collar of frizzled gray fur at her throat. She sat between two elderly men, and I could tell that one was not with her, because he was smiling.

There are suggestions of class identification in the description, which from the mention of a fur-lined (though not fur) coat, the pearls and the stock ownership suggests that Liebling labels her a member of the petit bourgeoisie: middle class, but certainly not the ruling class. It is clear from his account of her "frizzled" hair and thin lips that he finds her appearance severe and unattractive, and based on his portrayal of the two elderly men beside her, he suggests that she is an unpleasant wife and companion—all descriptions designed to contain our reading of her actions.

Having established his dislike for Mrs. Immaculate, Liebling recounts her shouted comments and running critique of the match, which she offered to her husband and anyone else within earshot. Many of her observations concerned the villains in the ring. At various times during the matches she commented: "Boy, will he get what he deserves—he's so mean"; "All those tough guys, they're so yellow"; and "The meanness is in them, and they just can't help it, no matter how hard they try." For Mrs. Immaculate, male villainy is a category with which she has great familiarity: for this particular group of men, meanness is an innate characteristic of masculine nature, one "they just can't help." Nevertheless, beneath this tough exterior is a cowardice ("they're so yellow") that undermines and pollutes their strength. And in the end, she observed, justice will prevail: at some point they will pay for their meanness and get what they deserve. Taken together, these judgments could be seen as a critique of patriarchy, of the injustices suffered at the hands of an often mean and self-serving cultural system.

Mrs. Immaculate was afforded moments for positive commentary as well, such as when a local hero took to darting between the widely straddled legs of villain Hans Herman. Liebling observes: "Virtue's cheerleader back of me caroled, 'Ha-ha, he makes a fool of him!'" However, at this particular event, Mrs. Immaculate apparently had little to cheer about. As the villains in a tag team match flouted the rules, using the ropes to win a fall in a heated match, Mrs. Immaculate bitterly observed: "That's the only way they always win, with their foul tactics!" Throughout the match, this woman's indignation flowed freely, as she decried the villainous actions she saw before her, describing a masculine villainy she knew all too well, judging from the knowing phrasing of her commentary. Wrestling afforded her an opportunity to publicly critique the rule-breaking meanness she saw before her, giving her a voice in the process.

In addition to offering a running critique of the proceedings, Mrs. Immaculate also intoned comments directly to the combatants, alternately directing helpful suggestions to the heroes and pointed invective to the villains. In the opening bout between local wrestler Hal Kanner and villain Buddy Lee of Hollywood, Lee grabbed a handful of Kanner's hair; Liebling reports the response of the woman to Lee's illegal act: "'Why don't you pull *hiss* hair?' the woman behind me yelled." And in a later match, as the villain gestured to his throat, protesting to the referee that he had been choked, Mrs. Immaculate yelled out, "You're not choking, you're faking!"

In her own way, Mrs. Immaculate was participating in the drama before her, sending her own pointed comments to the ring as she saw fit. Whether through her running commentary on the event or through the various comments hurled at the stage, this woman was stepping outside the feminine role prescribed for her at the time, pleased to give a pointed public testament.

At the conclusion of his article on the match in New York, Liebling acknowledges the power wrestling fandom afforded the woman he had observed

throughout the evening: "As for Mrs. Immaculate, she got her husband out of there winging, and I heard her say, as she hustled him out to the aisle: 'We can just get back to Staten Island in time for the wrestling on television.'"[21] No doubt the broadcast offered her yet another pleasurable opportunity both to sharpen her vocal abilities and to break with a conservative construction of femininity, pleasures that writers like Liebling may have denigrated with more than a modicum of hidden concern.

Muttering on the Home Front

This sort of expressive vocal commentary was not limited to audience members attending matches at the arena. Newspaper articles described wrestling programs as a prominent fixture in many households (as well as on televisions in taverns and outside appliance stores), suggesting that women comprised a significant share of the audience. Despite the fact that domestic leisure technologies have often been controlled by men in the household, as Gray's work suggests, when it came to professional wrestling, women successfully commandeered the television set.[22] A writer for the *New Yorker* who spent a week with a Manhattan family in 1947 to observe the effect television had on family life noted: "On WNBT there were fights from St. Nicholas Arena [and] on WABD there were wrestling matches from Jamaica Arena." The family and its guests chose wrestling. Asked about the preference for wrestling, the wife explained: "Wrestling's more fun than fights."[23] This sentiment was corroborated by the *TV Guide* article cited above, as well as by *Business Week*, which observed: "The wives want to watch wrestling; the husbands haven't much choice."[24]

Some press sources reported that women watching at home reacted vocally to wrestling broadcasts as well. A 1953 feature in *Cosmopolitan* pointed out the role that television played in drawing most women to the live event: "Usually exposed to wrestling by television, [women] come for an experimental look at it in the flesh and remain to scream themselves hoarse."[25] One wrestler, known in the ring as the Ape Man, was cited in *TV Guide* in 1954: "'Women aren't supposed to yell and scream around the house,' says The Ape Man, 'but they *do* feel they can let themselves go when they're watching a wrestling show on TV.'" In the same article a referee commented unhappily after being attacked in the ring by a disgruntled female fan: "I like it better when ladies just stay home and mutter at me."[26] In each instance, whether at home in front of the television (and the family), or in public at the arena, wrestling offered women the opportunity to break with conventional expectations and give voice to their pleasures, frustrations, feelings and passions.

In his analysis of wrestling, John Fiske points out that "billingsgate"—verbalized and gestured curses and oaths—is an active component engaged in by both wrestlers and spectators. Billingsgate, Fiske writes, is "oral, oppositional participatory culture, making no distinction between performer and audience."[27]

The magazine and newspaper extracts described here visibly illustrate this type of engagement: by shaking their fists, cursing and crying out, women were participating in the performance. At the same time, they were breaking with the domesticated role that society had suggested for them. For some fans, this sort of unfeminine—or *anti*-feminine—behavior suggests an explicit break with normative constructions of the woman's role. Some women were not simply exercising freedom *from* control, but were taking action *against* the constricted gender norms used to control them, both in the public space of the arena and the private space of the home.

Physical Confrontation

Beyond the verbalized and gestured actions lay another form of aggressive response: physical confrontation. Articles regularly documented how some female fans chose to *physically* engage the wrestlers, a more direct, heightened manner of participation. One of the most frequently cited examples of this behavior was provided by the most infamous fan of the period, a Bronx native named Mrs. Eloise Patricia Barnett but better known as "Hatpin Mary," whose actions were the inspiration for many female fans, and who both baffled and amazed the press corps. This description, appearing in the *American Mercury* in 1950, was typical: "Everyone seems to want to get into the act. Women like Hatpin Mary (recently enjoined) will sit at ringside and prod any portion of a protruding anatomy which carelessly presents itself. When [wrestler Gorgeous] George has landed in the seats, women have pulled his hair and clubbed him about the curls with their spiked heels. Others have showered him with bottles."[28] Four years later, *Look* described the continuing antics of wrestling's most notorious fan: "Hatpin Mary, a spectator, made eleven stabs at wrestlers and drew nine cries of baffled rage" (Figure 3.1). And *TV Guide* featured a large photo of Mary in action, being "restrained by a smiling policeman from banging a wrestler with a baby bottle" (Figure 3.2).[29] Judging from the repeated press coverage, Mary was a fixture at New York wrestling events and had become a regular part of the drama at ringside. Her matronly looks belied her tenacity, and her abilities with a hatpin and a baby bottle were highly regarded by wrestlers, reporters and fans, as discussed in chapter 6.[30]

Mary may have been the most well-known example, but she was by no means the only woman at ringside interacting with the wrestlers in a physical manner. Many other women tried to engage wrestlers this way, as the article in *Look* observed: "Gorgeous Gene Dubuque was walloped on the head with a lady's loaded handbag. Lady spectators sometimes take off their shoes and strike hapless wrestlers within reach. It is a kind of ritual."[31] The repeated nature of this behavior suggests that these are not occasional aberrations, but regular features at wrestling events. And as the pictures accompanying the article demonstrated, women's performances were as varied as they were active.

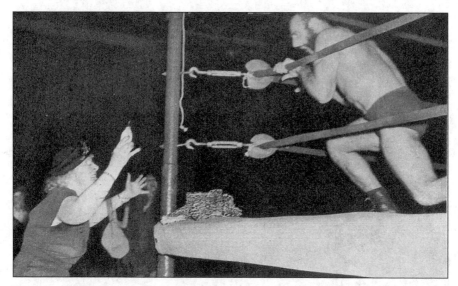

Figure 3.1 Hatpin Mary challenges the Wolf Man. (Phillip Harrington, *Look Magazine*)

Many other newspapers took note of the frequent nature of women's attacks at ringside, as in this excerpt from the *New York Times*: "Women, for some strange reason, often go berserk and stick pins in a wrestler who comes within the reach of their soft, white hands. The villain especially is in danger and women specialize in taking off high-heeled slippers and beating the poor man heavily about the head. Or sometimes they just yank out his hair."[32] Though she is not mentioned by name, the author begins the description with the signature actions of Hatpin Mary. While describing the actions of many different women in this passage, the writer creates an image for the reader of a white woman who, when not attending wrestling, would otherwise live a life of leisure.[33] This is the message conveyed by the author's description of her soft, white hands—a class reference to someone apparently unaccustomed to physical work—and high-heeled slippers. The deviant transformation occurs when the subject attends a wrestling match, where she then unexplainably goes "berserk," pulling hair or beating wrestlers with her shoe. The author playfully suggests that these are women who would otherwise be normal, were it not for their passion for wrestling.

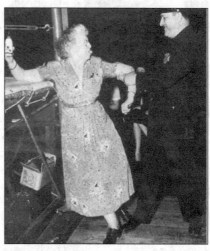

Figure 3.2 Hatpin Mary at ringside. (Phillip Harrington, *Look Magazine*)

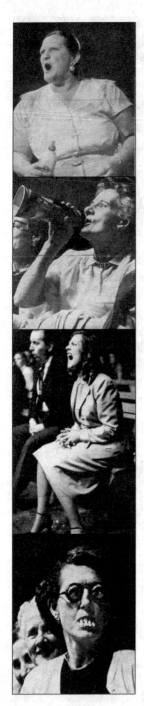

A 1954 feature in *TV Guide* offered perhaps the most comprehensive collection of stories of mayhem visited by female spectators, including some who, watching the proceedings on television, chose to drive to the wrestling arena and take on the offending wrestler in person:

> In Waycross, Ga., last summer a lady became so upset while watching [the Ape Man] throttle an opponent via her TV set that she jumped into her car, drove to the local sporting arena, and stroked him on the head with a soft drink bottle. He finally restrained her with a half nelson.[34]

Nor were the physical confrontations limited to the wrestlers. Referees also occasionally tasted the ire of disgruntled female fans:

> "One night in Buffalo," one referee recalls, "a lady objected to a decision I made concerning her favorite wrestler, a large bundle of suet called The Bat. She leaped into the ring, hit me in the eye with her shoe, removed a handful of my hair, and jumped up and down on my feet. It took four cops to get her out of there."[35]

Hatpin Mary and many female fans like her took the performance to new levels, physically accosting both the villainous male wrestlers and the referees—patriarchal representatives of justice in the ring—with the symbols of domesticated, civilized femininity: high heels, hat pins, hand bags and soft, white hands. It is as though these women were gleefully throwing the emblems of femininity back into the face of a patriarchy that was temporarily suspended and momentarily vulnerable. Exacting payment, drawing blood, these female fans drew pleasure from violent disorder and bodies out of control.

Assertive Sexuality

Figure 3.3 Female fans (Phillip Harrington/*Look*)

The third form of participatory pleasure engaged in by these fans was passion. If the image of physically

aggressive women was troubling to both male reporters and wrestling's villains, then aggressive female sexuality was challenging for wrestling's heroes and villains alike—though more challenging for some than others. The matter of female sexual expression was, like so much else, enormously conflicted in the postwar era. Entering adolescence, girls were taught to tread a fine line between indirect display of sexual attractiveness and the proscription against "going all the way," forcing them to act as the regulator in negotiating sexual boundaries with male suitors. Elaine Tyler May points out that the new activity of going steady created a form of sexual brinkmanship in which women were required to draw the line during lovemaking.[36] Despite the kind of statistics uncovered in the 1953 Kinsey Report, in which half of the females surveyed said they had engaged in premarital intercourse, women were expected to protect their virginity until marriage. By the time women reached adulthood, this sexual dichotomy translated into concern that they could become frigid, thus continuing the pattern of sexual restraint established before marriage.[37]

Sex was increasingly commercialized in movies, movie magazines and in advertising in general, though as Breines argues, the "sexual story encoded in American culture was simultaneously punitive and permissive."[38] Assertive sexual behavior was at this historical moment principally a male prerogative; women who conducted themselves in an aggressively sexual manner were stigmatized. Motion pictures regularly represented the dichotomy between wholesome, desexualized "good girls" like Debbie Reynolds or Doris Day, and their sexy, assertive "bad girl" counterparts, who were ultimately portrayed as neurotic and unattractive.[39] Still, Susan Douglas argues that the 1950s also saw a significant rise in movies with more sexually risqué themes. Hollywood was portraying a new sexual frankness in films such as *Peyton Place* and *Baby Doll*, while a growing number of foreign films were also pushing boundaries.[40] The contradictory messages of female sexuality and sexual expression added to the conflict that was endemic to the postwar era.

And then there was wrestling. Decades before specifically female-targeted male striptease shows became commonplace, genres such as professional wrestling provided a context for women to publicly exhibit sexual assertiveness and transgress the norms of "acceptable" female sexual behavior. One explanation for wrestling's appeal as a venue for assertive female displays lies precisely in the sexual dualism of the period. Wrestling provided women a context where they could give voice to assertive sexuality where contentious, declarative discourse was welcomed as part of the program. And for those middle-aged women facing the accusation of frigidity, the wrestling arena provided an easy venue to challenge the stigma through brazen assertive displays.

This assertiveness was manifest in numerous ways. Much like the contemporary women who verbalize their desire at a Chippendales performance,[41] female wrestling fans were often equally forthcoming, as a male writer for *Cosmopolitan* observed:

It is obvious from the kind of sentiment expressed by many of the women in the heat of a match that their psyches are responding to something besides the purely dramatic aspects of wrestling. "Lookit that hunk of man!" is a common cry. "What a build! How would ya like to date that one. C'mon, Superman, bust him one for me!"[42]

Cosmopolitan's explanation of this behavior focused on the "romantic thrill" these women received from seeing "large, lusty males in violent contact." Still, I believe much of the pleasure involved had more to do with the act of participation itself than with the supposed "object" of their affections. Many of these expressions take wrestlers as the object, but are intended specifically to be *shared* with other audience members. Yelling out "Lookit that hunk of man!" may express sexual desire, but it also demonstrates the speaker's ability to publicly express that desire within a specific social community, transgressing the role prescribed by patriarchy. This type of fan self-reflexivity was borne out in the analyses in the previous chapter, which described how women who had just engaged with the wrestlers at ringside would look at one another and laugh at their own performance. A significant aspect of the pleasure in these exclamations comes from sharing transgressive behavior with other women and receiving validation in return.

Recognizing the performance of transgression does not discount the role of sexual desire in these women's fandom, nor the apparent discomfort it caused. The point was aptly expressed in the *TV Guide* essay discussed above, which described the thousands of gifts and proposals sent to "disgruntled" wrestlers from adoring female fans. The *New York Times* pointed out that women would approach wrestlers with "ardor burning in their eyes."[43] In each description, the tables are turned on sexual relations: women are the pursuers, men the objects of pursuit.

Some women took their interests beyond the public performance area at ringside, camping out at the stage-door entrance, in hopes of engaging with the wrestlers on a more personal basis. A feature article on wrestler "Nature Boy" Buddy Rogers demonstrated this point:

> The more bold members of the opposite sex wait outside his dressing room, hoping to know him better. "We call them stage door Jennys," said Nature Boy. "Ninety percent of them are nice kids but the other 10 percent are—" Here Nature Boy stops to grope for polite but stronger words.[44]

Rogers' inability to find the words perhaps betrayed a discomfort with sexually assertive women. More likely, he was simply being polite to the reporter. The fact is that some female fans did more than just talk about sexual interest; they actively pursued it (see chapter 6). What is clear from this excerpt is the degree to which a group of assertive women pushed the boundaries of "acceptable" gendered sexual roles.

Some women sought out wrestlers in other venues, transcending the wrestling arena entirely, as the *Times* article illustrated: "Often wrestlers sleeping peacefully in hotel rooms are awakened by a phone call from a dulcet-voiced girl murmuring, 'Oh, Mr. Ape Man, I just think you're so—.'" The article reassuringly concluded that the wrestlers "properly" responded with "horror."[45] Whether or not the wrestlers were themselves actually repulsed by the advances of assertive women is unimportant (and many, of course, were not). The author is careful to conclude the story by situating the wrestler in the role of sexual gatekeeper, saving the girl from her own transgressive desires in the process. Still, these accounts clearly demonstrate that norms of female sexual expression were much more contested and in flux than traditional histories of the period would have us believe.

Underlying the frequently arch writing style of these articles is a measure of disapproval, betraying the alarm with which such behavior was received at most levels of society. In the 1950s, 75 percent of Americans professed to believe that intercourse outside marriage was wrong.[46] The articles above supported that position by labeling aggressive sexual behavior as outside of social norms. At the same time, the articles illustrate the willingness of many women to test those boundaries in either word or deed, by coming back to the arena week after week to yell, scream, carry on and more.

The Press Wonders Why

Nearly all the articles studied made some attempt to explain the behavior of these women, calling on psychologists, psychiatrists, promoters or other "experts" to rationalize women's actions. One common explanation ventured was simply the appeal of attractive male bodies on display. *TV Guide*, for one, relied on the wrestlers themselves for expert advice: "'It's simple,' a current mat favorite remarked the other day. 'Women like to look at my muscles the way I like to look at Roxanne's—uh—nice blonde hair.'" Two male writers for *Collier's* corroborated this perspective, suggesting that the appeal of wrestling for women was tied to the visual gratification and objectification it provided. They argued that wrestling "is done only by extremely well-built men, and it is just as natural for a woman to stare appreciatively at a semi-nude wrestler as it is for you and me to stare at Betty Grable in sweater and shorts." For these authors the appeal of wrestling boils down to visual pleasure, the pleasure of viewing attractive bodies on display.[47]

Cosmopolitan concluded that desire alone was not a sufficient explanation. Instead it was "women in need of letting off steam" who benefited most, the "suppressed, overworked, underappreciated, elderly housewives, who probably get the deepest satisfaction out of watching wrestling."[48] The *New York Times* offered a similar explanation, arguing that wrestling acted as a safety valve for its predominantly female audience: "Most people are meek. They never hit each other or knock each other down. A boxing match might be a kind of release for these

feelings, but a wrestling match is almost perfect. By proxy, their atavism can find full, noisy, apparently heartless expression. They can work themselves into vicarious frenzies. A wrestling show is like tears, or sudden anger in its unfrustrating effect."[49] *Business Week* noted that the most "common" explanation was that watching wrestling gave women a "mental release for some kind of sexual frustration," but also cited the opinion of "psychiatrists" who contended that "little girls are brought up to control their hostility and to be ladies at all costs. Watching wrestling—and especially siding against the villain—lets them release their aggressive feelings."[50] As these articles demonstrate, in most cases the mainstream press argued that women used wrestling as a venue in which to vent frustrations and to release their pent-up aggravations. Still, the safety valve argument does not mitigate the social effect of these regular displays by women.[51] As press coverage of wrestling demonstrates, female fans were using wrestling as a means of carving out, to use de Certeau's terms, a space from patriarchy, both privately in the home and publicly in the arena.[52] The huge surge in female attendance at matches, the transgressive behaviors the women exhibited, and the communal nature of the behavior, all speak to the social allegiances being formed around this performance genre. Women fans could enjoy the pleasure of rebellion, of shared public defiance, as they rewrote the roles expected of them by society. Far from simply subverting ideological constructions of gender, these women were demonstrating the contested nature of gender itself in the postwar period, and the heightened degree of cultural power they could exercise.

Within the context of the home (which, after all, was thought to be a man's castle), the *TV Guide* article illustrated how millions of women during the 1940s and 1950s occasionally but effectively commandeered the television set. Women successfully insisted on watching televised wrestling two or three times a week, during which time they openly admired the parade of male bodies that filled the screen, transgressing the roles set out for them as wives and mothers, while disgruntled husbands and sons looked on. In doing so, they created a space of engagement within the home, employing tactics that allowed them to supplant the demure, care-giving role expected of them with an assertive, self-gratifying, sexualized role.

In each instance, these women found tactics for challenging the pressure of patriarchal expectation and enjoyed playing out a renegotiated femininity with other female fans around them. Even women isolated at home could find evidence of this rebellious community simply by reading the hints of discomfort expressed in the articles which appeared in magazines and newspapers across the country.

It is possible that some men might actually have benefited from this phenomenon, gaining new insights into the women around them by coming into contact with such fandom. One man articulated such a transformation after reading the *Cosmopolitan* article in 1953, writing the following to the editor of the magazine: "Vastly enjoyed amazing experience of reading your article. I begin to think I understand my wife. E.C. Struthers, New York, New York."[53]

CHAPTER FOUR

The Wrestling Press

Pick up a copy of a wrestling magazine off a newsstand in the early 1950s, and you might see a glossy photo of a barefoot, snarling Antonino Rocca leaping out at you from a black background. Or the All-American grin of Verne Gagne, or Jack Dempsy trying desperately to separate Carol Cook and Mae Weston, locked in mortal combat. While they might look little different from the covers of pulp magazines like *True Crime* or *Modern Screen,* readers in the know immediately understood that the subject was professional wrestling.

The "wrestling press" was an amalgam of for-profit weekly and monthly magazines and news sheets, which existed in a journalistic nether region between sports journalism, tabloids and internal "house organs." At most times in professional wrestling's history since World War II, as many as a half-dozen magazines have been devoted to the subject, available at wrestling arenas in major cities, or through subscription or newsstand sales.[1] Wrestling publications have been created and circulated by various individuals and organizations: wrestling promoters interested in publicizing their principal business venture; publishing groups seeking additional periodical titles; and individual entrepreneurs, often one step removed from fan club bulletins (discussed in the following chapter), hoping to work at their passion full time. While motives may vary, the wrestling press by and large has shared a basic *raison d'être*: to promote the health of the wrestling industry and profit from wrestling fans.

This chapter will demonstrate that because the wrestling press was dependent on magazine sales rather than advertising for its financial viability, it was particularly sensitive to and reflective of the interests of its readers. In the 1950s, wrestling magazines became a site of struggle between male and female readers, battling over the types of performers wrestling should offer, and the content of

the entertainment they supported. The magazines reflected male ambivalence over the presence and behavior of women in the audience, but also proved to be an excellent venue for women fans to extend their reach and influence.

The appearance of wrestling magazines in the post–World War II era reflected a larger trend in the publishing industry. Magazine publishing experienced enormous growth during the twentieth century, particularly following World War II. One publisher estimated that the U.S. magazine market at the beginning of the twentieth century stood at roughly 750,000 purchasers. By 1947, the Magazine Advertising Bureau found thirty-two million magazine-reading *families* in the United States, and the number grew to more than forty-one million by 1959. Advertising revenue nearly doubled between 1946 and 1955.[2] Tebbel and Zuckerman argue that growing magazine revenues were driven by a postwar rise in income and education levels, increased leisure time and increased access to magazine outlets.[3] Of course, the phenomenal growth of the magazine industry reflected a larger expansion in the U.S. marketplace as a whole, driven by increased population and income.

One of the striking developments in the publishing industry following World War II was the proliferation of magazines of specialized appeal, including sports magazines. While this period saw the launching of the first two successful general-interest sports magazines—*Sport* (1946) and *Sports Illustrated* (1954)—more narrowly focused sports-and-leisure magazines were the rule during this period.[4] Periodicals such as *Archery, Skin Diver, Golf, Tennis,* and the like crowded the newsstands, joining the few hardy single-sport magazines that had survived the war, such as the *Ring* (boxing) and *Sporting News* (baseball). Ironically, the prosperity of these narrowly targeted sports magazines was due, in part, to the success of television, which had seriously eroded popularity of the general-interest magazine field. Publishers responded by offering increasingly specialized periodicals, attracting readerships with distinct interests and more sharply defined demographics, which in turn could draw advertisers willing to spend more on such highly focused reader groups.[5]

It is in this context that wrestling magazines grew in the 1940s and 1950s. Few periodicals dedicated exclusively to wrestling existed prior to World War II.[6] Yet during the decade following the conclusion of the war, no less than nine wrestling publications were launched, including five in 1951 alone.[7] The wave of new publications began in 1948 with *Wrestling As You Like It* (WAYLI), published on a weekly basis by promoter Fred Kohler. Launched initially as an expanded event program for patrons in the Chicago area, WAYLI soon took on a life of its own as a national wrestling magazine, paralleling the success of ABC's *Wrestling from the Rainbo Arena* and DuMont's *Wrestling from the Marigold* television programs, both of which originated in Chicago.

Until the emergence of eBay, wrestling magazines were extremely difficult to find outside of the network of fans and collectors. Of the wrestling magazines

published during the period whose issues were registered with the Library of Congress, relatively few copies remain in institutional collections.[8] Many of the original holdings at the Library of Congress have either been lost, disposed of, or are listed simply as "lacking." Most of the press materials for this chapter were obtained through private collectors. The observations for this chapter are based on an analysis of forty issues of six wrestling periodicals published between 1948 and 1955. The majority of my analysis is based on the two dominant wrestling publication efforts during the decade: *Wrestling As You Like It*, originating from Chicago between 1948 and 1954 (*Wrestling Life* replaced *WAYLI* in 1955), and *Official Wrestling*, published by the National Wrestling Alliance in Washington, DC between 1951 and 1953 (its successor, *Wrestling World*, was published in New York by *Official Wrestling*'s editorial staff between 1954 and 1955). In addition, I examined single issues of *Wrestling* (published in Jersey City, New Jersey in 1951 by body-building entrepreneur Joseph Weider) and *Wrestling USA* (published independently in Charleston, West Virginia in 1954–55).[9]

Wrestling magazines can be sorted into two broad, overlapping categories: "house organs" and independent publishers. Among the dominant wrestling publications during the 1950s were those originating from the wrestling industry itself. The weekly publication *Wrestling As You Like It* and the slick monthly magazine *Official Wrestling* were both published by wrestling promoters. While each publication took on the appearance of "objective" journalistic endeavors, parallels can be drawn between these periodicals and "house organs"—newspapers or magazines published by and for individual corporations or industries, designed for a specific audience of company employees or customers.[10] While such publications draw on the style, techniques and characteristics of "legitimate" journalism, the underlying motivations of the house organ are more clearly apparent: to further the interests of the company. Thus while the approach of publications such as *WAYLI* or *Official Wrestling* mirrored those of other sports publications, the publication clearly worked in service of the economic health of the wrestling industry, in particular of the promoter-publishers.

The second type of wrestling periodical originated from publishers outside the wrestling industry, such as Stanley Weston, who founded his operations on the strength of publications such as *The Wrestler* (1951) and *Wrestling Revue* (1959). By the 1970s, Weston's G.C. London Publishing Company offered four separate wrestling magazines on newsstands across the country; by 1989, Weston published thirteen monthly sports periodicals.[11] Another outside publisher, the Joseph Weider organization produced both *Wrestling* and *Boxing and Wrestling* during the 1950s. Perhaps best known as the doyen of the weight-lifting equipment industry, Weider's full-page advertisements have long been a staple of sports magazines, comic books and other specialty publications. Finally, *Wrestling USA* represented a more fan-based independent publisher. Published in Charleston, West Virginia, by Douglas Dalton of Dalton Publications, *Wrestling USA* had no

obvious financial ties to a local promoter, nor any clear connection to other published titles.

Independent or not, the success of these publications are tied to the health of the wrestling industry itself; if wrestling as a performance genre loses popularity with its audience, readership will also decline. Therefore it is in the publishers' interest to promote the well-being of the host industry. And it is notable that few, if any, wrestling publications (outside the fanzines discussed in the following chapter) were openly critical of a wrestling promotion.[12] In a way, the wrestling press functioned as an extension of the wrestling performance space, supplementing the wrestling story line with additional narrative material. Weekly publications such as *WAYLI* focused significant attention on promoting upcoming matches: articles detailed recent matches and provided information on the various combatants and their preparations for their opponents.

Because of publication deadlines, monthly magazines focused less attention on pending shows, concentrating instead on the careers of the individual performers as a way of creating excitement for future matches. Both weekly and monthly magazines provided considerable personal detail on the public and private lives of the wrestlers. Some historical details were factual, such as date of birth, amateur wrestling career and military service, especially when reporting on "heroic" characters. At the same time, plenty of information was fabricated to add fuel to the wrestling narrative and the imagination of the buying public. Mat star Andre Drapp was said to have worked with the French Underground for four years during the war; Bob McCune claimed he had adopted the stage name "Lord Pinkerton" so as not to alert his Scottish family—of noble origins—of his career choice; and the Sheik's childhood was said to have been marked by the sounds of brutal murders taking place outside his tent.[13] Articles filled in narrative detail in each character's background, providing an additional layer of meaning to performances in the wrestling ring and creating fan interest in the characters and matches.

If wrestling is a performance of sport, then the wrestling press also could be said to function as a performance of journalism. Every wrestling magazine published extensive background information on the wrestlers themselves: that is, on their wrestling characters, not the actors who played them. One constructed element that separated the character from the actor was salary. Wrestler Ted Lewin pointed out that the wrestling press "*always exaggerated* the amount of money that wrestlers made; it was always this *enormous* exaggeration." Another common fabrication concerned college degrees. A correspondent for *Wrestling* commented in 1951 that Lewin's brother-in-law Danny McShain "fights like a lawyer battling a stubborn case. [He] comes by this naturally, having once passed his bar exam after studies at UCLA." Lewin chuckles each time he hears this story, noting that Danny never actually finished high school.[14]

In these and other ways, the wrestling press often foregrounded the fabricated traits of the wrestling characters, rather than the real biographies of its per-

formers, using a journalistic voice to further the narrative. These references also speak to the class diversity of the audience. References to nobility or to a law degree might well rouse a working-class reader, while also playing to an upper middle-class audience, who would have approved of a college-educated wrestler.

The Wrestling Press and the Audience

In addition to its dependence on the wrestling industry, the wrestling press was also highly dependent on its relationship to the buying public. Certainly the financial health of the wrestling press was contingent on its appeal to the public, for the readership constituted a significant share of its revenue base. Though revenue figures are not available for these publications, one can theorize from the magazines themselves the financial basis on which they stood. Some titles within the wrestling press served multiple functions, beyond simply selling magazines and turning a profit. House organs such as *WAYLI* and *Official Wrestling* could fund operations with income generated directly by the parent wrestling organizations, justifying their existence and expense because of their value as a publicity vehicle. Other magazines, such as Joe Weider's *Wrestling*, served as a mechanism for publicizing his principal business endeavor—sales of weight-lifting equipment—and can be understood as a precursor to the television "infomercials" of the 1990s. Thus profitability in and of itself was not the only goal of some wrestling publications, although *viability* certainly was important.

Advertising was another form of revenue, though in no way did it play a dominant role. While all wrestling magazines included some paid advertising in its pages, judging from volume, the amount of revenue generated was certainly not significant.[15] While mainstream magazines and newspapers generated up to 85 percent of their revenue from advertising by the 1940s, the wrestling press was devoting less than 5 percent of its pages to ad copy, an indication of the diminished role advertising played in the financial viability of the genre.[16] With the exception of those advertisements that publicized a publication's other business ventures—generally wrestling or body-building—the impact of advertising was at best marginal.

This also speaks to the influence this revenue source had on the editorial direction of the wrestling press. For while the mainstream press was in the business of serving the needs of advertisers, the wrestling press' primary emphasis was on pleasing the readership at large while maintaining and fueling the audience's interest in wrestling.

Reporting the Audience Shift

As a result of this financial bind, the editors of the wrestling press had to adapt to changes in the wrestling audience, finding ways to both acknowledge and accommodate the growing number of women attracted to the entertainment

genre. An obvious shift in the wrestling audience in Chicago is apparent from the articles appearing in *Wrestling As You Like It*. In April 1949, *WAYLI* reported that promoter Kohler had decided to set aside a portion of the International Amphitheater during an upcoming appearance by wrestling sensation Gorgeous George exclusively for teenage girls, announcing that he was reserving "a special section at ringside for bobby soxers who want to be near their idol."[17] The notice acknowledges the increasing popularity of wrestling icons among teenage girls in the region (as well as a chance to sell more tickets). A few months later, *WAYLI* acknowledged wrestling's rising popularity among women of all ages. In an article entitled "Ladies Attend Wrestling Shows," the magazine observed:

> An increase in the number of ladies attending wrestling shows has been shown the past few months. It seems that the female sex gets a real kick out of the exciting matches at the Midway, Rainbo, Madison and Parichy arenas. An increasing number of the fair sex are requesting autographs from their favorite wrestlers and many are purchasing photos of their favorites. The ladies like to show preference to certain wrestlers as favorites and they are not backward in cheering their favorites and booing the ones they do not like.[18]

The article illustrates the shifting demographics of the wrestling audience and the increasing role women played in the financial health of Chicago's wrestling establishment. It also could be read as a veritable primer on "appropriate" fan behavior while attending the matches: purchase merchandise, cheer and boo, seek autographs. As such, it acknowledges that the women in the crowd were "getting it right," acting appropriately as members of the wrestling audience.

Another confirmation of this national trend appeared in *WAYLI* two years later. In a statement released by the National Wrestling Alliance, an association of the most powerful wrestling promoters in the nation, NWA president Sam Muchnick announced:

> Wrestling will rise to greater heights in the next few years because the sport is reaching the public more than ever before by means of television. In years gone by, before the advent of television, millions of people, *especially the feminine sports followers*, had heard of wrestling but had never gone to matches. Now that they have seen wrestling, they have become more interested and are developing into cash customers.[19]

Clearly, then, women were a significant segment of the rapidly expanding audience for professional wrestling. Muchnick went even further in a column by ABC-TV wrestling commentator Wayne Griffin in *Official Wrestling*: "Sam Muchnick, of St. Louis, President of the National Wrestling Alliance, tells me that in the old days 90 percent of wrestling fans were men but now women are

in the majority. Could it be the advancement of the science? If you doubt this listen to their screams on [ABC's national TV broadcast on] Wednesday nights—there are more sopranos than tenors."[20] Muchnick's statement goes even further in identifying the gendered shift: women audience members were not just present at the wrestling arena, they now assumed majority status.

Editorial Ambivalence

Though articles on the new audience demographic were straightforwardly jour-nalistic in style, the perspective on the editorial page betrayed a profound ambivalence. In the second issue of *WAYLI*, editor Dick Axman penned a "short short story" that offered up a parable regarding the appropriate behavior of women at a wrestling match and demonstrated Axman's concerns about the presence and behavior of women in attendance at the wrestling arena.

The story concerned a young couple—Jerry and Charlotte—who had been dating for a few months and were becoming increasingly serious. Jerry was con-sidering the possibilities of marriage, but wanted to test Charlotte's "real dispo-sition" before agreeing to a lifetime commitment. So he asked if she had ever been to a wrestling match. "Mercy no," answered Charlotte. Still, he proposed a date, and she accepted without hesitation, attending her first wrestling match that evening. Axman was careful to capture the genuine intensity of the event and the crowd in attendance:

> Jerry, who had not seen a wrestling bout for some years was impressed by the action and some of the roughness in the matches. One wrestler was tossed out of the ring; another was sent to the canvas repeatedly as the opponent reigned [sic] blows on him.
>
> The ladies especially became excited. "Break his Leg! Tear off his arm! Throw him out of the ring! and 'sock' him," were some of the expressions used by the men and many of the ladies during the bouts.

Charlotte's reaction, however, was markedly different than those of the other women in the audience; while she "bit her fingernails, and on occasions placed her hands over her eyes," Jerry observed she seemed genuinely "scared and looked sympathetic toward the wrestler who was absorbing the punishment." At the conclusion of the event, Jerry abruptly asked Charlotte to marry him.

> "Why Jerry," she gasped, looking at him in astonishment, "of course I will, but why the sudden proposal. Why so abrupt?"
>
> "I'll tell you why," answered Jerry. "When the matches got rough and so many of the ladies present were hollering 'break his leg, break his arm and throw that wrestler out,' I could not help but see the tenderness that came into your eyes and the even disposition you possess. Charlotte, I found out tonight

that you are sweet and that there is no cruelty or vehemence in you. You are the girl for me."

Axman concluded sentimentally by instructing the box office to reserve two seats each week at the wrestling shows for Jerry and Charlotte.[21]

The message of the story was clear: women who might be considered appropriate marriage material respond to professional wrestling with sympathetic and tender emotions, rather than with the aggressive reactions demonstrated by the majority of the women present. This of course contradicts the *raison d'être* of the wrestling genre, which is to stir the passions of the audience to the boiling point, but it illustrates the editor's ambivalence regarding the presence of women in the audience, particularly those who react "normally" to the show. The women may have acted the part of an appropriate wrestling audience, responding similarly to their male counterparts, and women clearly were increasing the fortunes of the wrestling industry, on which his own position was dependent; they were not, however, proper marriage material, since they failed to fulfill the normative construction of "appropriate" femininity of the time. Charlotte's behavior was an indictment of the other women in attendance. Like the more generalized efforts of containment by the mainstream press described in earlier chapters, Axman's column attempts to regulate women's performances at the wrestling arena.

Still, despite the moralistic conclusion of the story, the editorial offers another message to its readers: by singling out the behavior of the women in the wrestling audience, the article also offered readers evidence of the audience's changing character. While Axman did not sanction the women's behavior, he did reveal the power women exercised at the wrestling arena to redefine appropriate feminine behavior. There is clearly an excess of meaning here—the short story overflows with messages that both condemn and grudgingly acknowledge the increased presence and influence of women in the wrestling arena. Fiske argues that excess is a common characteristic of popular culture, often containing meaning that is out of control, having exceeded the norms of ideological containment. One such example is the excessive victimization of the heroine that typifies romance novels, as Janice Radway's work demonstrates.[22] While Axman's position as editor depended on the success of wrestling, his profound ambivalence at the cost of that success—radical changes in the constitution of the wrestling audience and, indeed, in the fundamental wrestling experience, changes in the appropriate behavior of women in the postwar era—was unmistakable.

In later issues of the magazine, Axman's editorial stance regarding the role of women in wrestling's audience appears to change, even if his personal opinion did not. On 5 May 1949, eight months after Axman published his short story, a short item entitled "His Girl Excited" was situated just below Axman's weekly editorial, which read: "A letter from Al Smith states—'I took my girl to

the wrestling show last Wednesday at the Rainbo Arena. She didn't think she would enjoy it, but now it's a must every Wednesday night for us. I still don't know who got beat up the most, me or the boys in the ring.'"[23] This item repeats the story of a woman attending a wrestling match for the first time, and like the first couple, they quickly become weekly patrons. However, this woman's behavior is markedly different from Charlotte's, demonstrating the same passionate response typified by the "other" ladies in the previous item, though in this case, the woman's response goes beyond verbal to include a bodily reaction—"beating up" her date during the matches. That Axman chose to publish the item and prominently display it directly below his own commentary indicates a change in his perspective. This new narrative validates a woman's passionate response to wrestling as normal, worthy of publication without any editorial comments that might mark her behavior as aberrant. While Axman remained ambivalent, he was gradually becoming more accepting of this new audience.

In September 1949, at the start of the fall wrestling season and barely a year after *WAYLI*'s launch, Axman devoted the opening segment of his editorial to another story about a female audience member, this time without any relational connection to a male partner. The unnamed woman had seen a medical doctor, who concluded she suffered from "nerves and a run down condition," and suggested as treatment that she attend a wrestling match. Axman continued the story:

> It has been two years since that lady saw her first mat show. She is now a steady patron and the doctor has lost a patient. She has become interested in the personalities in the mat game. She has her favorites and those she detests. She cheers for the favorites and she boos and jeers the unethical and unruly athletes. All this has taken her mind off imaginary ills and keeps her interest at fever heat. No doubt her boss has wondered what happened to give her the new enthusiasm she possesses. It's a new life, but she alone can credit it to wrestling.[24]

This item represents yet another shift in Axman's representation of the female audience. In this story, the woman demonstrated what could be described as a "proper" response to the wrestling text, by providing the appropriate verbal and emotional responses to wrestling's characters. While her utterances are consistent with those of the "other" ladies in the first story, there is no moral reprobation by the editor in this case, signaling his acceptance of the presence of women at the wrestling arena.

However, this acceptance is not unconditional. The woman in the story is pathologized as a hypochondriac, suffering from "imaginary ills." Certainly this reveals Axman's continued discomfort (or dis/ease) with women. However, in that the character's imagined ills are replaced by a more acceptable

and observable bodily response—her "fever heat" interest in wrestling—the character is "cured" through her fandom. Her cure, then, eliminates the disease and provides a happy ending—one that not coincidentally supports and validates the audience's continued support of the wrestling industry. Thus in a year's time Axman's attitude toward the presence of women in the audience changes from derision to grudging acceptance. While this is but one man's perspective, it is evidence of a larger acceptance of the staying-power of women's fandom of wrestling, and of the cultural shifts that were in process in the postwar era.

Changing Ways of Speaking

As the audience for wrestling changed, wrestling magazines attempted to find new "ways of speaking," through words or photos, in order to resonate with their increasingly female readership. Certainly the editorial approach taken by WAYLI in offering biographical information about wrestling characters changed. When WAYLI began in 1948, editors emphasized the achievements of the wrestling character in and out of the ring, including college, the military and other sports contexts. Family background that may have influenced the wrestler's development and character, such as parents, siblings, spouse or children, were typically absent from these biographical sketches, unless the wrestler's father or sibling was part of the wrestling community. For instance, an article appearing in the premiere issue of WAYLI titled "Brilliant Gordon Hessell to Meet Billy Goelz Monday," strictly emphasized the professional careers of the two wrestlers, documenting the events both inside and outside the ring that led to their pending meeting. There was a smattering of background information included in the article, such as the hometown of each wrestler:

> Billy calls Chicago his home and for that reason the fans are all for him. They are proud that a Chicagoan has become the titleholder. Nevertheless, Hessell is respected for his fine talent. . . . Hessell . . . was brought up in Marinette, Wisconsin, a small town in the neighbor state and he took up wrestling at an early age. He never gained much weight since the days he was an amateur.[25]

There was no indication of past or present family life; the details about the wrestler's hometown are provided principally as a guide to indicate which wrestler the reader should support. The story goes on to provide more facts regarding the wrestlers' training, weight and the like.

Placing emphasis on the measurable facts and achievements of each wrestler was typical of WAYLI's editorial approach during its initial year of publication. However, the magazine's editorial approach changed the following year. This was illustrated by the biographical sketch appearing in the 7 July 1949 issue of the publication, the same issue featuring the article that

announced "Ladies Attend Wrestling Shows" discussed above. "All About Hessell" provided a very different collection of facts than those featured in previous articles:

> Gordon Hessell is a native of Wisconsin, hailing from Milwaukee, though he now makes his home at Lake Beulah in Wisconsin. Gordon is thirty-three years of age, is married and has two sons, eleven and nine years of age, respectively. He proudly points to the fact that his oldest son, when he was nine years of age, won the Amateur Championship of the Toledo Boys Club at wrestling.

Like previous features, the article includes Hessell's list of achievements as an amateur and professional wrestler, though it also notes that "he is an ardent golf fan and also likes swimming and football."[26] Neither his golf interests nor his familial background was likely to directly influence the outcome of his pending matches and would appear to be less-than-relevant "factual" information. Instead, it was included primarily for its interest to the magazine's growing female readership. Nor was this interest theoretical; the item was preceded five weeks earlier by a letter from a Miss Chickie Walker, who wrote to announce that "a group of girls had formed a Gordon Hessell Fan Club [and] would appreciate an article on Hessell in the near future."[27] The Hessell feature undoubtedly appeared in response to Miss Walker and her friends.

The inclusion of formerly extraneous information became a regular aspect of WAYLI's coverage. For instance, a feature article on wrestling star Verne Gagne pointed out in the lead paragraph that Gagne was "an extraordinarily likable fellow—a genial, unassuming man who looks miles removed from the mat world." After detailing his youth in Robbinsdale, Minnesota, and his achievements both in athletics and academics, the article concluded by noting, "On the personal side Gagne likes hunting, fishing, dancing, books, and lots of rough matches."[28] While most of the information was not useful in a strict athletic sense, it was highly valuable in a narrative sense, establishing the familial background—and thus the moral foundation—of the wrestling *character*. This type of information frequently found its way into print, no doubt because of the editorial staff's perception that it would appeal to a female readership.

This was not the first male-centered magazine genre to make such a change. Richard Butsch's work on early radio in the United States suggests that with the advent of broadcasting in the early 1920s, wireless magazines that had formerly served a primarily male hobbyist readership began to shift focus. Magazine covers no longer offered black-and-white illustrations of equipment; instead, they featured sophisticated color images of well-dressed women and men listening to radios. Articles increasingly hinted at women's equality, while offering unflattering stories of men struggling with radio technology.[29] Like radio magazines before them, the wrestling press quickly adjusted to serve its growing female readership.

Speaking in Pictures

Another means of appealing to an audience is through the selection of photos or pictorials. *WAYLI* included many photographs in its pages, and its photographic style underwent a marked shift in its eight years of publication. When it began in 1948, the typical *WAYLI* photograph was a publicity still of the wrestler adopting a preparatory wrestling position—one an opponent might see at the start of a match—often looking directly into the camera.[30]

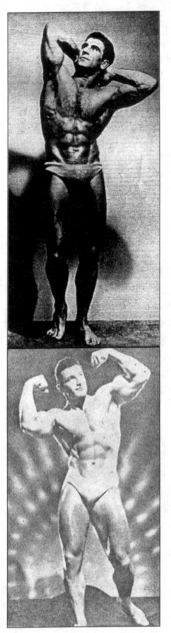

However, toward the end of its initial year of publication, *WAYLI* began to include a new type of pose, one that emphasized the body's physical attractiveness rather than its aggressive potential in the ring. A photograph of Gene Stanlee (later dubbed "Mr. America") in the 2 June 1949 issue of *WAYLI* presented Stanlee with his hands behind his head, looking off at the horizon, in a pose more reminiscent of a body-building competition than a wrestling match.[31] The side lighting used by the photographer emphasized the taught musculature of the body, and the full-length frontal shot invited the reader to appreciate the sculpted detail of Stanlee's toned form. It is also revealing to note that this photograph appeared on the letters page, amid an entire column of inquiries by female fans.

A similar photograph, this one of Lord Pinkerton (Bob McCune), appeared in the 25 November 1950 issue (Figure 4.1).[32] Also a full length frontal shot, this one found Pinkerton flexing his biceps in a typical muscle-man pose, his gaze trained on the distant horizon. Again, the lighting trained on Pinkerton's body emphasized the detail of his muscled form, and the background lighting created a starburst, halo-like effect. These photographs, and others that appeared in the pages of *WAYLI*, emphasized the body's to-be-looked-at-ness, the body on display for the reader as an object, perhaps an object of desire, rather than posed as a threat to an opposing wrestler.

Figure 4.1 Andre Drapp (top) and Lord Pinkerton (Bob McCune)

WAYLI's editorial staff may not have initiated this thematic shift in the photographic representation of some wrestlers; many of the photographs were publicity stills produced and distributed by wrestling organizations, the wrestlers themselves, and outside studios. Some photos were produced by the nascent gay physique photography movement that was emerging in the late 1940s and 1950s, an outgrowth of the body-building magazines of the 1930s and Bernarr MacFadden's *Physical Culture* "health and fitness field" from the 1910s. Bob Mizer's Hollywood-based Athletic Model Guild produced an extensive collection of photographs of nude or nearly nude male models, including the photos of wrestler "Lord Pinkerton" (Bob McCune). F. Valentine Hooven III argues that Mizer's efforts, which sparked a series of magazines in the United States (including Mizer's own *Physique Pictorial*), focused publishing attention for the first time on the attractiveness of the male physique.[33] This movement, emerging from the gay community, contributed to the representational photographic style emphasizing the to-be-looked-at-ness of the objectified male body seen in wrestling magazines during this period, but whether the men who ran the wrestling industry were aware of the source is another question. This new representational photographic style was likely seen by the wrestling industry as another means of appealing to the growing women's audience, though it no doubt found other unintended audiences as well (which only increased wrestling's popularity and bottom line). That the photos appeared in the pages of magazines such as WAYLI and *Official Wrestling* is to my mind another indication of a general shift in the approach the wrestling industry and its publications took with regard to its presumed audience. It certainly reflects the emerging influence of the gay community in the postwar era, despite the rampant homophobia that gripped the country.

A similar pictorial approach was championed by *Official Wrestling*, which relied heavily on photography to get its message across. When *Official Wrestling* began publication in 1951, it may well have benefited from the discoveries WAYLI had made regarding wrestling's changing audience base. The editorial assumption that both men and women would be reading in relatively equal numbers is apparent from the first issue, the unwritten theme of which could be characterized as "bodies on display." Both male and female wrestlers were represented in numerous ringside photographs: a pair of pictorial features appropriately entitled "Men at Work" and "Women at Work" were laid out one after the other, though the number of pages devoted to the men was double that of their female counterparts.[34] Equally striking were the number of posed photographs taken in studios. Early in the issue, a feature article on Andre Drapp called "Crusader from Lorraine" offered a full-page photo of the barefoot wrestler, dressed in scant bikini trunks that left little to the imagination, striking a muscled pose under studio lights that accentuated his toned, oiled body (Figure 4.1). The accompanying caption declared: "The superb development of Andre Drapp is not merely decorative. It is a big business asset."[35]

As if to offer compensation to the male readers, the Drapp article and photo were followed immediately by a four-page pictorial of women wrestlers entitled "Rough, Tough and WOW!" featuring studio photographs of six top female wrestlers.[36] Five of the women appeared in bathing suits—four of them strapless—and high-heels; only one wore her wrestling outfit and boots.

Nor did the editors hesitate to recognize and play to feminine desire: one pictorial article, a four-page photo display featuring eight male wrestlers striking poses in a studio setting, was simply titled "Beefcake." While the accompanying text positioned the item as a primer on "the ideal way to build bodily proportions," and the captions were quick to tie the images to the wrestling context, the photos delivered what the article title advertised: male "beefcake." Thus *Official Wrestling*, from its initial launch in 1951, appeared designed to speak to the desires and pleasures of both its male and female readers.[37]

Authorized Voices

When *Wrestling As You Like It* began in 1948, the only indication of the presence of women was through editorial talk *about* women. Later, editors tried to talk *to* the female audience, through both words and pictures. In a third phase, *WAYLI* expanded its writing staff, inviting writers from across the country to contribute columns and items of interest to a national audience, and unlike most other mainstream or sports magazines, *WAYLI* made column space available to a cadre of women writers. By including women writers among its ranks, the discursive "voice" of the publication shifted again to articles that increasingly sought to speak *with* women fans.

The first instance of this phenomenon in the issues I examined came in *WAYLI*'s second year of publication, in a column entitled "A Woman's Opinion."[38] The column was unsigned but was apparently in the process of becoming an ongoing feature, judging from the first sentence of the column, directed to editor Dick Axman: "I appreciate your letter asking me to continue my column." The columnist spoke in a familiar, personable style, quite distinct from the other voices in the issues (though not unlike the tone taken by the editor himself). Her column described a match she attended in Chicago: "The wind-up [concluding match] was a real thriller. Frankie Talaber is certainly a wonderful wrestler, and a real inspiration to the crowd. His opponent, Meanness Incorporated, Al Williams, was his usual nauseating self. I would like to see someone clout him so hard that he would have to retire from the ring." Though the reader was not provided with the "usual" information—we don't find out, for example, who won the match—we do glean who the hero and villain characters were, and how the crowd thought of them. That Talaber was "a real inspiration" and Williams "his usual nauseating self" provided the reader a useful measure of the two performers' charisma in the ring. Both played their roles quite expertly, judging from the writer's assessment, and easily provided the

highlight to an evening's worth of entertainment. In relating the information, the author employed a first-person style that stood apart from the more distanced reporting technique used elsewhere in the magazine.

The author's personal style speaks even more specifically to a female readership in her concluding anecdote: "Imagine my thrill after the matches at meeting one of my favorites Joe Millich. Millich is much better looking in person than on television. He has an air of sincerity and modesty that is most becoming." The author's writing style speaks with, rather than simply to, the reader.

She specifically invites the reader to stand in her shoes and imagine her emotional response in the experience, before going on to give her personal assessment of the wrestler's appearance and personality. While the information is of little "factual" value, it has enormous usefulness in terms of evaluating the wrestler's strength of character and desirability. This type of reportage is comparable with the function of the close-up in televised soap opera in that both provide the spectator with "inside" information that allows for a specialized reading of the character, a skill often attributed to a feminine subject.[39] Suffice it to say, this writing approach is quite different from the sort engaged in by male writers or sought out by the majority of male readers and signals an important shift in "way of speaking" visible in the magazine.

By 1953, *WAYLI*'s coverage of wrestling had expanded significantly: the size of the issues doubled to sixteen pages, and a series of regular regional columnists were added—some on a weekly basis, others appearing more occasionally. The magazine consistently offered at least five separate regional columns per week, rotating among a range of correspondents, and nearly half of them were authored by women.[40]

Dorothy Brydges' column "San Francisco News" frequently appeared (Figure 4.2). Brydges regularly featured information in her column that provided insight into the character and familial background of the wrestlers appearing in her area. Brydges' column dated 24 January 1953, for instance, was devoted to a "thrilling" tag team match featuring Lord James Blears and Lord Athol Layton. She wrote:

Figure 4.2 Columnists Dorothy Brydges, Joan Ellis and Arlene Edwards (top to bottom).

Lord James Blears is one of the most fascinating personalities in wrestling. He is a clever wrestler and has many effective holds and counter holds at his command. In addition, he has two very interesting hobbies. One is the study of the life histories of the gun fighters of the old west, men like Billy the Kid and Wild Bill Hickok. He has read every available book on the subject and is still eager for more knowledge. His other hobby is photography, and he is an expert with the camera, both movie and still. Both Lord Blears and his manager, Captain Leslie Holmes . . . have applied for United States citizenship. All three of Lord Blears' children were born in this country, so are already citizens.[41]

While Brydges noted Blears' acumen in the ring, she focused on his private rather than public life, concentrating on his hobbies, his citizenship and his children. Certainly, a knowledge of Blears' interest in gun fighters might have led some fans to afford the wrestler a tactical edge in the ring, but it is doubtful that the information was included for that reason. Instead, these details provided insight into Blears' individual character, pointing out his intellectual interests. Likewise, the fact that Blears had three children, each born in the United States, was not particularly "useful" information, unless one were interested in his family background, as were Brydges and her female readership.

Joan Ellis' "Texas Letter" was another column that appeared frequently (Figure 4.2).[42] Written in an informal first-person style, each column began with "Dear Mr. Axman," and concluded with a pleasant salutation and signature. Her column typically included descriptions of matches held in Dallas and Houston, the comings and goings of wrestlers to the area, and activities of Texan fan clubs. Her descriptions were filled with personal asides and specialized information not typically included in other articles, as demonstrated by the following item on wrestler Fuzzy Cupid (nee Leon Stop), known as the "Gorgeous George of the midgets." Though she provided ample information about his wrestling abilities and physical capability—such as his ability to bench press 160 pounds more than his body weight—she also included a significant amount of personal information:

Born September 24, 1928 in Newport Rhode Island of normal parents, Leon Stop often wondered why he wasn't normal like his other two brothers. . . ."To my knowledge all the midgets I've known in show business and wrestling come from normal parents." You fans remember the cute Canadian Indian Little Beaver married out in a California ring last year. Fuzzy Cupid said the doctors were almost sure Beaver's kind [sic] would be normal. "We kid Little Beaver a lot by telling him when his son is six years old he's going to ask his mom how come daddy is so short." Fuzzy's Dad was a Holland wrestler, a heavyweight, from 1901–1903. His mother is French. Fuz enjoys shooting pheasants with his .22 or trout fishing on the lake. . . . And, Fuzzy Cupid likes his books like he likes his wrestling . . . rugged and raw. His favorite author is Mickey Spillane.[43]

Consistent with the other examples discussed above, Ellis included a significant amount of personal information regarding Cupid's family background and personal interests. Furthermore, her direct address to the reader invoked a more intimate, conversational style of communication, consistent with the characteristics of women's oral culture described by theorists such as Deborah Jones.[44] Rather than talking *to* women readers, Ellis clearly engaged in a conversation *with* her readership, providing them with a woman's perspective on the wrestling scene. The writing of women such as Joan Ellis and Dorothy Brydges engineered a fundamental shift in the publication. They were able to change the tone of the magazine and expand its subject focus to include information of interest and value to a female reader.

Women writers achieved a presence in *Official Wrestling* as well. The majority of the articles written by women dealt with personal rather than professional issues, taking the *WAYLI* approach a step further by explicitly focusing on women's personal relationships with wrestlers. In March 1952, a new series appeared, titled "His Kind of Woman" and written by a woman identified only as "Corry." Each installment began with a preamble that mused: "You gals may be interested in knowing just what the 'eligible' young wrestlers prefer in the way of a helpmeet—their 'dream girl.' Corry is a gal herself, and she'll get the dope for you and pass it along each month."[45] Interestingly, the initial feature on Don Leo Jonathan proposed no guidelines for the appearance of his "ideal" woman: "She may be short or tall, blonde or brunette, that is not important." (Conveniently, this description could reasonably include all of the magazine's female readers.) Instead, the article suggested a series of character traits the wrestler desired: "She must be understanding, kind and sincere[,] of good character, conservative in manner and speech. It is the nice girl I am seeking. The average American wholesome woman." Certainly the characteristics Jonathan listed fit snugly with the conservative construction of womanhood in the 1950s. What they wouldn't have fit was the typical woman at ringside at a wrestling arena![46]

Another article turned the tables on the previous series, entitled "'My Prince Charming' in Rassling Trunks." Written by Mary McCauley, the article was a first-person recitation of the author's idea of a "perfect" man:

> My idea of a knight in shining armor is Flushing's gift to wrestling, Tony Cosenza. Just under six feet in height, Tony is the object of many "oohs" and "aahs" from the weaker sex. And no wonder, he possesses probably one of the more beautifully muscled bodies in the ring today, rivaling Stanlee and ["Nature Boy" Buddy] Rogers in that department.[47]

The article was a celebration of the author's desire, and, by extension, that of many in her female audience. She confided to her readers that Tony possessed "all the boyishness and charm that brings out our womanly instincts," concluding:

"The big question is[,] 'Will Cosenza escape matrimony in 1952?'" Whether or not he actually did escape marriage that year, he did not escape being taken up as an object of desire for many women readers that month.

These and other articles from the wrestling press of the 1950s document the increased presence of female writers and the multiple purposes wrestling fandom served women, one of which was the objectification of the male image. Whether through simple "eye candy," tales of encounters with wrestlers or fantasies of marriage material, these pictures and descriptions created a venue where women could indulge in the pleasure of consuming the masculine body. The female voice played an important role, offering women readers representatives in the writing corps who would speak to their interests and place them centrally in the text, proof of the cultural power women had to define their own interests.[48]

Voices of Readers: The Letters Section

As the ranks of regular, sanctioned writers increased in both *WAYLI* and *Official Wrestling*, the magazines also provided more space for readers to speak within their pages. Because the wrestling press depended on reader support for its livelihood, the "letters to the editor" section of a magazine encouraged reader participation while affording readers the chance to enjoy a measure of self-identification by "seeing" themselves in print. Though reader access was initially limited to letters to the editor, over time readers gained access to other areas of the publication as well.

In the premiere edition of *Wrestling As You Like It*, editor Dick Axman urged readers to write in with any comments or suggestions, proclaiming, "This is your paper." Still, *WAYLI* did not institute a letters feature right away, though apparently not for lack of material. It was clear from the start that wrestling fans were actively using the U.S. mail to talk back to members of the wrestling industry. In its eighth week of publication, *WAYLI* published an article entitled "Letters Pour In," which acknowledged the "many letters from fans" the magazine had received (though it didn't go so far as to print them).[49]

Official Wrestling was also quick to acknowledge the flood of mail being received from audience members. In its third issue, columnist and ABC-TV commentator Wayne Griffin noted the popularity of Don Eagle, whom he described as "the idol of the teen-age gals," observing, "I get more mail about Don Eagle than any other single wrestler."[50] Interestingly, both Griffin and Axman were the recipients of the viewer mail, not Don Eagle himself, though he no doubt received volumes of mail as well. This demonstrates the underlying intent of the letter-writers: to exert pressure on the wrestling establishment to insure future television performances by Eagle and other audience favorites. Similarly, in the succeeding issue of *Official Wrestling*, a feature article on KTLA-TV announcer Dick Lane pointed out that Lane had "a big hand in the

crusade to help clean up wrestling in Southern California. His fans back him on this with well over 1,000 letters per week."[51] Clearly, wrestling fans were turning to the mails, sometimes to influence the direction of the performance genre, other times simply to reach out to their favorite stars.

Persistence can yield rewards. Fiske argues that sports fans back a particular team in part to share in the rewards that come with success, and several studies of fan letter-writing efforts show how fans have used written communication to influence the production or distribution of television programs.[52] Certainly women saw increased coverage of their favorite performers, and, as I discuss in the following chapter, were able to influence the success of those performers in the evolving wrestling narrative.

Despite the volume of mail it was receiving, WAYLI did not initiate a letters section until well into its first year of publication. Usually a quarter page in length, the "Answering the Mail" column featured excerpts from a half-dozen letters. The column that appeared in the 2 June 1949 issue began by acknowledging the degree to which the readership was responding to the publication, noting, "The mail piles up, but there are a few letters we wish to answer in appreciation of the trouble that was taken in writing us."[53]

If the demographics of the letters feature accurately reflected the magazine's readership, WAYLI's readership was decidedly female. The first appearance of "Answering the Mail" printed letters by four women, one man and one unidentified writer. Still more revealingly, the letters feature immediately became a site of reader contestation, battling over the direction of wrestling. Al Kuglin, the lone male writer, complained bitterly about one of the more flamboyant villain wrestlers becoming popular at the time, writing that Nature Boy Buddy Rogers "galls" him with "that fancy robe and his arrogant tactics." In the same paragraph, as if to answer the complaint, the editors noted, "Harriet Smedlin also drops us a long letter stating she got a thrill out of Gorgeous George, and she wants to know whether the marcelled West Coast heavyweight is married." Even more flamboyant than Rogers, Gorgeous George gained the unequivocal approval of this female writer, in apparent (if unintended) response to the previous complainant.

The nature of Smedlin's interest in George was echoed in the three other letters from women. Two sang the praises of wrestler Gordon Hessell, "the handsomest wrestler," according to writer Angie Turzink; in the third, Miss Olga Bezowsky voiced her opinion that in fact Gene Stanlee was "the most handsome wrestler." Bezowsky also countered previous editorial claims, pointing out that Australian wrestler Fred Atkins had indeed begun making appearances in the United States.

Each of the women's letters takes a position in support of the new wave of flamboyant, colorful, glamorous wrestlers who were achieving prominence at the time, and about whom many men—including Kuglin—were complaining. The inclusion of Bezowsky's editorial correction establishes by example these

women's credibility as wrestling critics. Thus from the start, the letters column in *WAYLI* was established as a contested space, a battle ground between often-opposing forces, with a play of contrasting opinions regarding the direction of the wrestling performance, and its representation in the pages of the magazine.

Unlike *WAYLI*, *Official Wrestling* introduced a letters column almost immediately after beginning publication. Titled "Picking Up the Slips," the section started as a full-page feature in the publication's third month of operation and expanded to two full pages in the following issue.[54] And as in *WAYLI*, the letters section of *Official Wrestling* quickly became contested terrain. The opening letter, from Peter Jucci of Corona, Long Island, set the tone:

> Read your new *Official Wrestling* magazine and must honestly say I was a bit disappointed. I'm not criticizing. Perhaps your next issue will be better. As you know you can't please everyone. As a lover of wrestling, the sport in the time of [Ed "Strangler"] Lewis and [Joe] Stecher, not the joke it is today, I would like to make some suggestions if I may. I would like to see less pictures and more print on great old timers in wrestling and the fine wrestlers of today, of which there are some . . . Lou Thesz, probably the best; Robert Sexton; Yukon Eric; Don Eagle, Marvin Mercer, etc. These men are wrestlers, and let's hear less about Wolf Man, Golden Terror, Gorgeous George, Golden Boy, etc. These men are circus clowns, not wrestlers. If we were rid of the bunch of them wrestling would again be a sport as it should be with a genuine recognized champion as in boxing. Let's see or hear less about women wrestlers. Give the space full time to men.[55]

There is plenty to unpack from this letter. Like the complainant in *WAYLI*'s letters section, Jucci clearly advocated the "old-timer" style of wrestling, emphasizing its long-outdated, though still salient, image as a "sport." And he indicated a clear preference for "scientific" or clean wrestlers, typified by Thesz, Sexton and the like, over their newly popularized, flamboyant counterparts, exemplified by Gorgeous George. In doing so, Jucci supported a "traditional" or athleticized performance style over the more theatricalized wrestling spectacle that was increasingly garnering attention.

That the editorial staff selected Jucci's critique as the opening commentary for the letters page indicates that "Picking Up the Pieces" was created as a site of conflict. His opening salvo was met with two responses: first, an editorial reply, and secondly, a letter arguing the reverse of his stated position. The editorial response reinforced the terms of the debate, while indicating their desire to accommodate all the major audience tastes: "We can't please everybody, but we try, hence Old Timers on Parade, lady wrestlers and features on the men some consider clowns."[56] Their careful description of "the men some consider clowns" suggests that while "some" in the audience might disapprove of articles on them, the majority would respond positively, thus refuting Jucci's argument.

The letter that followed Jucci's opening remarks also served to question his claims. Though the letter was signed "E. Rydzik," leaving the gender of the writer unclear, I would speculate that the writer was likely female.[57] Rydzik wrote:

> Have just finished reading your first issue of "Official Wrestling," and it's terrific. I was also pleased to note that many of your professional consultants are former wrestlers or promoters. . . . I am one of the most ardent of wrestling fans and have been practically "selling" your magazine to all my friends. My favorite wrestler is the "Man-eating Matador," Antonino Rocca, closely followed by Gene "Mr. America" Stanlee, and Kiman Kudo, the judo expert.[58]

Rydzik clearly supported wrestlers Jucci considered "clowns," such as bodybuilder and teen heartthrob Gene Stanlee and the "Man-eating Matador," Antonino Rocca, who was both highly athletic and quite theatrical. Furthermore, the writer's glowing assessment of the magazine stood in stark contrast to the critique leveled in the first letter. And the writer established her wrestling acumen through her observations regarding the publication's professional consultants, demonstrating her knowledge of the genre. In short, Rydzik's letter provided a dispassionate rebuttal to Jucci, confirming in the process the terms of the debate: old versus new, athleticized versus theatricalized, and traditional male versus ascendant female wrestling tastes. Raymond Williams' concept of "emergent culture" provides a useful framework for understanding this clash of opinions; the writers found themselves at a point when "new meanings and values, new practices, new relationships" were being created in opposition to a "residual culture" formed in the past, but still "active in the cultural process."[59] As in the wrestling arena and the mainstream press, these conflicts were played out in the wrestling press. The direction of wrestling, the direction of coverage in the wrestling magazine itself, and the cultural influence of male and female fans upon both would be hotly contested in letters to the editor.

This scenario was replicated over and over in the letters pages of both *WAYLI* and *Official Wrestling*. Both magazines published excerpts from scores of letters voicing preferences for individual wrestlers, as if providing an ongoing tally of votes. In *Official Wrestling* in particular, the pattern illustrated above was repeated: men complained about the direction the magazine was taking and advocated an emphasis on traditional wrestlers or wrestling styles, while women complimented the publishers and offered suggestions as to their personal favorites:

> I think the magazine is coming along fine now, but why can't we have more stories and pictures on lady wrestlers. The Old Timer feature is particularly interesting to me, as I am an old time fan and saw many of the greats you write about in action.
>
> —Jim Continos, Los Angeles, Calif.

I have just finished reading your first issue. My reaction is "So what?" There just doesn't seem to be much to it. Not enough copy and who cares about cartoonists who pose with wrestlers for a gag, [and] lady wrestlers.

—Frank Schultz, Chicago, Ill.

Congratulations on your February issue. The magazine is wonderful. . . . Would like to see a story on Tony Cosenza, the Latin from Manhattan. He is an excellent pianist and concert singer. How about pictures of Jim Austeri too?

—Ruth Danish, Northampton, Pa.

Have just finished your last issue and think it's a wonderful publication. I think wrestling should be on TV five nights a week, and women wrestlers, along with midgets, are both disgusting and miserable. I'd like to see Baron Leone teamed up with Cyclone Ayana.

–Dolores Nonnemaker, Fullerton, Pa.[60]

In a sense, the letters page re-enacted the same battle between good and evil played out in the wrestling arena every night. The editors positioned writers with opposing viewpoints next to one another as foils, allowing readers to recognize both their own interests and those of their "opponents" in the audience.[61]

The letters page served as the gateway of the magazine for its readers, a space in the publication where the larger battle over the content of the entire magazine could be played out. And many readers doubtlessly saw the potential such a site represented, as a location where writers could encourage the editorial staff to better serve their interests. One reader of *Official Wrestling* didn't have to wait long at all to have her request met. She wrote, "My favorite is Don Eagle, and I would give anything to see his picture on the cover soon. I'm bursting with curiosity to see his outfits in [T]echnicolor."[62]

The selection of Ms. Crooks' letter was perhaps self-serving, as the editors met her request with a full-color photograph of Eagle on the cover of that month's edition, along with a suggestive headline tacked above the letter that read: "Wants Don Eagle in Color." Still, the underlying message was clear: readers' requests were influential and often would be fulfilled. No doubt the visible success of readers such as Crooks spurred others to try their hand at influencing the magazine and the industry it represented.

Sending Messages

Once established, readers found they could use the letters section for a number of purposes. In addition to directly influencing the editorial direction of the magazine, writers sent messages to others within the wrestling community and secured other avenues in which to pursue their interests. Not surprisingly, many

wrote to gain information on their wrestler of choice. Some women, for instance, wrote to inquire about a wrestler's marital status.[63] Other writers used the magazine as a go-between to pose questions to the wrestlers directly or to gain access to their favorite performer. At one point *WAYLI* codified this arrangement in its "Voice of the Fan" column, structuring it as question-and-response. While many letters were addressed to the column itself, some were directed to the individual wrestler:

Nancy Carpenter, Gary, Ind. to Lord Blears:

Q. What does the crest on your robe stand for?
A. The crest on my robe stands for my family crest in England.

Shelly Jordan to Bad Boy Brown:

Q. Is it true that you have baby tigers as pets?
A. Yes, I have two tigers given me by Clyde Beatty.[64]

While this conversational style may have given the appearance of a dialogue between performer and fan, other readers attempted to establish face-to-face contact, as these letters illustrate:

Mavarlene McGregor, Chicago to Voice of the Fan:

Q. How can I meet Verne Gagne? He sends me.
A. We might arrange a meeting but we wouldn't want to see you sent.

Joan Finnerty to Pierre LaSalle:

Q. Where do you live in Chicago?
A. At the New Lawrence Hotel.[65]

There is no way of knowing if either fan succeeded in meeting a wrestler outside the ring, though one wonders whether LaSalle was able to retain his living quarters following the publication of this item, particularly given the photograph of LaSalle's oiled and muscled torso that accompanied it in print.

Another strategy involved using the letters column to communicate with like-minded fans. Many readers wrote in hopes of swapping artifacts, information or correspondence with fans in other regions. Men were more interested in exchanging photos or printed information. Typical of these was a letter from Bill Straighter of Buffalo, who wrote to say he "would like to trade programs and newspaper clippings with a wrestling fan in each of the following cities: Houston, Texas; St. Louis," each a major wrestling market. In every case the writer listed what he had to exchange and specified what he was looking for in return.

Women, on the other hand, were more interested in exchanging personal information or observations. For example, Miss Rita Sheridan of St. Johns, Michigan, wrote "wondering if anyone would like to exchange letters with me." She did not specify her fan interests, leaving that up to the correspondents. Another woman in the same issue, Miss Judy Haussan of Peoria, wrote hoping to exchange pictures of three of her favorite wrestlers with like-minded fans, though she also indicated her desire to write to these fans as well. Unlike the male writers, Haussan hoped to exchange personal correspondence, rather than simply trading artifacts. In all cases, however, the writers used the letters column to establish additional lines of communication with other members of the wrestling audience.[66]

Much like the way women used the space at ringside at the wrestling arena, many women enacted performances in the letters columns that contradicted normative constructions of femininity. A number of women used the pages of the letters section to directly articulate their desire for wrestlers, such as the Verne Gagne fan described above. Others were less direct in their assessments, such as the letter from Mrs. Sally Beitler, who wrote to suggest her four favorite wrestlers. Three of the performers she nominated for their ring skills, but her fourth and final nomination admitted a different criteria: "Ed Francis, for his blond hair and handsome face (at least I'm honest)."[67] Though her performance was less assertive than many, its subtlety did not obscure the interest that lay behind her words, and it was voiced in a manner that probably resonated with a significant portion of the female readership. The editors recognized her interest for what it was: above the letter listing her four favorite wrestlers was a head-and-shoulders photo of only one: Ed Francis.

This image of women desiring male wrestlers and articulating their desire in print was regularly reinforced by the magazines: in addition to selecting these letters for publication, editors at times commented on them as well, as in the headline described early that suggested one reader "Wants Don Eagle in Color." Though the scale of their written performances do not match the intensity of those women enacted at the wrestling arena, they were limited by the gatekeeper function of the editorial staff. Nonetheless, the mere presence of such performances was evocative, containing echoes of those from other sites.

Women Wrestlers

There were other opportunities for women to push the boundaries of conventional femininity. A number of women wrote to inquire about potential employment opportunities within the industry—as wrestlers. Typical of such letters was this one from Miss Joyce Coalmer: "I want to become a lady wrestler but I need some help. Please don't let me down and someday when I become a success, and I WILL, I won't let you down." Another woman wrote seeking information on how to get started as a wrestling manager—another performative role.

The editors began their response on a rather glib note, suggesting: "First get yourself a wrestler," perhaps a veiled reference to the performances of female desire described above.[68]

Another reader, Phyllis Cooper, took a decidedly activist approach to the subject, stating flatly: "I would like to hear one good reason why women wrestlers are barred from wrestling in Indiana. I believe that if they want wrestling to be their occupation, they should be given the opportunity."[69] Interestingly, she did not advocate for female wrestling based on spectator interest, but rather on increased employment opportunities for women—this at a time when women were being told to leave the work force altogether and return to the domestic sphere. Readers were not the only ones to take such a position. In 1951, WAYLI feature editor James Barnett wrote a column on the subject of women wrestlers, noting that "over one hundred girls are currently wrestling professionally in the United States." Though Barnett argued that each of the women had different reasons for entering the profession, the underlying message of the article was that economic independence was the principal factor.[70] This stance runs contrary to the magazine's characterization of women wrestlers, consistently depicted in "cheesecake" poses. But the message from Barnett and the letter-writers echoes the achievements of female athletes in a range of sports, from Helen Wills, "Babe" Didrikson Zaharias, Amelia Earhart and Althea Gibson to the women of the All-American Girls Professional Baseball League.[71] Seen in that light, it is no surprise that some saw wrestling as one of many legitimate professions for women, worthy of pursuit. Like the active performances of women in the context of the wrestling arena, these letters demonstrated the surprising fluidity of definitions of femininity in the 1950s.

Fan Clubs on the Move

Many wrestling fans were not satisfied to simply cull information from the magazine or see their questions answered in print. Mentions of the formation of various fan clubs began to appear in the pages of WAYLI as early as two months after its debut, and with the institution of the letters section, clubs gradually began to utilize the space to announce their existence to the readership at large. A letter from Marion Palmer of Buffalo typifies the type of letter published: "I am a newsstand subscriber of Official Wrestling and am waiting for a story on Kay Bell. I head his fan club and would like to hear from fans in other cities who would wish to join the club."[72] The writer began by identifying her status as a regular (paying) member of the readership, before turning to address the readership at large. Her full address accompanied the letter, so readers could contact her directly. By now, mailing addresses for most writers were included with letters in Official Wrestling, allowing readers to make connections with each other directly, bypassing the magazine. Thus the letters page became a centralized location for publicizing fan club efforts and attracting interested fans.

Having established themselves on the pages of the letters section, writers quickly extended their reach, convincing magazines to devote additional publishing space to fan interests. By 1952, fan clubs had made significant inroads in *Official Wrestling*, with a section of the magazine devoted exclusively to their activities. The section, entitled "Fan Clubs of America," was written by Ned Brown and took up over five pages of the magazine.[73] Atop the opening page of the section was the logo for the Wrestling Fan Clubs Association of America (WFCAA), which included two illustrations, positioned at either end of the logo, illustrations that spoke volumes about the identity of the typical fan (Figure 4.3). In the drawing at left, a mail carrier exited the frame with a bulging mail pouch, having just made a delivery. The recipient stood in the foreground with a handful of mail in one hand and an open letter in the other, which he read with a bemused expression on his face, obviously enjoying the message. In the illustration at right, a curly-haired white woman spoke on the telephone, a knowing look of pleasure on her face, her left hand raised and index finger extended as if to make a point. Behind her, tacked to the walls in what appeared to be a domestic interior, were two photographs of male wrestlers in silhouette, each striking a muscular pose.

The man in the illustration at left is presumably a wrestler, enjoying a handful of fan mail likely sent by female admirers. The woman clearly represents the typical fan, situated within the private space of the home. The wrestling photographs tacked to the walls demonstrate her desire to surround herself with the iconography of the wrestling performance, and her positioning on the telephone, in all probability sharing information with a like-minded fan, speaks to her performance as a fan. As such the illustration is quite suggestive of the magazine's image of wrestling's "typical" fan and her relationship to the genre's male performers.

The fan club section of *Official Wrestling* was itself subdivided into multiple subject areas, beginning with a column by editor Ned Brown. In the April 1953 issue, his column dealt exclusively with plans for the first annual WFCAA convention, slated for August of that year. Included as well was a fan club roster, with the names and addresses of 133 fan clubs listed; 94 were run by women, 25

Figure 4.3 *Official Wrestling* Fan Club page

by men, and 14 were unidentifiable. The fan club section now had its own separate letters area, where club operators announced the formation of new clubs or changes in existing club structure.[74]

A similar, less elaborate section of *WAYLI* served wrestling fan clubs under the title "Tom Cummins' Page."[75] Cummins noted changes in existing clubs and provided information on 15 new clubs—all of them run by women—while describing what amenities the clubs offered. He promised to provide a complete listing of the nearly 180 clubs on file. Other clubs used space in magazines to advertise the benefits or merchandise they offered fans in exchange for membership dues. They also began to make claims about the size of their membership rolls, from a modest 60 members for the Garibaldi Fan Club to upwards of 500 members in clubs formed around Ray Gunkel and Steve Stanlee.[76]

The growth didn't stop there. Fan club operators had expanded their sights beyond the letters and fan club sections. By the beginning of 1953, clubs had gained access to most of the regional columns published in *WAYLI* and were sending letters and supplying information to most of the individual columnists. Many columnists were made honorary members of fan clubs, and all were likely receiving fan club bulletins from those clubs that published them. In addition to "Tom Cummins' Page," dedicated exclusively to wrestling fan clubs, club materials were being regularly included in Eleanor Greene's "California Mat Observations," Joan Ellis' "Texas Letter," Dorothy Brydges' "San Francisco News," Arlene Edwards' "News From Newark" (Figure 4.2), and more occasionally in Barry Lloyd Penhale's "Canadian Wrestling Notes."[77]

A wide variety of information and fan performances were reproduced in both the regional columns and the newly created fan club sections. For instance, columnists would relay descriptions of club gifts presented to wrestlers, in some instances giving details of the ceremonies themselves, as in this account by columnist Dorothy Brydges:

> Between bouts Tuesday night in San Francisco, Riki Dozan was presented with a lovely robe by the members of his Northern California Fan Club. The presentation was made in the ring by two very pretty Japanese girls in native dress. It was a very impressive ceremony. The robe is royal blue velvet with a yellow satin lining and on the back is inscribed: "Riki Dozan Northern California Koenkai." Riki says that Koenkai is the Japanese word for fan club.[78]

The philanthropic efforts of fan clubs were also described, as were occasional social gatherings sponsored by clubs, such as the holiday gathering that brought together the membership of four fan clubs in Ohio.[79]

There were also reports of competition among clubs, both subtle and overt. It was not uncommon for two or more clubs to be formed for the same wrestler, and at times columns would receive competing reports from club officers detailing the

various offerings or activities that distinguished the two.[80] In one instance, inter-club competition became heated. In her "Texas Letter" column, Joan Ellis reported of a battle brewing between members of the Rito Romero and Danny Savich fan clubs:

> Betty [Shaw, Danny Savich Fan Club president] also was upset and rather astonished to find herself pushed into the big middle of a supposed feud with the Rito Romero Fan Clubs. . . . The Romero fans and the Savich fans in cer-tain distant areas were just about squaring off with six-shooters over Romero's last two matches in Texas with Savich. It was from these squabbles and certain letters, published in a Bulletin, that made everyone feel that these fan clubs were attacking each other on such low basis as race and nationality.[81]

Two weeks later, "Fan Club News" reported that the feud between the Romero and Savich clubs was peacefully resolved (apparently without gunfire). However, the columnists noted a second skirmish originating from the Duke Keomuka Fan Club and reminded readers that such incidents "do not help wrestling at all, and surely don't lead to friendly cooperation between the clubs."[82]

This excerpt is a useful reminder that social and cultural challenges existed on a number of fronts in the 1950s and cannot be seen exclusively in gendered terms. On one level, female-dominated fan clubs engineered spaces where they could exert power by creating supportive environments for woman-centered talk about wrestling. On another level, racial and ethnic definitions were also clearly in flux, as fans used racism to lobby on behalf of their chosen wrestlers.

The opportunities for fan performances of all sorts—publicizing fan club activities, attracting like-minded readers as correspondents, communicating with other clubs and engaging in forms of interclub competition (including racial and ethnic slurs)—increased dramatically through the early and mid-1950s. Women used publications as one venue to engage in such performances, successfully colonizing the pages of the wrestling press. It also is yet more evi-dence of the shifting conceptualization of the audience by the editorial staff at these two magazines, who opened up a significant percentage of their pages to women-dominated fan club interests and activities.

As this chapter demonstrates, the wrestling press was a fertile ground for fan activity. Magazine editors struggled to find ways of addressing a rapidly changing audience and increasingly acquiesced to including more female voices and femi-nine ways of speaking in their pages, this despite lingering uneasiness over the behavior some editors were seeing at the wrestling arena. Men and women fought for the privilege of defining the direction wrestling should take, with women winning the war on most fronts. Fan clubs mobilized to carve out more spaces within the magazines for messages supporting their activities and interests.

The magazines clearly demonstrate the shifting terrain of definitions of gender, sexuality, race and ethnicity.

More so than any other commercial forum, the wrestling press offered fans more opportunities to speak both at the margins and at the center of their magazines. Still, the ability to speak was ultimately controlled by the commercial press, as the gatekeeper of the magazine. Without a doubt, their decisions were driven by profit motives. As the next chapter shall explore, it is not surprising that fans increasingly created private spaces—fan clubs—as well as fan club bulletins, to meet and express themselves outside the forums controlled by the wrestling industry.

CHAPTER FIVE

Women-Owned, Women-Operated: Fan Club Bulletins

If you like your wrestling rough, we've had besides such old and revered roughies as Lisowski, Schmidt, Herman, etc., some great new meanies. . . . We must mention one very blonde, and very exciting youngster who really rates applause every time out.

—Ellen Hunt, *Ringmaster* (1957), 8.

For months after I began this project, I searched for wrestling magazines and memorabilia from the 1950s with precious little to show for it. Libraries were usually of little help, flea markets were hit-or-miss, and most collectors who advertised on the back pages of current wrestling newsletters offered items dating back only as far as the 1970s.[1] Then I came across the name of Tom Burke of Global Wrestling, whose collection offered not only the geographical reach befitting its name, but also the historical depth I was seeking. After a bit of correspondence, he graciously invited me to his home in Springfield, Massachusetts, granting me both an extended interview and access to his elaborate collection.

Arriving at his home, I thought I'd found heaven. There were the magazines I'd been seeking, along with lavish color posters, eight-inch-wide rhinestone-encrusted championship belts, and a host of other artifacts. Thumbing through a drawer, I happened across a file folder that stopped me cold in my tracks: in it were sixteen fan club bulletins from the 1950s, pages bursting with snapshots, colorful covers adorned with drawings and photos, and all written by women. I had certainly known such things existed; *Wrestling World* listed the names of hundreds of fan clubs in its pages. But I never expected these most ephemeral creations to survive, much less make it into my hands. Yet there they were.

This chapter chronicles the rise of the wrestling fan club in the 1950s and the unique role the fan club bulletin played in women's lives. (Often referred to currently as "zines," fan club bulletins of all kinds have a long and colorful lineage, which I discuss later.) In addition to serving as a creative outlet and a publicity vehicle for the wrestler, the fan bulletin bridged the gap for women between public and private—between the public space of the wrestling arena and the commercial fan magazine, and the private domestic space of the home. It offered a means of making connections with other, like-minded women (and men), establishing a community identity. The bulletin functioned as a forum for the interests of fans, often distinct from those of the commercial sphere, and gave voice to a range of topics, from personal fantasies to political exhortations. Women across the country used the fan club bulletin to carve out their own public space while holding on to the forms of private speech that long had served them.

These bulletins echo the character of the women who created them, as well as those who subscribed, read and contributed to them. In the context of the 1950s, an era for women of increasingly contested domestic containment, the fan club bulletin is a harbinger of feminism to come. Women sought public channels for their marginalized pleasures and beliefs, to rewrite the conservative feminine role that had been imposed on them. Wrestling and its fan clubs were one example of this nascent movement.

The Move to Fan Clubs

It is useful to begin the discussion of fan clubs by first reflecting on the terms "audience member" and "fan." In their examination of science fiction programs such as *Star Trek* and *Doctor Who*, Tulloch and Jenkins describe the role of audience member as one of a "follower," having a more casual relationship to the text as passive consumer. The fan, on the other hand, moves to a more active relationship with the program, to become an active participant "within fandom as a social, cultural and interpretive community."[2] Lawrence Grossberg suggests that fandom represents a transition to a more coherent sense of identity, constructed within a domain—in this case, the fan club—of one's own making. However, as Tulloch and Jenkins point out, the boundaries between fans and followers are fluid, and the fan community itself is constantly in flux.[3]

While wrestling has garnered a significant fan base over the years, the rise of wrestling fan clubs as a phenomenon came about in the years following World War II. One of the first mentions of the existence of fan clubs appeared in *Wrestling As You Like It* (*WAYLI*) on 21 October 1948, then in its second month of publication. The article heralded the return of wrestler Pierre LaBelle to the Chicago area, noting, "The LaBelle Fan Club have promised a rousing reception to the French-Canadian grappler."[4] *WAYLI* and *Official Wrestling* published sporadic references to fan clubs into the early 1950s, but by 1953, both publications had added regular columns devoted to the subject—understandably, given the

growing interest. In January of that year, *WAYLI* announced it was correspon-
ding with nearly 180 fan clubs, while in April, *Official Wrestling* published con-
tact information for 133 clubs.[5]

The trend of forming fan clubs was not just a new phenomenon; it was over-
whelmingly a women's phenomenon. While fandom in general attracts both
women and men (as fandom surrounding other sports cultures clearly demon-
strates), many fan formations have been dominated by women. Recent media-
based fan communities described by Bacon-Smith, Jenkins, Baym and others are
largely women-centered, as are many of the fan activities connected to music
and other performance-based genres.[6] Of the 133 clubs included in *Official
Wrestling*'s fan club column, 94 of them were run by women (25 were headed by
men, and 14 were unidentifiable by gender). A 1954 issue of *Wrestling USA*
listed 45 active fan clubs; all but 6 were headed by women. And in 1955,
Wrestling World published the names and addresses of the principal organizers for
136 wrestling fan clubs, which were run by 151 women and 18 men, a margin of
more than eight to one.[7] Women clearly were driving this new trend.

Non-Bulletin Fan Clubs

Some fan clubs operated in name only. Organized by one or two individuals, such
clubs functioned primarily as a centralized clearinghouse for information, mem-
bership cards (see Figure 5.1) and collectibles, interacting with other fans almost
exclusively through the mail. For instance, Marilyn Hanson operated the Lou
Thesz Fan Club (along with two other clubs) from her home in western Iowa
beginning in 1951.[8] She reported to me that for a fee of thirty cents, fans received
a signed membership card, a photo or two, and a mimeographed life history of the
wrestler. In addition, Hanson and her partner Lavon Tanner personally replied to
many of the thirty to fifty letters she received each day, answering questions about
the wrestler. She estimated that approximately 1,700 people joined her club in its
three years of operation.

In the case of Hanson's club, fan commu-
nications were always conducted on a one-
on-one basis through a centralized site,
between individual fans and Hanson and
her partner. There were no "club" gather-
ings in the traditional sense—in fact, Hanson
reported, there were very few like-minded
wrestling fans in her rural hometown. The
fan "club" in this instance consisted primarily
of Marilyn and Lavon, who met regularly to
carry on club business: documenting the
career of their "honorary" (as their wrestler of
choice was called), distributing membership

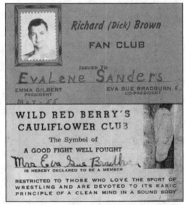

Figure 5.1 Fan club membership cards

and publicity materials, and initiating and responding to correspondence. The only assistance came from the honorary himself, who provided the pair with the membership materials and answers to fans' written queries. Though the members remained geographically isolated from each other, Marilyn and Lavon provided members with a sense of connection to a larger fan community.

The Bulletins

Figure 5.2 Fan club bulletin cover art

Like Marilyn Hanson's club for Lou Thesz, a number of fan clubs existed as informal networks, offering a membership card and perhaps access to addresses of other fans. But fan clubs are also communities, and as Duncombe points out, writing about zine culture, "A club needs a clubhouse."[9] At once public and private, individual and collective, the fan club bulletin became an arena in which fans had complete control over how they represented themselves, their interests and their perspectives on the world around them. As a publicly circulated document, it functioned as a public space, much like a public square where people could gather and converse. But because it was shared by a limited, self-selected membership, and typically read in the privacy of the home, in privately stolen moments at work or school, or in other places women fans might gather, the bulletin offered participants a safety no public arena could match. Within its pages, a member could freely express her interests and, by extension, her own identity and sense of self. The fan club bulletin represented a new performance space, beyond the margins of the wrestling magazines and outside the glare of the lights and cameras at ringside—and the glare of disgruntled family members at home.

The observations for much of this chapter are based on an analysis of Tom Burke's collection of sixteen fan club bulletins, edited by ten women and published between 1953 and 1961. The bulletins were largely printed on mimeograph or ditto machines of the sort readily available in schools, churches or neighborhood print shops. All save one were printed on letter-size paper and ran between six and thirty-six pages of content, printed on an average of twelve sheets of paper. Twelve was not an arbitrary number,

but rather was established for economic reasons: as Verna Powers' manual on mimeographed publications advised in 1964, mailing costs rose if one exceeded ten or twelve pages.[10] The bulletins examined here were evenly divided between those at or below twelve pages, and those above it.

Geographically speaking, the bulletins were spread across the United States, though none originated from the large urban centers (New York, Chicago or Los Angeles) in which the major network television wrestling programs were based. Instead, the bulletins came from California, Kansas, Missouri, Ohio, Pennsylvania, New York State, and Washington, DC. And while some were centered in or near cities with strong wrestling promotions—San Francisco, Pittsburgh, Columbus—many were situated in small towns, such as Marietta, Ohio, or Saratoga Springs, New York. It is likely that these women's geographical isolation spurred their interest in founding a fan club bulletin and reaching out to establish an interconnected network of fans.

Despite their geographical diversity, the bulletins' content revealed marked similarities. Many featured elaborate cover art and drawings, for example. One issue of the *Flying Tacklers* sported a birthday cake on the cover, printed in three colors; another, the *Sonora Flash*, had a cleverly screened logo (see Figure 5.2). The bulletins often contained individual copies of snapshots or wallet-sized black-and-white photos. A few included postage-stamp facsimiles of the photo of a wrestler. Every bulletin displayed an impressive array of creative photography and graphics, probably leveraging limited resources to every advantage.

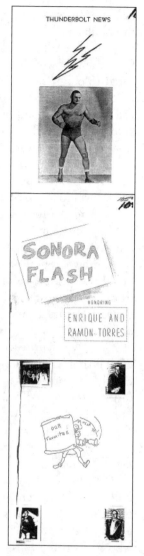

Figure 5.2—*(continued)*

Publicity and Identity

On the face of it, the purpose of the fan club bulletin was clear: to promote the careers of the featured wrestlers or honoraries. In so doing, club members would also achieve their second goal: to further the prosperity of wrestling as a whole. Diane Devine, the editor of the Red McKim International Fan Club bulletin *Look for a Star*, stated explicitly in her opening column: "I feel that any real wrestling fan should belong to a fan club

because this way he can support his favorite wrestler and also help the sport in popularity."[11]

Another editor took this notion a step further, devoting her efforts to the betterment of wrestling as a whole. She wrote in 1953 that her club was "dedicated to publicizing ALL WRESTLERS. [The club's] main and ONLY PURPOSE is to see that good publicity and promotion is made available through this medium on all wrestlers—and thereby circulated coast-to-coast and abroad."[12] Thus the articulated goal of many fan clubs was a quasi–public relations effort, the rewards of which were shared by the fans.

While this effort to perpetuate and strengthen the institution of wrestling was an oft-stated objective, and one from which fans themselves clearly benefited, I would argue that it was not, in fact, the main purpose of the organization. Instead, the most important function was establishing the collective identity of the membership itself, as a fan community and as a women's community. Writing about fans of *Star Trek*, Henry Jenkins argues, "These fans often draw strength and courage from their ability to identify themselves as members of a group of other fans who shared common interests and confronted common problems. To speak as a fan is . . . to speak from a position of collective identity, to forge an alliance with a community of others in defense of tastes which, as a result, cannot be read as totally aberrant or idiosyncratic."[13] Women with a taste for professional wrestling in the 1950s had to defend their interests (and still do today); speaking as a member of a group is clearly advantageous in that regard. Indeed, I would push Jenkins' claim even further; in the 1950s, it was important to establish a collective identity not only as fans, but as women. For as Duncombe argues, *participants* in a culture are afforded an opportunity to move beyond the circumstances into which they were born and assemble an identity "that they believe represents *who they really are.*"[14]

Women took pains to establish the communal nature of the club and the bulletin. Editors were always careful to highlight this aspect of their efforts, regularly making reference to "our" club and "our" bulletin. In one instance, the editor of the Roland Meeker Fan Club made a point of correcting a member who had written in to say she was "very proud to be a member of your club." The editor responded: "Many thanks to you also Maurine and we are proud to have you for a member, but it is not my club, it is OUR club."[15]

In nearly every issue, bulletin editors encouraged members to contribute to the publication in whatever manner they felt appropriate. The editor of the Art Michalik Fan Club urged members, "Try your hand at writing articles, poems, or anything pertaining to Art or his activities, you are welcome to do so. Remember, this is YOUR club."[16] This oft-repeated request not only provided the editor with a flow of new material, but also insured that the interests expressed in the publication were being defined by the entire community, not solely by the editor.

Interestingly, editors were also careful to extend communal ownership to the wrestler or honorary who was the ostensible focus of the bulletin. For instance, in a typical request to members to submit written material, the editor of the *Count Billy Varga Fan Club* urged club members: "Any new suggestions or ideas toward the interest of the club, poems or news items on our Honorary or news on wrestling in general that you may have, please do send them in . . . to make our bulletin one of the best out."[17] Consistent references to a wrestler as "our honorary," or even more commonly, "our boy," reminded the membership of their shared, proprietary interest (see Figure 5.3), reinforcing the communal ties binding the membership.

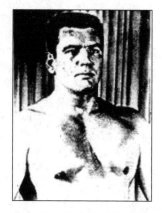

Figure 5.3 Big Bill Miller, "Our Boy Bill"

Club bulletin editors worked to establish and strengthen community bonds in other ways. Bulletin editors regularly published the names and hometowns of new members who had joined, and some featured a "pen pals" section in an effort to extend the bonds of membership beyond the pages of the bulletin. One club editor urged her exiting members to "write to the pen pals those of you who want pen pals and *get to know the new members*."[18] In reminding members of their responsibility to reach out and draw new participants into the club, this editor, like the others above, worked to stimulate individual member involvement in the group, and in doing so, to confirm the bulletin as a public space for its membership's use.

"Public" Voices

Bulletin editors may have found that encouraging women fans to speak up and participate was something of a challenge. In the postwar era, despite inroads in some areas, women generally were discouraged from participating in traditional public spheres of influence, such as governmental or business settings.[19] Many had little or no experience speaking out in public; even in the safe space of the fan club bulletin, finding one's "public" voice could be intimidating.

As it turns out, the semi-private, semi-public nature of the fan club bulletin was an advantage in overcoming this problem. Duncombe describes zines as a balance of expressly personal communications contained in a medium of participatory and community-oriented discourse.[20] This personal aspect of communication—which has long had a home in women's oral communication strategies—functioned particularly well for fan club bulletins. Women established communal bonds through the familiar forms of speech they used in the pages of the bulletins, drawing on and applying women's oral cultural practices to their written work.

In particular, they practiced what many have described as "gossip."[21] Deborah Jones describes gossip as a language of intimacy that emerged out of women's solidarity as "members of a social group with a pool of common experience." She describes the formal properties of gossip as "intimate conversations," characterized by the "rising inflection, sometimes accompanying a tag question, [and] the implicit reference to common knowledge, common values."[22]

The style of writing used by writers in the bulletins was personal and conversational, inclusive of group members, written so as to invite response from the readership. It was as if readers and writers were part of a circle of conversation, though in a written form.[23] While the conversation in each instance was dominated by the bulletin editor, whose voice comprised about 70 percent of the written material on average, the dominant writing style in the bulletins was what I would call dialogic in nature.

This dialogical style of writing took two forms: writers would directly engage with individuals within the club, or they would address group members as a whole. For instance, fan club editors would regularly invoke the names of individuals in the group, asking specific members to provide written bulletin materials for upcoming issues or praising particular members for their efforts. An illustration of both sorts of dialogue appeared in the *Flash*, the bulletin for the Johnny Barend Fan Club, in the opening column written by editor Betty LaPoint:

> A thanx goes out to member Sandra Failing for asking about the pics. sale. Jean has the list for you Sandra. Also I'd like to thank Donna Orpin for her suggestions of colors for JOHNNY'S gift.

Later in the issue she expressed her desire to print a guest feature in a future edition on wrestler "Whipper" Billy Watson, writing an aside to a fellow fan club editor: "How about it Evelyn, would you or Betty write me a story on him?"[24] In both instances the writer adopted a conversational tone, creating the impression of an intimate level of conversation among a circle of friends, all of whom are on a first-name basis.

Writers also often took on a conversational tone when writing news-oriented articles or comments to the membership as a whole. Editors in particular often addressed their readership in the second person singular, as if speaking individually with each reader, as well as inclusively to the entire group. In one instance, the editor of *Wrestling Publicity Ink* urged her membership to send in not only their subscriptions but their comments and criticisms as well, imploring: "DO IT NOW. . . . tomorrow you may not find the time—and time is important to you and I, now isn't it?" The editor of the *Kansas Flash* began her column by musing: "I hope this one will give you a few minutes of pleasant reading," adding how pleased she was "to say 'hello' to each and every one of you." Later in the issue, a letter written by their honorary, wrestler Dick Brown, is published under the headline, "A letter to you from Richard."[25] In each instance, the editor adopted a tone that was both

personal and inclusive, addressing the words to each individual reader and to the group as a whole. These examples of what Jones calls "intimate conversations" used language to create a sense of belonging among members.

Consistent with Deborah Jones' argument, writers would regularly use a "rising inflection" in their writing, looking to the readership for affirmation of what they were communicating. In one example, the writer used a long string of question marks at the end of a series of items in her "Here and There" column:

Wrestling is "DIRTY" in Germany—women wrestlers clad in shorts only—wrestled in a tank of mud. ??????

In this instance, the columnist seeks affirmation of her own sense of dismay at this particular brand of wrestling. Later in the column, she describes another variation on the wrestling familiar to the group:

Kazue Miszono—a LADY REFEREE, in Tokyo, Japan. What a novelty [sic] that would be. Just wonder how she would make out with some of our "Mat Meanies" ??????[26]

Again, the rising inflection invites the readers to participate by imagining the encounter. In this case, the author poses a fascinating encounter, where the reader can compare her knowledge of wrestling's most despicable villains (or "Mat Meanies," as the women often described them) with her fantasy image of a female authority figure, meeting face-to-face in the ring.

Other writers used a similar style, completing their thoughts with "Okay?" or writing in an inclusive style that invited response or affirmation. Violet Smith, editor of *Flying Tacklers*, the Wilbur Snyder International Fan Club bulletin, invited such a response when she proclaimed, "There is no one more deserving than our Boy to wear that crown. What do you think, Members."[27] No doubt the statement yielded agreement from the entire readership.

In each of these examples, the writing worked to frame a public space by using a conversational style that bridges the public and private, simultaneously speaking to each individual at a personal level and to the membership as a whole. Writers drew on the familiar patterns of women's oral speech to create a sense of intimacy and community. At the same time, they used the power of the published form and the strength of the membership to forge a public space from which they could speak with authority.

Technology and Community Identity

One function, for women, of the wrestling fan club bulletin was to explore and define their identity *as* women, an area of contest in the postwar period. As I demonstrate below, through the pages of these bulletins, women articulated

their interests, fantasies and desires; demonstrated their roles as cultural histori-ans; and displayed their writing creativity and their capacity for working collec-tively towards a goal.

Women took pride in finding a public voice in the bulletins, but they also took pride in contributing to a publishing venture. Groups of women collabo-rated to publish these documents in their "spare" time; the appearance of another issue, filled with colorful artwork, photographs, poetry, history and commentary, spoke to their ability and ingenuity.

Photography is but one aspect of the bulletins worthy of mention. Most of the issues I examined included at least one, and often two or three, black-and-white photographs (see Figure 5.4).[28] Taken by club members or provided by the wrestlers, the photographs were taped to the pages of each copy of the bul-letin or carefully framed with corner inserts glued to the page. One issue com-pleted sans photography nonetheless stood as evidence of the ingenuity of its editors. The editor of the *Flash* apologized to her membership in her opening column for the lack of photographs in the current issue, explaining:

> One nite when we were printing the photo's, the printing mech ine [sic] started to smoke. . . . so we decided we'd better not print with it anymore. One of the wires must have been burning out. So you members will receive the FLASH without all the photo's, but I'm going to fix up a home-made printer and shall have photo's in the next issue.[29]

Though such ingenuity is not particularly surprising, her technical abilities prob-ably challenged dominant constructions of femininity in the 1950s, when women were socialized to believe that technological design or repair was a "man's job" (despite recent images of Rosie the Riveter to the contrary). This example—along with the artwork (color and black-and-white) adorning indi-vidual bulletins and the many photographs taken and reproduced by members of the club—presents a clear image of the female membership as creative, talented and resourceful. Thus, the fan club bulletin offered women an outlet for creative expression and appreciation outside the masculine sphere of influence.[30]

Women's use of technology is evident in the physical publication of the bulletins, on ditto or mimeograph presses. This technology was easily available to many women through their local schools and churches, the only public spaces accessible to them in the 1950s. Both institutions have traditionally allowed women public roles, albeit limited, because such roles were seen as an extension of their familial and maternal responsibilities and authority. While leadership at these institutions was typically male-dominated, day-to-day opera-tions—such as office work and the publication of newsletters and announce-ments—were often left to women. Consequently, for some women, creating a wrestling fan club bulletin simply involved an application of their prior techno-logical knowledge gained in other public spaces.[31]

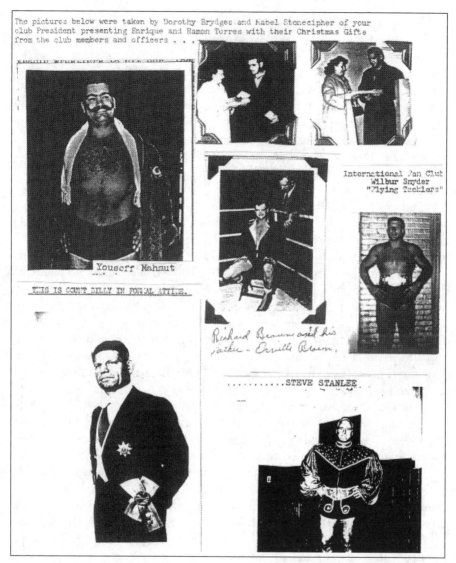

The pictures below were taken by Dorothy Brydges and Mabel Stonecipher of your club President presenting Enrique and Ramon Torres with their Christmas Gifts from the club members and officers . . .

Youseff Mahmut

THIS IS COUNT BILLY IN FORMAL ATTIRE.

International Fan Club
Wilbur Snyder
"Flying Tacklers"

Richard Brown and his father - Orville Brown.

.STEVE STANLEE . .

Figure 5.4 Fan Club Bulletin photo collage. Clockwise from top left: Youseff Mahmut; Vera Patterson with Enrique and Ramon Torres; Wilbur Snyder; Steve Stanlee; Count Billy Varga. Center: Richard Brown with his father, promoter Orville Brown.

The Influence of Newsletters

It is worthwhile to pause and consider the effect of the newsletter on fan club bulletins, which were likely influenced by other local or regionally produced newsletters, from church, school, civic and social organizations. Historically, limited circulation "news-letters" were popularized in the seventeenth century

in Europe. Written for wealthy subscribers by professional writers, the news-letter comprised a few handwritten sheets of localized information concerning business, diplomacy, politics and finance. After a period of relative inactivity, the newsletter form re-emerged in the United States in the twentieth century with the success of the *Whaley-Eaton Letter* in 1918, and the *Kiplinger Washington Letter* in 1921, which provided highly specialized political, regulatory and business information and predictions to diplomats, financiers and corporate lawyers.[32] Another publication form, "amateur papers," began as early as 1812. Quite distinct from the emerging professional press, the amateur press published poetry, prose, materials plagiarized from others, and much more. By 1875, nearly 500 such publications were in print.[33]

Perhaps the earliest fan club publications to emerge came out of science fiction (SF) fandom. Those interest groups had been in existence since the 1920s, formed to share and discuss science fiction stories, and in the 1930s, SF clubs began to produce what they called "fanzines" (more recently shortened to "zines"), with names like *The Comet, Cosmology, The Meteor* and *Scientific Magazine*. The largest and most successful fanzines were similar to celebrity magazines, including gossip regarding the professional SF magazines, information on popular authors, and news regarding forthcoming stories. Still other fanzines featured amateur writing, opinions of editors and contributors, and art.[34] In the mid-1970s, zines took another turn, as fans of punk music, itself ignored by mainstream music publications, began to create fanzines about their music and culture.[35]

The growth of zines, newsletters and amateur paper forms has been sparked by two factors. First, these publications filled a niche for specialty information unsatisfied by commercial media outlets and served a diversity of special-interest groups, both commercial and non-profit. Second, publication was made easier by the development and availability of a variety of duplication processes. The introduction of the gelatin-based "Novelty Toy Printing Press" in 1867 (which Paula Petrik argues greatly facilitated an already-emerging group of juvenile newspaper publishers), and the availability of liquid duplication ("ditto") and mimeograph systems in the twentieth century, made publishing a practical and affordable possibility for individuals and groups.[36]

By the early 1950s, *Business Week* estimated there were about 8,000 office equipment and supply stores in the United States, giving some indication of the availability of duplication machinery (like many other items, they were also available through mail order from the Sears catalog). Many local church and school systems in America had at least one duplicating machine, used for printing such things as school lunch menus, Sunday-service bulletins and the minutes of civic meetings. Another indication of the availability of duplicating machines comes from a 1955 symposium sponsored by the National Education Association for editors of local association newsletters. An article summarizing the results of the symposium suggested using the mimeograph machine assigned

to the high-school business department, also advising, "Your superintendent of your school board office may let you use their machine."[37]

Many instruction manuals on newsletter publishing appeared in the 1940s and 1950s, advocating the ease with which individuals and organizations could publish their own newsletters. Virginia Burke's *Newsletter Writing and Publishing: A Practical Guide*, published by the Teachers College of Columbia University in 1958, reads like a virtual textual analysis of many wrestling fan club bulletins, with her emphasis on "reporting news and other information, building morale, improving public relations" and distributing "personal" information. Burke argued that "a newsletter becomes a running record of the publishing group's accomplishments, current concerns, and future plans," an apt description of the work of many fan clubs.[38]

The ready availability of such information on starting publications, along with locally produced newsletters and bulletins, provided a strong model for the formal properties of the wrestling fan club bulletin. Further, the local availability of publishing machinery—through schools, churches and civic organizations staffed by women or by hire through local office supply stores—made possible the outpouring of women's fan publications.

Expressing Desire

Semi-public, semi-private, the fan club bulletin was the perfect venue for women to give voice to their desires and passions without fear of recrimination by the disapproving men (or women) in their lives. Unlike the contested spaces discussed in previous chapters—the wrestling arena, the pages of the wrestling press, and the family room where the television was located—the fan club bulletin was controlled entirely by fans themselves. Women had much greater latitude to express their interests and to create an image of self quite different from those publicly circulating. In point of fact, the wrestling fan club bulletin represented an opportunity for some women to entirely rewrite both their wrestling interests and their sense of self.

First, the fan club bulletin allowed women to articulate a sense of pleasure that was largely absent from public representations of commercial wrestling. Women writers described at length the appearance of wrestlers they favored. Writer Ellen Hunt characterized wrestler Seymour Koenig as:

A thrilling boy to watch. He is strong and well built, a perfect Mr. America example, but without the stiffness that often hampers the 'body-beautiful' model in active competition. Seymour is a clean wrestler, but is a bundle of unchained lightening [sic] when angered. . . . His movements are thrilling to see. Every move a study in muscular perfection. Truly this boy is poetry in motion, and one never tires of watching him. His favorite hold is a cobra twist which is double effective because of his terrific thigh development.[39]

Hunt's report goes beyond simple description. She judges both his physical attributes ("a perfect Mr. America example" with "terrific thigh development") and his ability to use his body fluidly and appealingly in the ring. Furthermore, her assessment subtly eroticizes Koenig through her description of her own reactions to his performance, which was "thrilling to see." Hunt's personalized portrait allows readers to step into her shoes and experience Koenig for themselves, in a manner that differs significantly from the perspective a TV announcer would offer.

Interestingly, this type of eroticized description was not used to characterize the honoraries themselves, as copies of the bulletins were sent to them. Such descriptions would have seemed inappropriate; besides, readers could create their own fantasies through the many photographs included in each issue. But *guest* wrestlers were fair game, and detailed assessments of them were a regular feature of the bulletins, as in this description of tag team members Joe Tangaro and Guy Brunetti (see Figure 5.5) by Violet Smith:

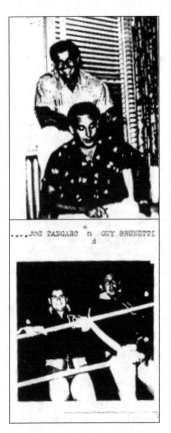

Personality personified is handsome, rugged Joe Tangaro, a marvelous master of the mat. Joe was born July 21, 1927 in Salt Lake City Utah. He has developed into a supple six footer and weighs in at 230 pounds of muscle.

Joe and Guy made their initial appearance in the midwest and all hearts succumbed to their outstanding ability as wrestlers not to mention their charm and patience with the many fans that always await them before and after their matches. Joe and Guy are primarily clean and scientific, but should their opponents want to get rough, they can be twice as rough.[40]

Smith's prose allows fans to relish the "supple," "rugged" physicality of these wrestlers and to imagine their performances in the ring, as did Hunt's description; Smith, however, also offers readers the opportunity to encounter the wrestlers outside the ring, to experience their "charm." When she claims that "all hearts succumbed" to the wrestling pair during their trip to the Midwest, it seems as though she speaks from personal experience (elsewhere in the issue she describes her recent trip to Chicago). Whether true or not, she certainly offers readers the vicarious thrill of the experience.

Figure 5.5 Joe Tangaro & Guy Brunetti

Each of these testimonials, regular features of the bulletins I examined, are expressions of the pleasures women experienced when visually enjoying the bodies of the wrestlers, seeing bodies in motion in the ring, and encountering these men in person. They speak to the complex nature of gender construction in the 1950s, far different from the façade of female passivity and domesticity circulating elsewhere in the mass media, and demonstrate the wider power that women exercised in the articulation of female sexual pleasure.

The Lure of the Mat Meanies

If feminine attraction to wrestling's "babyfaces" (heroes) was considered risqué in some circles, then celebrating wrestling's villains ("heels") was positively over the top. Yet some women were clearly drawn to those rougher characters, even though their attraction violated the messages offered by the industry, which encouraged fans to side with the babyfaces and against the heels. Their desire also violated the norms of society at large, which in the 1950s was troubled by feminine passion for antiheroes, to say the least (think of Marlon Brando in The Wild One, or Elvis Presley gyrating on stage).

In the case of professional wrestling, some fans obviously preferred the mat meanies.[41] By emphasizing and finding pleasures not intended in the villainous performances, these women actively rewrote the industry's construction of these characters. Jenkins' work on fan communities is particularly useful here. Drawing on Michel de Certeau's concept of textual poaching, Jenkins suggests we look at "fans as readers who appropriate popular texts and reread them in a fashion that serves different interests."[42] Rebellious women fans found pleasure not in hating the villains, as the wrestling industry intended, but in appreciating them for their "rough" performances and rugged physiques. This subversion is not unique in women's relationships to mass culture, as the work of Seiter, Borchers, Kreutzner and Warth suggests. In their interviews with female fans of soap operas, they found a clear preference for the villainesses, in contradiction to the context of the shows. Women responded to the strength of the characters and to their ability to transgress traditional boundaries.[43]

Many of wrestling's most reviled characters in the ring acquired fan club followings outside the arena. Among the more hated "heels" that attracted female-led fan clubs during the 1950s included "Big" Bill Miller, Wild Red Berry, Freddie Blassie, Killer Kowalski, Hans Schmidt and Roy Shire. One club, simply adopting the name "Villains, Inc." claimed it had attracted members in eighteen states.[44]

The Miller Brothers Fan Club, run by Ellen Hunt and Joan Stuff, was dedicated in large part to promoting the wrestling career of "Big" Bill Miller (Figure 5.3), a wrestling heel in the ring and licensed veterinarian out of the ring. Though the club's bulletin, titled the Ringmaster, was the only bulletin of the

sixteen I examined that was dedicated to a villain, it was consistent with the other publications in both form and content. Co-editor Ellen Hunt, who freely admitted in her column to "being a gal who likes her wrestling rough," urged her club membership to "stick with Dr. Bill cause he's just so doggone wonderful and he loves you all so much. We've got the greatest guy in the world to work for, and that's why this is fast becoming the greatest club in the world." Later in the column, Hunt revealed a bit more of her passion for mat meanies when she alerted the readership to some "wonderful roughies":

> The Sheik is . . . one of the nicest fellas around though he is hardly a favorite of the majority of wrestling fans. Wild and unruly he may be, but exciting also. Handsome too, and very very charming.[45]

Interestingly, Hunt balanced both the industry's "preferred" reading of the Sheik's character with her own in this excerpt.[46] On one hand, she acknowledged the standard understanding of the Sheik as "wild and unruly," "hardly a favorite" among wrestling fans; on the other, she suggested that a minority of fans have found him to be an acquired taste. She pointed to his good looks and his charm as two of his better attributes, judging him "one of the nicest fellas around," which suggests that her experience extended beyond watching him perform in the ring. Hunt expertly balances the characteristics of the wrestler available in the text with her own reading, offering an intriguing evaluation for her reader's pleasure.

Celebrations of mat meanies were not limited to bulletins from fan clubs honoring wrestling's heels. Many bulletins devoted to babyfaces also offered readers discussions of wrestling's villainous characters. In her bulletin *Publicity for Favorites*, which focused in particular on the careers of June Byers and Leon Graham, editor Carol Holmes (see Figure 5.6) printed an extended account of her encounter with the Zebra Kid, arguing:

> I think the fans take unfair advantage of the fact that because he is a "villain" wrestler and a very good showman, that he isn't as sweet as the others. In most cases I've found that the so called "villains" have more of a personality and sense of humor than do the majority of scientific wrestlers. The Kid, indeed is one of the finest men outside the ring.[47]

Like Hunt, Holmes was careful to make a distinction between the Zebra Kid's on-stage and off-stage personas, drawing on both the "preferred" reading and her own. She noted, for instance, that he was a "villain" in the ring, apparently displaying many of the signs typical of the heel character. However, she gives only one oblique proof, citing his ability as a "showman," that is, his reliance on stage gimmickry more than the traditional athleticism of the scientific wrestler. By contrast, she characterizes the Kid as "one of the finest men" she knows,

indicating that he, like most heels, has preferable qualities of "personality" and a "sense of humor."

Some women remarked that even the so-called scientific wrestlers could muster up some rough-house tactics if needed, suggesting that they, too, might possess some of the exciting qualities of their villainous adversaries. In her description of Joe Tangaro and Guy Brunetti described above, editor Violet Smith reminded readers that "should their opponents want to get rough, they can be twice as rough."[48]

In each of these examples, women writers balance the generalized, negative understanding of heel wrestlers with their own more nuanced interpretation. Of course, as the writers cleverly note, the pleasure of despising the villain, a pleasure not limited to the wrestling genre of entertainment, remained; it is part of the pleasure wrestling affords its viewers, a pleasure all readers would understand. Acknowledging the "preferred" reading of these wrestlers—as unruly, as showmen, as "villains"—is a safe frame for the discussion, given the context of the 1950s, in which some readers might find women's unbridled celebration of wrestling's villains unseemly. A subtle preface tempers the tone just enough to let the ensuing contents pass.

And the bits that inevitably follow *are* delicious, flying in the face of the traditional meanings of these vile, despicable characters offered by the wrestling industry and demonstrating once again the gap that often lies between fan's interests and interpretations and those of the commercial establishment. At the same time, however, by making room for a variety of fan responses, these alternative readings allowed wrestling to flourish commercially.

This re-reading of male character in wrestling's meanies also reflects women's emergent understanding of female character in the 1950s, creating space for the type of powerful woman who can stand toe-to-toe with these unruly men and master their "charms." This is nothing less than a renegotiation of feminine desire, breaking away from the safe, sanctioned characteristics of femininity that suffocated many women in the 1950s. The wrestling bulletin, positioned safely between public and private space, was an ideal arena to voice these new constructions of feminine identity.

Setting the Record Straight

The act of speaking—of finding a public voice and using it to propose new ways of understanding femininity—is a fundamentally political act. Fan club bulletins showed readers that there were powerful alternative conceptualizations of what it meant to be a woman in the 1950s, and that many women were thinking along those new lines. While women such as Mary Hasley in Marietta or Joan Stuff in Mansfield, Ohio, may have felt physically and ideologically isolated, the bulletins proved that they were not. Indeed, there were women all over the country who shared their beliefs.

The women who wrote in fan club bulletins challenged social conventions in a variety of ways. While some clubs rewrote the meaning of the heel in wrestling, many more clubs sought to document the history of wrestling, at times challenging the stories the wrestling industry offered customers as historical record. Tracking the honorary's performance record was a major aspect of most fan club's activities; fourteen of the sixteen bulletins I examined featured results of their honoraries' matches, and some descriptions were quite elaborate. As wrestling in the 1950s was, by and large, still regionally organized, this is not too surprising. In addition to televised performances, matches were held throughout a promoter's region, and wrestlers traveled from region to region, working for various promoters for a fixed period of time. As a wrestler's popularity grew, whether because of television or the efforts of fan clubs, he or she would travel even more widely, making the task of tracking match results that much more challenging.

Tracking the performance record of a wrestler is not a benign activity. In some instances it is at odds with the interests of the commercial wrestling industry and its basis as a theatrical rather than strictly sporting endeavor. Promoters created an ongoing narrative by predetermining wrestling's winners and losers, and they based their decisions on how to best exploit the economic potential of a match with the highest gate receipts. For instance, a confrontation between two characters would be established first during a regionally broadcast television event, and then followed by a series of untelevised local appearances, at which the two would meet and "resolve" the conflict. Customers would have to attend in person to learn the resolution of the narrative, which was repeated for audiences at each local venue. Furthermore, some wrestlers might be known in one region as a heel and as a babyface in another. As a result it was not in the promoter's best interests to carefully document the results of each match, lest it spoil the potential drawing power of the next evening's performance.

Thus the historical tracking of a wrestler's performance by the women and men in these fan clubs at times worked against the commercial interests of the wrestling establishment, countering the "official" history offered by the industry with their own localized, detail-oriented, fan-observed history, what Michel Foucault calls "effective" history.[49] Fans were writing a different history of their honorary, one that at times turned up the discontinuities and contradictions of a theatrical performance industry that masqueraded as sport.

In one telling episode, the editor of *Flying Tacklers* described the confusion over whether their honorary still held the title:

On Oct. 30th in Des Moines Iowa, Wilbur and Verne Gagne wrestled, and Wilbur lost that match; they say he lost his title that night, but I received a letter today from our member in Wisc. who says Wilbur is still Champion, so it is a little confusing not knowing all the details. . . . I also heard that Wilbur and Gagne won the World Tag Team Championship from the Lisowski Brothers but still have not gotten all the details on that match either.

She follows with nearly a page of single-spaced results, tracking the performances of their honorary through five states.[50] Her report, based on accounts sent in from members around the region, demonstrates the incongruities of a performance genre in which a character can lose a title one night and still be announced as the champion the next—in which two performers can battle in one venue, only to appear as a team somewhere else.

As this example demonstrates, fans understood that the historical record they gathered did not always match the "official" truth promoters fed to them. This is likely why so many clubs took it upon themselves to document the results of their honoraries. This also represents another gap between the belief systems of the fans themselves and those of an outside organization purporting to serve them. There were clear differences in fan's interpretations of wrestling's meanies, in their understanding of wrestling's ongoing historical record, and in the construction of their own identities as women. Readers and writers were not blind to interpretive blanks in the social text, and there was plenty of evidence to suggest to them that their own reading was, in fact, the valid one.

Wrestling with Politics

Some writers went even further, using the opportunity of the bulletins to bring larger social and political issues to bear on the readership. Writers interjected political commentary in their columns, reminding fans that wrestling, like other aspects of people's lives, was touched by the larger workings of government and industry. In one instance, an author writing in her column "Chit Chat . . . By Ann" told the story of a chance encounter with wrestler Lord Leslie Carlton in Chicago. She began the story by noting:

> Can't help recalling an incident that happened last November right after the [1952] Presidential election. Everyone was saying that if the Republicans got into office we would all be standing in bread lines.
>
> The Republicans got in and on Wednesday we went to the matches—we were sitting in the "El" when who should get on but LORD CARLTON carrying his own suitcase. What a shock.

It's not yet clear whether the author is more shocked by running into Lord Carlton on the elevated train, or because he was taking public transportation, carrying his own luggage. Later the author directed Carlton to the stop for the Rainbo Arena and agreed to walk him there:

> We were walking along when I said that they said that when the Republicans got in office that hard times would be here, but I didn't think it would happen so fast. At first he didn't catch on but I said that the Republicans were just elected and already he was reduced to riding the "El." He has quite a sense of

humor and thought that it was funny. He explained that [his valet] Swamee and his car both were in Georgia.[51]

Ann later commented that politics was "a subject that [she knew] least about" and admitted to Carlton that she was too young to vote. Her pointed critique of the Republican Party and the feared consequences of its assumption of power was in no way diminished by her admission, however. Ann used her column, in part, to voice her uneasiness with the conservative direction the country was taking and the potentially devastating ramifications (bread lines) that would result. While her story is firmly positioned within the context of wrestling, the social consequence of the message is clear and demonstrates the political potential of the wrestling bulletin in the 1950s.

Nor was this an isolated incident. Bulletin editors in particular often used their columns as a "bully pulpit" from which to offer a range of socially oriented observations. The editor of *Look for a Star*, Diane Devine, offered up her views on race relations in America in her opening commentary in October 1960:

> There is one thing that wrestling allows which most sports disagree on and this is the fact that so many different races and nationalities are in professional wrestling. If more professional sports would allow this, I believe that it would help in a small way toward World Peace. As in pro wrestling, all wrestling fan clubs allow *all* people to join in. I don't believe many fans realize this fact and I wish it would be improved in all sports, especially in America.[52]

Devine took the opportunity to critique not only racist sports practices, but racist attitudes among her readership, whether they were club members or members of the larger wrestling community. And she quickly offered access to those with "disagreements or opinions," providing the opportunity for others to advocate their own views and positions. While Devine did not take the risk of speaking on behalf of the membership at large, she did avail herself of the activist role, contributing to the image of women as public activists. In so doing, she suggested that readers could influence the world around them and effect change in a range of ways to benefit others and themselves.

Conclusion

The 1950s was a changing time for women, particularly those who had tasted a measure of economic and social freedom during the war. Increasingly conservative codes of feminine behavior were being promoted, in public spaces from the press to the pulpit, and in the privacy of American homes. It is little wonder that professional wrestling held appeal for growing numbers of women in the postwar period, with the lure of attractive male bodies on display and the license to "act out" enjoyed by audience members. Still, whether acting

out in the public arena or at home in front of the television set, women still risked recrimination.

The fan club bulletin was one solution to that problem. The newsletter bridged the gap between the public sphere of live and televised wrestling, and the domestic sphere of women's lives. It functioned as a public space, where women could gather to speak openly about their interests and beliefs, creating a circle of conversation, discussion and debate. Yet as a restrictively circulating publication, it was read and enjoyed by a controlled circle of readers, in private, self-selected spaces. And the publication employed the conventions of private conversation with which many women were at ease, making the act of public speech more familiar and comfortable. In short, the wrestling fan club bulletin in the 1950s was a wonderfully executed mechanism for bridging the public and private worlds of its members.

The wrestling bulletin was also used to facilitate public discussion of a range of issues of significance to its readers. It allowed members to revel in their passion for wrestling and their interest in specific performers, which cannot be taken lightly in the context of the postwar era. The articulation of these sorts of pleasures actively challenges our commonly held notions of 1950s feminine behavior. Women were writing of their pleasures and desires, giving voice in public to a range of women-centered interests and passions. Women could objectify the male physique, turning the tables on men who commonly judged women in terms of their physical appearance. They were holding up wrestling's villains as objects of pleasure, to be enjoyed rather than reviled, thus challenging the wrestling industry by rewriting the meaning of these characters. And they were urging their members to challenge other social norms—such as those of race and ethnicity—in the practice of their daily lives.

Through it all, the underlying message offered by these fans rewrites the meaning of femininity as active, sexually assertive and in control. Women also became writers and publishers, photographers and printers, historians and critics, which also contributed to an evolving sense of identity. Women rewrote the history of wrestling, documenting the actions of the performers they enjoyed, examining the everyday activities of the industry for cracks and discontinuities in the story it told. And having rewritten the wrestling industry's narrative, they found they could also tackle other concerns, urging members to take more interest in social and political matters, such as racism in America.

While writers never spoke explicitly in such terms at the time, I am convinced that the wrestling bulletin stands as an important step for women in the 1950s, in terms of identifying who they were as women, who they could become, and what sorts of actions they could take to better their lives and the lives of those around them. While what I'm describing here is not an overtly political activity, it can be characterized as what historian Eric Hobsbawm

calls a "pre-political" movement, in which members are just beginning to discover the language that will lead to change, but have not yet dedicated themselves to the process of political change itself.[53] To my mind, the wrestling bulletin represents a fledgling step in the direction of feminism, a precursor to the larger debate over the status of women in society that would emerge full force a decade later.

CHAPTER SIX

Wrestling with Memory

We jumped up and down a lot, you know, which, we couldn't pound on the
ring there because it was too high. I mean, it was always . . . those guys'd get
thrown down there in your lap, you know? [*Laughs.*] "Carol's got to touch
him!" [*Laughs.*] That was funny! Gee whiz! I forgot that!
 —Carol Holmes Verdu[1]

There is an unmatched richness in Carol's voice and a glint in her eye as she
revisits memories of her days as a young wrestling fan in the 1950s. I knew from
the start that observations such as these would get at the heart of this project;
the question was how to locate them.

Members of the wrestling industry were comparatively easy to find, in part
because of their status as public figures. Some, such as Freddie Blassie, still
worked in the industry in supplementary roles; others had moved on to new
positions in the public eye, such as former announcer Bill Cardille, who has a
career as a meteorologist at WPXI-TV in Pittsburgh. And members of the fan
community had kept track of many of the wrestlers who had slipped from public
view into either retirement or quieter occupations.

But the task of locating wrestling fans active during the 1950s was consid-
erably more challenging. Turning to the commercial wrestling magazines, I
culled names and addresses of women who ran fan clubs in the 1950s, along
with the occasional pen-pal request, adding zip codes to the addresses as best I
could. Some women's listings contained no street address at all; only a name,
the town and state were supplied, a reminder of an earlier era when the post-
master knew every area resident. I included these entries in my mailing in a
romanticized hope that some regions of the country had retained that sense of

community. Unfortunately, none of those notices apparently reached their intended addressees.

The saga of the postcards—and the many fascinating if unanticipated replies I received—is in itself a worthy area of study.[2] Postal offices across the country have as many different ways of saying "Addressee Unknown" as I had cards returned. "Attempted—Not Known" was common, as was "Moved, Not Forwardable." More surprising were such replies as "Forward Order Expired"—which led me to wonder how recently the addressee had moved—and "No Mail Receptacle," which left me just wondering. Other replies produced a more bittersweet response, as in the card from Trenton, New Jersey, marked "Building Vacant/Sealed." The class implications of that entry were immediately apparent. Perhaps this woman had lived in a thriving neighborhood or at the edge of poverty; in the intervening years, her building and the area surrounding it had since declined.

Some current occupants were kind enough to jot notes on the card to help in my search for information. "Doesn't Live Here," was noted on one card; "No such person at this address," on another. Another card was less than kindly marked. Obscuring the original address, large scrawled letters read: "FIRED"; below that, "20 YEARS AGO." Could it be that this former employee had been operating the Adrian Baillargeon Fan Club out of her place of employment, using the company to finance her fan interests? If so, her 1955 activities probably continued undetected, as it was another twenty years before she was terminated. Perhaps some additional fan activities were underwritten by the Hackensack firm—and many others like it—in the ensuing years.

Of the 300 cards sent out, I received eight responses, a quite respectable return, especially when put into context. Current mail order businesses consider a 6 percent response from a mailing a successful return; achieving nearly half that from forty-year-old addresses is close to astounding.[3]

The foundation for this chapter rests principally on in-depth interviews with fourteen individuals, along with more informal communications with more than thirty others. Additionally, I draw upon contemporary recollections from published sources. I have tried wherever possible to avoid significantly editing the commentary of my respondents. I intentionally quote longer responses to give the reader a sense of who is speaking and what she is saying, through language, experience and perspective. I see the women and men who generously gave their time and memories as active contributors to this project, and I have tried to allow them to establish their own voices. Part of my aim in preparing this chapter, in fact, is to create a space wherein some of those who have largely been spoken of and for thus far can participate more directly in the writing of this history.

Watching on TV

Not surprisingly, many fans were first introduced to wrestling through the magic of television. Marilyn Hanson Nelson began watching wrestling on television

in western Iowa at the age of eighteen, beginning in 1948. Enthralled with the broadcasts, she soon began making regular trips to Omaha to see live events. She later started fan clubs for Lou Thesz, Verne Gagne and Pat O'Connor, which she ran for a number of years with her friend LaVon Tanner. For women like Marilyn who lived outside major cities, wrestling was very different from the typical entertainment available in their day-to-day environment:

> I guess it was just the fact that in Red Oak, Iowa, even the school systems had no sports in those days. They had boys' football, but that was it. There was no basketball. There were no sports for females. It [wrestling] was unusual. It was different. It, um, it was just fun to watch them. I just got interested and they had so many, oh, people like Gorgeous George and some of these old wrestlers that would put on such a wonderful show. It was just an interesting program to watch.[4]

Carol Holmes Verdu was also drawn to the stimulation she first saw on the screen. Like many I interviewed, she was first introduced to wrestling through television in 1949 or 1950 at the age of twelve and soon was attending matches every week with her parents in Columbus, Ohio.[5] Thinking back to what first attracted her to wrestling, Carol zeroed in on "the excitement of it from those [early broadcasts]. We first started watching it [broadcast] from New Jersey, and the excitement was something *fierce* from those matches up there, 'cause they really had some winners."[6]

Still, for some, balancing an interest in wrestling with the expectations of others was a challenge. Elizabeth Mackey's mother was a devoted wrestling fan living in New York City in the late 1950s.[7] Elizabeth described her mother as "lace-curtain Irish, prim and proper and *very concerned* with what the neighbors thought." Yet she also was an avid wrestling fan, and Elizabeth witnessed her "becoming thoroughly engaged by the action, reacting and interacting with the drama unfolding." Mrs. Mackey even attended several wrestling matches with an equally avid male neighbor. On the other hand, Elizabeth recalled, when her father was home on a wrestling night (he often worked nights), he didn't watch the broadcasts. From Elizabeth's description, it is apparent that her father did not share her mother's enthusiasm for the genre (at least not at first);[8] nevertheless, Saturday night wrestling was a fixture in their home from 1957 through at least 1961. That the wrestling broadcasts were a weekly event in her household suggests the importance the broadcasts held for her mother, who would have had to exercise considerable sway at home to insure her continued access to wrestling in the face of her husband's disinterest.

Getting Close

While watching on television offered viewers wrestling excitement on a regular basis, for many the broadcasts simply weren't enough. Carol, Marilyn, Elizabeth's

mother and many other women soon found their way to the wrestling arena to see the events in person. Lillian Beltz, her sister Barbara Serasto, and close friend Nancy Jacobs were all introduced to wrestling on television in their hometown of Pittsburgh, watching Chicago wrestling broadcasts on Wednesday and Saturday nights. But their love of wrestling crystallized at the local arena. Lillian Beltz remarked, "I think we just got caught up in the excitement of it. Just *being* there." Her friend Nancy agreed: "Yeah, I think that was the beginning of it."[9]

After watching wrestling on television with her mother in Houston in the 1950s, Delores Hall made the jump to seeing the show in person: "We'd just start going on Friday nights, Friday nights was rasslin' night. And, in Houston, as I say, everybody went to rasslin.'" Still, as an African-American woman, Hall's experience was significantly influenced by the racial policies in place in the 1950s:

> In those days, we were segregated. And I had to sit way up at the top. And the little Mexican boys could sit down lower. But they used to always try to get me to come down where they were. They'd say, "Oh, they'll never know! Come, you come sit with us." And I'd say, "Oh, no. . . ." But I did stay where I was supposed to be [*laughs*], and they came up *there*, where *I* was. But the only thing was I couldn't get close enough to see . . . too much.[10]

From Hall's vantage point, the wrestling arena in Houston was hierarchized by race, with white patrons—unmentioned in her description—seated at ringside, Mexican Americans situated in the lower balcony, and a section reserved for African Americans at the very back.

Still, Hall found that nothing quite matched the experience of seeing the event in person, despite the racist policies that relegated her to the worst seats in the house. As Hall told me repeatedly, she was strongly motivated by her desire to *see*: "I went, 'cause I wanted to *see* them, I wanted to meet—see them close up. And I was able to do that. That was my purpose for going . . . I mean the first time I went, I was just in awe, I was: 'Oh my God, there they are!' In real life!"

This motivation was also what drove her to wait at the stage door for the wrestlers to exit: "I found out that, if you stay, if you wait around, afterwards, when they come out, you can meet them. I didn't want to meet them; I just wanted to see them up close. That was my thing, I just want see them up close."[11] Attending wrestling matches afforded Hall the proximity she desired, and a way of seeing unavailable to the television viewer.

This ability to get close to both the action and the performers was a recurring element throughout my discussions. When I told Marilyn Nelson of the videotape I'd seen of the group of nine women in Hollywood eyeing Leo Garibaldi from the front row (discussed in chapter 2), she quickly nodded in affirmation, saying: "You bet, getting just as close as possible." She then confirmed her

interpretation of the scene I had described for her with experiential evidence, adding: "Of course I did, too."[12]

Many women attended the show with other women, either in pairs or larger groups. Marilyn Nelson noted that large groups of women regularly sat together when she and her girlfriend LaVon attended matches in Omaha, observing, "There'd be a section of a whole bunch of, it looked like a whole bunch of females that had come together."[13] The presence of clusters of women at the arena may well have made the otherwise imposing athletic venue appear more inviting to first-time female attendees.

Wrestler Red Bastien was no stranger to women in the arena. Beginning his career wrestling in taverns in the "skid row" area of Minneapolis, Bastien wrestled the carnival circuit before getting his break in 1949, appearing on a televised wrestling program for promoter Jack Guy. He has since wrestled throughout the world, holding various solo and tag team titles, before retiring from the ring in 1980.[14] Bastien speculated that wrestling may have become a gathering spot for women in the community: "I guess that might be just like 'ladies night out' or something, you know, to get a bunch of girls together and go to the wrestling matches."

But from Bastien's perspective, the venues that originated the weekly television broadcasts, such as the Marigold Arena in Chicago, held a special attraction for women:

> When television was still quite young, to get more to the point of the ladies thing, I think that's where really they really started becoming fans then. It became more acceptable. You know, instead of just saying well they're going down to some arena to watch wrestling, they were saying, well, "We're going to the Marigold Arena." And it became an "in thing." And the stigma that was attached to wrestling wasn't so bad at that time and so it was kind of fashionable to be seen on television down at the arena.[15]

From Bastien's perspective, women could attend wrestling not simply for the enjoyment of seeing the performance, but also for the pleasure of *being seen*—by the cameras and by viewers at home. Women didn't have to perform; simply being seen in attendance at the event was enough.

Even for matches that were televised, Delores Hall found that attending in person afforded her an additional pleasure she could capitalize on when she returned home, by sharing the insider information she had gathered. Following the performance, Hall compared her experiences with her mother, also an avid fan, who had seen the mediated version at home on television:

> I would come home, and tell my mother *everything*. She had to sit up and listen to the news. I said, [*in a small breathy voice*] "Mom, guess what? And then . . . Did you see when such-and-such a person did this? Did you see

when so-and-so hit so-and-so?" She says, [*in an authoritative voice*] "Yes, Delores, I *saw* it. I saw it." And then, um, they don't, they didn't show all of it on TV, but there were some matches that didn't come, they'd had before the main event. And, 'cause they want you to *come* to it too, you know, and you couldn't see it. So I would mostly tell her about those. She would sit up and listen to me.[16]

Attending the matches in person afforded Hall a viewpoint of the proceedings unavailable to the broadcast audience, though she still compared what she had witnessed personally with the view from her mother's perspective, to corroborate her experience. Delores could use her insider knowledge to insure a rapt audience from her mother, who awaited a full description of the proceedings. In this way, Hall was assured the best of both worlds, having fully seen and experienced the live event and its participants (both during and after the performance), while comparing her view with the mediated experience reported by her mother. For both Hall and her mother, the real pleasure was in *seeing*.

Hero Worship

For some of my respondents introduced to the entertainment genre in their early and middle teenage years, wrestling allowed them to indulge in a form of what some described as "hero worship." Tom Burke's earliest wrestling recollections date back to 1956, when at the age of ten he watched Fred Kohler's *Wrestling from Chicago* with his father from their home in Springfield, Massachusetts. By age thirteen, Tom had begun attending live shows and soon started his first fan club. Unlike my other respondents, Tom is still pursuing his interest in wrestling, as a collector, historian and active fan.

As an adolescent, Burke was much less interested in sports than his father. Still, wrestling held an appeal unmatched by other athletic endeavors:

Tom Burke: Back then I was so enthralled with wrestling, and so hypnotized by it, really. It was a draw.

Author: What was the draw?

Burke: I think a combination of things. Personalities, the controlled violence, the hero worship, you know? I remember one tag team match—Mr. Hito and Mr. Moto were wrestling two "carpenters,"[17] and they totally destroyed 'em. Then they went out, and they undid the canvas, and they rolled both of 'em up, and started jumping on them, and doing kicks and everything. And Mark Lewin and Don Curtis came running out of the wings, and that set up the angle for the feud. It was so great! It was just outstanding

stuff, you know, and the people used to just eat it up! Stuff like
that—it's just great stuff.

Author: Who were your heroes?

Burke: At that time Pat O'Connor, I liked all the babyfaces, all the good
guys. And as the years progressed, I changed. I liked all the bad
guys! You know? And today, it's a combination of both.[18]

Nancy Jacobs also recognized that her initial attraction to wrestling, in par-
ticular to wrestler Don Eagle, was nothing less than adolescent hero worship. In
describing her feelings during the 1950s, it was easiest for her to explain by
making analogies to fan responses to stars of similar stature: "I was fascinated
with [Don Eagle]. I was 17 or 18, I was still in high school, so I was fascinated.
This was hero worship, this was, y' know, this was the Bruce Springsteen thing
or the Beatles thing."[19]

Carol Verdu also used the term "hero worship" to characterize her initial
adolescent fandom. However, in Carol's case, she learned as she got older that
the dynamic between wrestlers and fans could undergo significant change:

Some of the girls from high school ran around with me and we used to just go
hang out wherever the wrestlers were, to get autographs, and talk to them, and
whatever. We were probably freshmen in high school then, or sophomores,
something like that. Stand outside [promoter] Al Haft's office downtown and
watch for them to go in and out and run and get autographs. Course I don't
think some of them appreciated that, but some of them didn't care. Some of
the nicer guys didn't care. And we were kids, so they were very nice to us, and
they were real gentlemen. They'd carry on conversations with us, you know. It
was real *hero* worship. Then we got older. [*Laughs.*] And then we got . . ."Uh
oh, better watch out!" [*Laughs.*] Better watch out.[20]

Like Nancy Jacobs and Tom Burke, Verdu initially idolized some of the per-
formers she experienced as a teenage wrestling fan. Though Verdu characterized
her original view of the wrestlers in the Columbus area as "hero worship," her
relationship with the performers became increasingly complicated as she and
her friends matured, an experience shared by many female fans.

Carte Blanche

Wrestling held a variety of appeals for its female audience members. Red
Bastien recalled that wrestling offered women license to let loose, which he
observed from his vantage point in the ring: "We saw a lot of that, of course.
They just went ahead and it seemed like they had carte blanche to go ahead
and holler and scream and do whatever they wanted to do."[21]

Delores Hall suggested that wrestling represented an opportunity to indulge her "excitable" side, despite the fact that she was otherwise a shy and retiring girl:

> I've never understood *why* . . . we're like that, people are like that. I just . . . You can take the most timid little girl and she'd be something like: [*in a wispy voice*] "Kill 'im, kill him!" [*Laughs.*] I used to enjoy it though. I screamed to the top of my lungs! [*Laughs.*] Ah, yes. 'Cause I love to scream, or get excited about it. Actually I'm very excitable, really, I get excited. I'm enjoyin' things. [*Repeats happily in a soft voice*] "Kill 'im!"[22]

Wrestling possessed transformative powers as far as Hall was concerned, allowing her to step outside of her normally "timid" persona and try on a more active, empowered role.

Carol Verdu also enjoyed yelling at wrestling matches, though she suggested that women could turn the screaming itself into a competition. Verdu recalled engaging in playful yelling contests with other women in the front rows: "I can remember yelling, trying to out-yell people. Some of those women who were in the front row yelling, or those ladies running up the aisle, y' know. I can remember doing that. But we just, it was just something we did."[23] In each case women in the crowd seemed to garner as much enjoyment from sharing the experience with other women as they did experiencing the event itself.

Of course there were also battles among patrons as well, as Lillian Beltz reminded me: "And even people in the audience would get into little ruckuses about, you know, if you cheered for the wrong person."[24] This suggested that at times the screaming would turn seriously competitive, with potentially violent results. Carol Verdu recalled one incident between fans that ended in a battle:

> I can remember one night at Memorial Hall, though, there was a brawl between the fans over something that was going on in the wrestling match. This one girlfriend of mine ended up with her neck all out of [*laughs*] out of joint and everything else. It started because these two girls were for the one guy and this other lady was for another guy, whoever the opponent was, and this one gal got, got really slammed down. . . . She got the worst of it, by this lady that had the nail file.[25]

These incidents serve as a reminder that the wrestling match was not a utopian expression of gendered solidarity. It was a complex and at times conflicted set of performances and relations, between audience members and wrestlers, and between fans and other fans. Caught up in the moment, fans easily suspended their disbelief of wrestling as a performance of sport, fighting in earnest defense of their allegiances. These examples also speak to the many fans who aligned

themselves with wrestling's heels or villains, reading against the grain of the performance, and at times incurring the wrath of other fans.

The Crazy Lady in the Crowd

The image of a woman with a nail file was intrinsic to wrestling in the 1950s, and each of the men I spoke with who worked in the industry had a story to tell, for the usual target of a woman's ire at the wrestling arena was not another fan, but a wrestler in the ring. Describing the crowds he encountered during the 1950s, Bastien remembered: "Some people, some places they'd just get rowdy as heck, you know, ladies too, and everything. I'm sure you always heard the story about Hatpin Mary. The ladies could become quite violent at times."[26] For Bastien, invoking Hatpin Mary was easy shorthand for the physical response wrestlers sometimes experienced from women surrounding the ring.

Wrestler Ted Lewin was also very familiar with the Hatpin Mary kind of character. One of three wrestling brothers in the family, Lewin began his career as a wrestler in 1952 with Al Haft's organization in Columbus, Ohio, wrestling for fifteen years in the Midwest, Texas, Louisiana and throughout the Northeast before fully committing to a career as an artist and illustrator.[27] Lewin pointed to the role television played in publicizing—and encouraging—the physical antics of some female fans:

> On television you wondered if they didn't go bananas because they become then part of what happened on television. They would always focus on some crazy old lady who would go up there and pull somebody's tights, or . . . You remember Hatpin Mary, of course. There were imitations of her all over the place. And these people got sort of involved *physically* in the whole thing, and then the wrestlers a lot of times would use them, you know, they'd pick them out and they'd use them and work on that particular person solely. They'd get that person so crazy they'd come up *screaming* at ringside, and that would get everybody else screaming, and you know, kind of use them as part of it. And a lot of times I think they enjoyed that celebrity that they got from that. But my earliest recollections were that there were *always* at least one or two old ladies like that. They used to be *so funny* because they would get so *really, legitimately,* so angry that they couldn't sit in their seat. They'd have to get up and go up and either tell them off, or physically try to grab a hold of them, or *something.* Those I can always remember.[28]

Like Bastien, Lewin used the image of Hatpin Mary as an easy means of communicating his past experiences. Of course, wrestlers also use these women to agitate the crowd and generate additional audience fervor or "heat" in their matches. Still, there was an underlying danger in doing so, as Lewin's remarks

suggest, for the "legitimate" anger that resulted often led to unpredictable, and uncontrolled, physical reactions.

Bill Cardille was very familiar with the Hatpin Mary characters frequenting wrestling arenas and television studios, though he rarely was victimized by them. Beginning his broadcasting career fresh out of college in 1952 at WICU in Erie, Pennsylvania, Cardille announced televised wrestling matches (along with many other programs) through the 1970s in Pittsburgh, though his services were used in Chicago, New York, and many other eastern cities. Cardille remains a fixture of Pittsburgh television as meteorologist for WPXI-TV.

In Pittsburgh, Ann Buckalew, a local woman who used to walk to the television station with a few other ladies to attend weekly wrestling broadcasts, played the role of Hatpin Mary. Ann was better known to Pittsburgh audiences as "Ringside Rosie," a name entirely appropriate to the historical period just passed, as Cardille explained:

> With Rosie, she actually *was* Rosie the Riveter. I mean, she actually worked in a forging plant somewhere on the north side and she riveted. That was what she did. But, she had lost her husband, and she had a son who was her whole life, and Rosie was one of the nicest people going. However, ah, she was a character on camera. She'd come up with her purse and [when] a wrestler would come over the corner, she hit him.

While there were other women competing for the attention of the wrestlers, television cameras and the crowd in the Pittsburgh area, Ann was by far the best known:

> There were a lot of Ringside Rosies. I mean, there were about four or five and they used to try to upstage each other. I don't remember any males that carried on like the women. I remember Rosie using her umbrella, and it went over pretty good. She always carried an umbrella and she'd shake it, y' know, and she'd shake her fist and she'd shake her purse and then the camera would pick her up.[29]

In Cardille's description, the television camera looms large again, suggesting the role the camera played in conveying the image of the physically active female fan to the television audience, eclipsing the presence of their male counterparts in attendance. No doubt the presence of television cameras encouraged many Ringside Rosies to step into the role and achieve notoriety in the process.

Though Cardille describes a spirited competition between these women acting out at ringside, another explanation is also possible. In addition to competitive drive, their actions also demonstrate camaraderie between them. Each of their individual actions at ringside, demonstrating their emboldened agency and authority, created a space for other women's performances as well, making

such actions safe. Because there were multiple Ringside Rosies, no individual performer could be contained.

It is not surprising that individualized characters such as Ringside Rosie and Hatpin Mary remain prominent in the memories of wrestlers. For as Cardille pointed out, such women were not among the wrestler's favorites: "A lot of people think that Ringside Rosie was a plant. She was none of these; the wrestlers did not like Ringside Rosie because they, she took the play away from them. . . . The wrestlers didn't really like her to be around. She took a pin a couple times and jabbed them with it—it was no act with her."[30] While such women were useful to wrestlers in generating heat, they were just as able to shift the spotlight away from the men in the ring, taking the "play" away from them, in many senses of the word. Beyond the shift in attention, some women posed a potential physical threat to the wrestlers. Thus it is not surprising that images of individuals such as Ann "Rosie" Buckalew and Hatpin Mary, and the many women like them, remain vivid in the memories of these wrestlers and industry workers. These women not only knew of wrestling's performative character, they also recognized the potential for carving out their own role and succeeded in inserting themselves into the act. It was yet another expression of power women were able to publicly exercise in the postwar era.

Gender Battles

The Ringside Rosie character remained a very specialized type of performance, engaged in by a select few women in the crowd. Another type of gendered battle took place farther from ringside, between the women who attended wrestling and the men they may have left behind at home (or who were sitting next to them). As some of my respondents recalled, wrestling represented a welcome reversal in the battle over gender roles waged in the domestic sphere. For Carol Verdu, the subject evolved from a memory she had about a favorite tag team of hers:

It's like, I don't know, there was Jay Tangaro that was so nice. He was so good-looking. And this other guy, Guy [Brunetti], those guys were always a tag team, and they were always so nice to everybody, and just, they loved the ladies, you know. And I think that's what a lot of the women were looking for, just that attention they weren't getting at home. Go to the wrestling matches and these guys'd smile at you and talk to you and, treat you like you're human instead of like some husbands did.[31]

Similar memories emerged in my discussion with Nancy Jacobs and Lillian Beltz, as well as with Lillian's sister, Barbara Serasto, another longtime wrestling fan, and her husband Tom. Towards the end of our conversation, their recollections of the relations between men and women were even more pointed.

Wrestling, for them, provided an alternative to what they saw as the deteriorating gender relations that followed World War II.

Lillian Beltz: I think it's just that there was nothing else [available]. They didn't . . . Today we have a lot more soap operas, or women are more into their soaps, and ah, there are just more places to go, more things to do.

Tom Serasto: Yeah, women, I mean they're independent. They got good jobs.

Nancy Jacobs: I can almost say that there was no explicitness in the '40s and the '50s on TV. So here's this, here's not only an outlet where, ah, "Mary" fought with "John" all day about his drinking beer, and she was really upset. Now she couldn't holler at him, because he'd walk out or belt her across the mouth, because women were more subject to men at that point. So here she could go to the wrestling match, she could see somebody, the direct opposite of her beer-drinking husband with his belly hanging over, she could see this really handsome athlete, she could probably touch him if she wanted to, and she could yell and scream . . .

Barbara Serasto: . . . at the bad guy.

Nancy Jacobs: Yeah. And they could fantasize. . . . But I really think that had a lot to do, because maybe, and I didn't think of the liberation because of the jobs and that, but I was thinking of the woman being more subservient to the man at that time.[32]

Lillian Beltz pointed out that wrestling seemed unique compared with other entertainment genres; there just "wasn't anything else" like wrestling available to women at the time. For Nancy Jacobs, echoing Carol Verdu's comments above, wrestling represented the antithesis of what marriage—and the role offered to women at the time—epitomized for her at the time: confinement, subservience, subjugation and silence. Unlike the familial context, where protest could be met with abandonment or domestic violence, wrestling freed women to verbalize, to protest, to express and indulge their desires both verbally and physically. For Nancy Jacobs, the wrestling arena represented the feminine equivalent of the masculinized local bar, where women could gather, socialize and indulge in shared pleasures. Perhaps, Jacobs mused, the woman in question might take "her beer-drinking husband" along with her. Were that the case, he might have been subjected, at least indirectly, to a sort of feminine behavior not thought possible in the domestic context, watching women's active desires and protestations finding free expression.

This sentiment was echoed by Bill Cardille, who suggested that the wrestling arena was a space ripe for gendered conflict:

> The women would bring their husbands. And right away you'd have conflict—good against bad. The husband would be mad 'cause he didn't want to be there. The woman, he'd say, "What's she see in this guy?" Y' know. So you always had a vociferous crowd, that was for sure.[33]

Cardille's observations illustrate the gender conflict that would emerge when women brought unwilling spouses to the matches, a terrain dominated by women. For Bill Cardille and women such as Nancy Jacobs and Carol Verdu, wrestling represented in some manner an articulation of the gendered conflict and the behind-the-scene struggle over definitions of femininity, masculinity and domesticated familial roles in the 1950s.

Fantastic Bods

A persistent theme throughout this book has been the pleasure of bodies, access to which was one of the clear attractions wrestling held for most women and men. From his vantage as television producer of *Wrestling from the Olympic Auditorium*, originating on KTLA-TV in the mid-1950s and syndicated to stations across the country, Los Angeles promoter Mike LeBell could observe the loyal women who attended his matches each week. He succinctly concluded that women were attracted "if a wrestler was good-looking or had a good build. Men, on the other hand, would fantasize about them—men would want to 'be' a particular wrestler, whereas women were attracted to them."[34]

Wrestler Bob Orton Sr. summed it up nicely: "For two men in a pair of tights to get out there with great bodies and just go against each other, it just really attracts people." Orton grew up in a tough area near Kansas City, then home to one of the best wrestling promotions in the country. For him, the initial appeal of wrestling was in some ways similar as for many others in the audience: "I thought, 'Oh, my god,' you know, these guys. Look at them, great bodies, big strong powerful men, assertive. Driving big new cars and they get to travel and see the sold-out house every week, y' know, the money, and I said, 'God, that's what I want to do.'"[35] Orton confirms LeBell's theory that men idealized wrestlers and fantasized about standing in their shoes. Orton turned fantasy into reality, achieving his goal of becoming a wrestler and attracting many capacity crowds across the country in his thirty-year wrestling career.

Bill Cardille was also well aware of the physical appeal many wrestlers had: "A lot of those guys weren't big fat slobs. I mean they were very well built, they were good talkers, and they were active, and I can see in some of the cases where women liked the muscles."[36] In each of these accounts, the attractive

body of the male performer offers the most satisfactory explanation for the appeal of wrestling for women.

The phenomenon of male bodies on display is by now a common encounter, as in advertising for underwear, perfume and the like. Yet it wasn't always thus, particularly in the postwar era. Body-builder Eugene Sandow was one of the earliest performers to construct the public display of the male body specifically for the pleasure of looking by female audiences. Dutton points out that Sandow's frequent "ladies-only" shows at the start of the twentieth century "first established the unclad male figure as an object of public female scrutiny."[37] For years, women have objectified film and music stars in much the same way, though their performances are much less explicit in their overall presentation. In her study of the Chippendale revue and female audiences, Clarissa Smith usefully describes the evolution of a representational vocabulary of exhibition of the male body, encompassing theatrical, music video and striptease forms. [38] As a performance of sport, wrestling offered women an invitation to view and take pleasure in male bodies, an opportunity unavailable in other venues. And through the enactment of the wrestling performance, audiences were offered a performance of maleness—of bulging muscles, sweaty torsos and the clash of bodies—created for the increasingly female-dominated audience.

Each of the women I interviewed in depth brought up the attractiveness of the wrestlers' bodies in explaining the appeal of wrestling for women fans at the time. Marilyn Nelson suggested:

> I don't think there's any doubt but what these girls were attracted by these fantastic bods. You know? I mean, let's face it, they were good-looking guys. Well built and, and they didn't have, that was probably as close to, well, they didn't have pornographic movies in those days, you know, they were never heard of. And this was one way to see the male body. I think a lot of them went for that reason. 'Cause they were good-looking. Just remembering the comments like, you know, "*Wow, look at that bod!*" y' know, and that type of thing, so you know that they were there for that purpose.[39]

Though Nelson's analysis was not explicitly self-inclusive, she, too, had expressed her interest in getting close to the performers; thus she was in good position to observe not only her peers at ringside, but also the "fantastic bods" of the performers in the ring. The example she cites suggests that women were not satisfied simply with passively taking in the bodies of the performers as objects of desire; they went further, sharing their assessments with the other women around them, as they yelled out, "Wow, look at that bod!" In doing so, they were enjoying the expression of feminine desire in a decidedly public context. And because women had become a dominant presence at the wrestling arena, they could express their pleasure safely and unreservedly, outside the often constrictive sexual atmosphere of the 1950s.

Carol Verdu concurred with Nelson's assessment that one of wrestling's principal appeals was the thrill of seeing attractive bodies on stage:

> Well, it's just like the women after movie stars. Or singers, or whomever. Really, all you were looking for was just the thrill of it at the time. You weren't looking for anything after the matches or anything like that. It was just the thrill at the time of these beautiful bodies, and some of them did. I mean some of them had nice bodies. They worked out, you could tell they did. College graduates and intelligent men, you know, getting in there getting their bodies beat up.[40]

For Verdu, there was apparently no desire to engage sexually with the performers. Instead, she was satisfied with simply viewing a series of attractive bodies. Her assessment is also interesting in that part of the pleasure for Verdu was class-based, seeing apparently intellectual men—in her words, "college graduates and intelligent men"—competing at the physical rather than mental level and putting their attractive bodies at risk in the process. The middle-class appeal of college-educated performers (themselves initially introduced to wrestling in an educational context) suggests that wrestling's audience cut across class lines.

On the Edge of Danger

For some women in the crowd, seeing was not enough. Ted Lewin argued that for some women, attending the live event offered an experience not available to the television viewer, *danger*:

> [Women] sit at ringside, and they watch these 250-pounders getting *body-slammed* or falling out of the ring and crashing all over. And I've looked at their faces, and they get this *weird* kind of a [look], you know: "We're on the edge of danger." You know: "Even if we don't believe that these guys look good, this guy just fell fifteen feet at the bell, bounced off and landed in my lap!" You know, "This is serious stuff!"[41]

From Lewin's perspective, the unpredictability, the dangerous potential that wrestling represented, was what attracted some women. But Lewin may or may not have recognized that some women wanted more than a threat of contact: they wanted a real opportunity. Carol Verdu suggested that at times the wrestlers would facilitate women's chances for touching them by throwing each other out of the ring. This was an advantage of a ringside seat, as Verdu recalled:

> We jumped up and down a lot, you know, which, we couldn't pound on the ring there [in Columbus] because it was too high. I mean, it was always . . .

those guys'd get thrown down there in your lap, you know? [*Laughs.*] "Carol's got to touch him!" [*Laughs.*] That was funny! Gee whiz! I forgot that![42]

Just as she had been astonished by the attractive male body unexpectedly in her lap, Verdu was surprised again at the memory of suddenly being able to touch the wrestlers and the envy of her female friends at ringside.

Nor were such opportunities simply accidental, outside of a woman's control. In fact, as Nancy Jacobs pointed out, the wrestling arena presented ample chances for women to touch the bodies of the wrestlers, should they so choose:

I thought, "This is where women could go and be close to an athlete." You can't go and touch a football player or a baseball player or a hockey player. They're sequestered, but you could get up to the ringside and you could touch them when they went out and y' know, it was a touchy thing. There was a physical attraction. There's these oiled bodies coming out of the shower, all they had on was a pair of trunks. Y' know, there was a sexuality there.[43]

Nancy's assessment brings the element of desire into sharp focus. It was not necessary to enter into a sexual relationship with these performers, with all the attendant risks of pregnancy, disease or damage to reputation; one simply had to be in a position to touch the wrestlers.

"Arena Rats" and "Hang-Arounds"

While women were clearly drawn to wrestlers as the objects of desire, in Bill Cardille's estimation, only rarely did women cross the line in an attempt to enact their desires:

Women are a lot cooler than men give them credit for. And I think women handle themselves a lot better and because I was sorta the center of a lot of it, I really, even though they may have fantasized, when the matches were over they went out the door and 98 percent of them, 99, we never saw them again.[44]

And apparently, as Cardille saw it, if the situation were reversed, male customers would not have exercised the same level of restraint. For the vast majority of women, in Cardille's estimation, the pleasure afforded by watching and occasionally touching attractive male bodies remained on the level of fantasy. However, even Cardille acknowledged that some percentage of women, however small, were willing to test the boundary between fantasy and fulfillment.

Wrestling was neither the first nor the only entertainment genre where female fans sought to engage the performers beyond the context of the production itself.

The term "groupie" was coined in the 1960s to describe women who sought sexual relationships with rock musicians, and the term has since been extended to describe similar pursuits in a range of performance genres. Other names have also been used: for instance, groupies of rodeo cowboys are described as "buckle bunnies," while hockey players describe them as "puck bunnies."[45] Baseball players, who have long used "Annie" and "Shirley" to describe such fans, have had a long history of such encounters. For instance, Babe Ruth was one of many players known to be promiscuous with female fans.[46] While some women seek out stars simply to see them up close (as Delores Hall described), others seek the status that comes with close association. And then, some women's intentions are entirely sexual.

Bill Cardille's account of feminine desire was told from the perspective of an observer, rather than as a direct object of fan interest. In Pittsburgh, Cardille himself was often drawn into the process:

> I was the contact for all the outside people for the wrestlers; they'd write me a love letter and say, "Enclosed is a letter" for a wrestler, you know, and I always gave them the mail. Or cards, or "Call this guy," or "Call this girl," y' know. So I was "Johnny Cupid."[47]

Cardille maintained that wrestlers rarely made contact with individual female fans outside the arena. But women attending the show in groups apparently had better luck:

> I know that the wrestlers would go out to dinner or maybe have a drink or two with some of the groups [of women]. But normally in groups. I mean, they didn't, now that you mention it, there weren't too many single, y' know, one-on-one type things.[48]

Cardille's observations are consistent with those examining other performance genres. In their study of baseball, Gmelch and San Antonio note that women seeking to meet players often gather strategically in groups of two or three, making it easier to interact with players who routinely go out together in groups. It also affords the women a modicum of safety.[49]

From Cardille's perspective, the articulation of female desire was confined largely to the public space of the wrestling arena, and less occasionally spilled over into other areas. For some in the industry, however, the issue of feminine desire was an aspect of wrestling that had to be contended with directly, on a regular basis. A number of women took their interest beyond ringside, approaching wrestlers at the stage door and in public and private spaces outside the arena. A variety of regional terms were used to describe these women, all with the same underlying meaning. Ted Lewin knew them as "hang-arounds":

There was always the kind of, [what] they called "groupies" later on, but again, we'd use the term "hang-arounds" 'cause they'd hang around the dressing room door. It wasn't only getting autographs, they wanted to, you know, get *close* to wrestlers, you know. [*Pauses knowingly.*] And sometimes the goofier, the wackier the wrestler, the more desirable it was to try to get close to them. Somebody whose whole persona was to turn your stomach in the ring would be *very* attractive to some females.[50]

In Lewin's estimation, not all the women were looking for sexual engagement with wrestlers. At issue for many was *getting close* to the performers, wherever they may have been. The dressing room door wasn't the only place where "hang-arounds" would congregate, as Lewin explained:

Like the wrestlers would go somewhere to have a drink or something to eat, and these girls would be there. And I don't know if it was always about sex or something, but they wanted to be in the scene. And every once in a while they'd say to [you], you know, "Do you need a ride back?" So you'd get a ride back to the city or something, and it was always this kind of a . . . I don't know, they just wanted to be around the scene. They, uh . . . well, [*adopts a faux sophisticated tone*] "Wrestlers are a *charming* bunch," you know, when they're not sort of, off the deep end or something, they're a lot of fun. And I think that they liked whole kind of repartee and the kind of rough fun that goes along with the whole thing.[51]

Getting close could establish a bond between performer and fan, a "repartee," in Lewin's words. These women wanted to be a part of the world of the wrestler, not simply a distanced observer. Achieving proximity also represented an element of danger, echoing a theme Lewin discussed previously. There was a certain risk involved in breaking the narrative boundary between performer and spectator, engaging in the type of "rough fun" some wrestlers were known for, particularly with the villains for whom rough behavior was a stock in trade. But for some, the benefit of being "in the scene" was well worth the risk of trading the reasonably controlled public space of the wrestling arena for the less controlled spaces beyond it.

If there was risk, there was also a measure of safety—even for those women seeking physical intimacy. While sex or an affair with a local man might have posed a risk to a woman's reputation, wrestlers were often outsiders to the area, and a sexual encounter was less likely to result in a long-term entanglement. At the same time, as recognized performers in the public eye, wrestlers had more to lose if the encounter went sour.

When Bastien moved to the professional wrestling circuit, his experiences were consistent with those of Ted Lewin and the other wrestlers with whom I spoke, though Bastien had a different term for the women hanging around the dressing room door:

I don't know if you've run across anyone who, when the girls would hang around a lot and they would be there going with different wrestlers every week, we had a name for them. And we called them "arena rats." If you were wrestling in the same place a lot, then, of course, you would become known and vice versa.

When Bastien did stay in one area, fans made efforts to track him to the local hotel where he was staying, though they were not always successful in their attempts:

Author: Did you have any fans track you down away from the arena?

Red Bastien: Try to, sure, yeah. I used to, when I was wrestling in New York, I used to go check in the hotels under an assumed name. Yeah. Get some rest. [*Laughs.*]

However, while Bastien apparently eschewed such contacts with the "arena rats," some of his colleagues felt differently:

Bastien: Well, you know what we used to do when we'd go someplace. We'd, we'd go to hotels and some guys would check in, y' know, and you'd take that hotel towel, and you'd wear that into the ring, [*laughs*] and you'd shake it out and everything like that, and display it and everyone'd know where you're staying. [*Laughs.*] Terrible, terrible, terrible.

Author: Well, it's one way to make friends.

Bastien: Yeah, that's right. You just want to build your "fan base."[52]

These stories reveal the lengths to which some fans went to "get closer" to wrestlers, and vice versa. For some wrestlers, the benefits of a wrestling career extended far beyond the ring. Beyond building a fan base, for wrestlers such as Bastien and Lewin, these encounters represented a struggle to define the boundaries between narrative and reality, between public and private life.

It is significant that the performances of particular women stood out in the memories of these former wrestlers and industry workers, performances that ran counter to normative constructions of femininity during the 1950s. These recollections of active, *individual* women in the arena (and beyond) mirror the impressions recorded by reporters and television cameras, and then transmitted to readers and viewers across the country. Though they were not necessarily representative of audiences as a whole, or of the women who made up a sizable share of the crowd at the time, these memorable women retain a prominent place both in period constructions and in ongoing memories of wrestling audiences during the 1950s.

Conclusion

This chapter suggests that wrestling evoked for women variety of complex appeals and pleasures. Nancy Jacobs astutely summarized the range of female desires and motives present in the context of the wrestling arena, usually in connection with the body of the male wrestler on display:

> Nancy Jacobs: I think there was an interest in the body of the wrestler. The physical, I mean, all he had on was a pair of trunks. Now you can go to the beach and see the same thing, but this was on display. This was a muscle type, well-developed, handsome in most cases. And I think that was a very, very strong attraction for all ages: some women there hoping to go to bed with them, some of us hoping to be friends with them. Others couldn't care less, they just wanted to look at them and take their picture and, and as they came in or out, touch them. It was a very touchy kind of thing with the fans.
>
> Lillian Beltz: Mmm, yes.[53]

Jacobs' telling analysis demonstrates the scope of women's desire and attraction articulated at the arena. The appeal of wrestling resided not just in seeing bodies; it resided in knowing that the bodies were explicitly on display.

For "some women," though clearly not for Jacobs, sex was the primary objective, at least in her estimation. Still, it was sex on their terms, with the women acting as the active agent in the encounter, as the pursuer and not the pursued. Nor did Jacobs begrudge them their wish; it was simply part of the equation.

For others, simply exercising feminine desire was enough, whether by visually objectifying them ("seeing" them, as Delores Hall's comments illustrate), capturing their image on film, or touching them as they passed by. For most women, it was a rare opportunity to be able to objectify men without ramifications: without having to fend off reciprocal sexual demands or protect their reputations or their own bodies from pregnancy, disease or abuse.

For Jacobs, the principal appeal was the potential for establishing bonds of friendship with the wrestlers, signaled in her comment above by the one moment when she spoke inclusively: "some of *us* hoping to be friends with them." For each of the women I spoke with, wrestling was something shared between women: between Marilyn and LaVon; between Delores and her Mother at home; between Carol and her mother, as well as with Carol's many friends at the arena; and between Nancy, Lillian and Barbara. There was a solidarity among the many women in the 1950s who counted themselves wrestling fans.

Looking back, Nancy Jacobs suggested that wrestling afforded women a measure of freedom not found elsewhere. As Jacobs thumbed through the many articles that appeared in the mainstream press, with the headlines like "Lo! The Lady Wrestling Fan" and "Where Grandma Can Yell 'Bum,'" she suddenly said:

> Yeah, see, that's what I was saying. Here's this freedom that you can do this now. And it's permissible. There's this freedom and the sexuality is there, which you didn't have on TV, there just wasn't the explicitness then on TV that there is now. And there was a chance to touch these bodies.[54]

For Jacobs, wrestling offered women opportunities they couldn't find in other contexts, such as the freedom to act sexually assertively, to see and touch the bodies of attractive performers, to yell and scream, and to share the pleasures of public defiance with friends. Though it was more difficult in other areas of women's lives, in the public sphere or within the context of the home, such actions were possible for a time, within and beyond the confines of the wrestling arena.

Looking Forward, Looking Back

The 1950s were a time of enormous contradictions. We remember fondly its televised representations of happy, contented women in domestic roles, from June Cleaver to Harriet Nelson, but it was also a period marked by social upheaval. The 1950s saw the rise of rock and roll and FM radio; Beat poetry and a bohemian sensibility; disaffected teenagers rebelling against the dreary sameness of suburbia; long-suffering African Americans chafing against a racist society; and the nascent empowerment of gay and lesbian communities. Representations of sexuality were in transition, as films made and distributed in the United States in the wake of the Supreme Court's 1952 *Miracle* decision (which extended First Amendment rights to motion pictures) demonstrated more freedom of expression and relaxed sexual mores. The introduction of *Playboy* magazine and its inclusion in the publishing mainstream signaled societal changes in definitions of masculinity and femininity. It was in this context that millions of women became fans of professional wrestling, catapulting it into the national consciousness.

The distinctive feminine response to wrestling that developed in the postwar era was markedly different from that of previous audiences for wrestling—and likely for any other sport or sports performance, for that matter. Women used their growing numbers to advantage, raising their voices to celebrate their passions, their pleasures and their community, and asserting their social, cultural and economic power in ways unrecorded by most histories and conventional media representations of the era. Their actions cannot be dismissed as marginal and in fact present a more accurate image of postwar femininity. Despite the persistent message in the commercial media that women should remain in the domestic sphere, subservient and obedient, attractive without being sexually

assertive, women wrestling fans felt free to express an entirely different version of femininity. Having often experienced wrestling first on television, women arrived at the arena culturally literate, knowing what to expect and what pleasures were available to them. And many women felt sexually emboldened, able to use the participatory context of the arena to engage with the attractive male athletes. Women found it easy to sexually objectify the male performers in front of them, taking them as the public objects of their pleasure. The sexual appreciation of male athletes became a common theme for female fans, a form of expression that sports itself has tended to downplay. The result was an exhibition of feminine agency on a nationwide scale, displayed on television and in the mainstream national and regional press, as well as in myriad other publications.

Representing Women

Women of all sorts and backgrounds were drawn to professional wrestling. All classes of women were represented: women wearing fur coats sat at ringside next to those in simple dresses. Women produced fan club bulletins, those with means procuring the duplicating machinery themselves, those without appropriating it from their school, church or workplace. And many more watched televised broadcasts, from the well-to-do who could afford sets in the late 1940s to the many who flocked to buy them later when prices dropped. Women of both the professional and working classes gathered each week to watch wrestling outside hardware and appliance stores or in the bars and restaurants that advertised "Wrestling Tonight" on signs prominently displayed. My mother described to me a friend's past experience of watching wrestling on television with her maid.[1] Their economic positions marked divergent class backgrounds, and each brought a different perspective to her interpretation of the program and the experience, yet both women drew enjoyment and gratification from their ritual together: the homeowner sharing her pleasure with another woman, the maid enjoying both the program and the time off from work. Each of these examples speaks to the range of class positions occupied by female fans and to the complex nature of the audience for wrestling.

Women of all races were drawn to wrestling, from "white linen" Irish to African Americans, Hispanics and immigrants of all backgrounds. As with every aspect of life in the 1950s, race and racism played out in the geography of wrestling viewership. Many arenas were segregated by skin color, with people of color relegated to watching the performances of black or Hispanic wrestlers from great distances—ironic since those performers were allowed to be the celebrated victors in matches against white villains. Some hardware stores displayed the cheaper television sets in the store's side windows, reserving the front windows and the best sets for their white customers.

A full range of ages were also represented: young girls, teens, working women, housewives, women in their forties and fifties, and a full complement of

women aged sixty and over could be seen at the arena. While some women sat with male companions, many others could be seen in groups with other women, sharing in the pleasures of the moment. And women from all areas of the national landscape were drawn to wrestling, from bustling urban neighborhoods to suburban colonies and isolated rural areas. The 1950s were marked by the continued breakup of extended families and the increased movement of both individuals and nuclear families around the country, drawn to employment opportunities and new suburban housing enclaves.[2] Entertainment such as wrestling provided women important contact with other like-minded fans. And for those in rural areas, such as Marilyn Nelson, wrestling was an opportunity to move beyond the offerings of small-town America and gain a taste of the outside world.[3] Whether attending matches in nearby cities or communicating with other fans through the mail, women found countless opportunities for contact, information and community in professional wrestling. And many of these contacts reinforced a sense of women's growing power in America.

Attracting Women

Professional wrestling offered considerable appeal to women in the postwar era; access to male bodies was a significant and immediate draw. Some women noted that being able to gaze lingeringly upon attractive, scantily clad men, whether on television or in public, was a unique opportunity. The chance to see, talk to, yell at and openly flirt with those men was a heady experience.

Wrestling also became a mechanism for connecting with a growing women's culture. As the arenas became filled with increasing proportions of women, female fans could respond to performances in voices both distinct and communal. Many contributed performances of their own, weaving themselves into the fabric of the evening's entertainment and re-centering the cultural experience on women. They then reached beyond the arena to exercise their influence in other venues: in commercial wrestling magazines, in fan club bulletins and in the home.

For some, the simple act of viewing became an exercise of power. Women carved out leisure time that could not be easily challenged by others in the domestic space, reserving the television for hours to revel in the parade of wrestlers across the small screen. Many women felt free to yell, laugh and carry on without fear of recrimination; their fandom of wrestling became a protected slice of "free" time in what was otherwise a domestic workspace in which leisure choices were too-often determined by husbands or children. Wrestling allowed women to flex their cultural muscles and demonstrate their agency on the home front, knowing that millions of similar demonstrations were occurring in homes across the nation.

Finally, in the myriad opportunities presented by wrestling magazines, fan club bulletins and individual correspondence among fans, wrestling afforded

female fans further opportunities to participate in a culture dominated by women. Women could demonstrate their cultural capital and expertise through their knowledge of wrestling and their particularized negotiation of the text, all while enjoying each other's company in a collective pursuit of interest. In sum, wrestling was a vehicle for women to exercise considerable power in varied social arenas.

Fan Studies

While careful readings of television texts have long provided scholars with opportunities to speculate about audiences, little has been done previously to closely examine actual audiences' responses at the edges of live broadcasts. Such analyses provide glimpses of the meanings those in attendance made of the program, and the performances they inserted into the text. Fandom is complex and cannot be reduced to a single thesis or story; audiences are multiple and conflicting, bringing myriad lived experiences and perspectives to their engagement with the program. Female fans of professional wrestling represented a broad, diverse, largely adult population. While this population included teenage girls—some of whom were predictably enchanted by wrestling's performers—it also included women of all ages, races and classes, whose responses were far more complex. Male and female fans diverged sharply at the arena and in the commercial fan magazines over issues ranging from what constituted the preferred performative direction of their entertainment to passionately held beliefs on race, class and politics. Female fans were united in neither their responses nor their interpretations of the program, at times battling in the aisles.

This book illuminates the many audiences who were attracted to wrestling in the postwar era, and who, for a period of time, created a wave of popularity that catapulted professional wrestling into the cultural limelight. Steeped in women's culture and demonstrative of women's considerable power in the postwar period, this phenomenon forces us to redefine what "woman" meant in the postwar era. June Cleaver can no longer be considered the archetype of the 1950s woman; too many examples to the contrary force us to understand the postwar woman in a new light. Far from simply subverting ideological constructions of gender, women of the 1950s—economically empowered, fueled by their job experiences in wartime and by the economic boom of the postwar era— demonstrated the contested nature of gender itself.

Changing Sex Roles

Our notion of the 1950s as a decade of sexual containment can no longer be sustained, given the era's changing definitions of gendered roles. These changes are evident not only in the context of professional wrestling, as I have shown,

but in other contexts as well. As Susan Douglas argues, the 1950s saw the rise of sexual expression in society across a range of contexts. Books, movies and magazines increasingly featured sexually frank or risqué subject matter, and encouraged women—particularly unmarried women—to venture further with their own sexual practices.[4] Women's free, playful expression of their sexual desires and interests in the wrestling arena is just one proof of the mainstream's evolving attitude about women's sexuality. The fact that women were attending in droves, and millions more watching on television, openly enjoying the male physique, speaks to the bold sense of entitlement many women felt.

The importance of display to this type of performance is also noteworthy. The public display of male bodies was nothing new, in wrestling or other forms of public entertainment: films had long featured attractive male forms on the screen, from Rudolph Valentino's smoldering portrayal in *The Sheik* to Johnny Weissmuller's loin-cloth-draped *Tarzan*. What was new in the 1950s was the deliberate, public objectification of male bodies—by the women in the wrestling audience, the promoters, the wrestlers themselves—and the general understanding that the men were performing specifically for the pleasure of women. The female objectifying "gaze" was shared by women in a joyful, active and self-reflective way.[5]

Women fans of wresting brought to the foreground what sport as a genre tends to deny: the sexualization and objectification of the male athletic body. Wrestling may well have been the first instance of women *en masse* standing up to publicly objectify and sexualize the male athlete—and of many male athletes responding, in this case by offering up photographs of sexualized poses in the commercial wrestling magazines. In this way, women's appreciation of the male figure opened up sports fan culture in general to the possibility that male fans could also enjoy the sexual aspect of the male athlete.[6]

The 1960s and Beyond

As the 1950s came to a close, wrestling and its audiences underwent another significant shift. The first change actually occurred mid-decade: professional wrestling was dropped from prime-time network schedules in 1955, overwhelmed by the ratings strength of television dramas and sitcoms. Wrestling still was seen throughout the country on regional television stations, which either produced their own locally originating broadcasts or scheduled one of the many syndicated wrestling programs available from the major urban centers where wrestling was strong. But in many regions, the scheduled time slot for wrestling also changed, from late evening fare to Saturday or Sunday afternoons. This precipitated the change in wrestling's audience in the 1960s from adult women and men to younger family members—boys in particular—an audience more accessible on weekend afternoons than in the final hour of prime time.

As wrestling was dropped by the national television networks, the wrestling press went through a period of significant adjustment. *Official Wrestling* ceased publication in 1953, and *Wrestling World,* launched the following year, did not last beyond 1955. Fred Kohler's *Wrestling As You Like It* underwent a radical transformation in 1955 from weekly to monthly publication, changing its name to *Wrestling Life* in the process and dropping all of its female correspondents and much of its focus on fan activities. Most of the wrestling magazines that had been started in the 1950s had ceased publication by 1958.

The wrestling press resurged in the early 1960s; at least five wrestling magazines were being published in 1962 and 1963, and a number of those lasted well into the 1980s.[7] But judging from the content of these magazines, the audience for wrestling was different from what it had been in the early 1950s. More emphasis was placed on spectacle than ever before, with a return to a combative theme. By the late 1960s, a number of wrestlers were turning to steroids to enhance their physiques (and their employment prospects), a change reflected in the photography and covers dominated by larger and larger bodies. Many of the images and articles increasingly emphasized violence and blood, with garish color photographs on the covers vividly displaying (or, more likely, re-creating with healthy amounts of fake blood) the grizzly results of bouts. By the end of the 1960s, photo layouts depicted women's "apartment wrestling," as scantily clad women tore off each other's clothes for the photographer. Obviously, women were no longer perceived to be a significant audience for wrestling; they had been replaced by a new target audience: adolescent boys.

The constitution of the wrestling fan club slowly underwent a metamorphosis as well, as more young men took to publishing wrestling newsletters, and women dropped from sight. With this shift came a change in the relationship among participants, from the two-way model of communication favored in women-centered bulletins to a one-way flow of information from male editors and writers to male subscribers. The new tenor of the information published emphasized win/loss records, wrestling style, rankings of wrestlers, and so on. Under male tutelage, fan clubs increasingly came to resemble nothing more than limited-publication newsletters, with little sense of organizational bond among the members of the club. By the 1960s, wrestling fandom was firmly in the hands of young men.

On the other hand, a look at the changes wrought by the second wave of feminism reveals a significant widening of the choices available to female fans. In television entertainment, a host of powerful women garnered significant fan bases over the years, suggesting that women's fan interests have slowly shifted or expanded. The image of the active woman on television gained momentum, from Mary Tyler Moore's portrayal of Mary Richards to the portrayals of increasingly active, self-actualizing women on *Charlie's Angels, Dallas, Cagney & Lacey* and more recently, *Buffy the Vampire Slayer* and *Alias,* to name but a few.[8] Many of these women-centered shows sparked the creation of listserves,

websites and other fan-centered discourse and creative output. Likewise, the participation of women in sports has grown dramatically, with women marking successes in a wide range of pursuits, including ice hockey, boxing, basketball and amateur wrestling. The female fan bases for women's tennis, Olympic and World Cup soccer teams, and the WNBA have grown significantly, in some cases making professional women's sports a viable economic enterprise. At a WNBA game, vestiges of women's wrestling fandom can be heard in the high-pitched cheers and chants that dominate the proceedings. Whether women's interest in female sports and entertainment icons has largely supplanted their past focus on male wrestlers such as Gorgeous George, Antonino Rocca or Don Eagle, or simply expanded to take advantage of these new opportunities, is an open question.

By the dawn of the 1960s, women may have no longer needed professional wrestling and the sense of community it provided for that brief period in the postwar era. Did women's passion for wrestling evolve into a passion for women's rights? Or was it the other way around—did a nascent interest in female identity and community provoking the interest in wrestling? The evidence isn't clear. Women's training as wrestling fans did prepare them well for the sweeping social change taking shape on the horizon, and specifically for the battle over women's rights, with its emphasis on agency, social formation, identity and empowerment.

This look at the world of professional wrestling offers a vivid illustration of the contentiousness of the postwar era and the considerable economic, social and cultural power women possessed. The veneer of soothing ideological homogeneity in the 1950s that so many Americans still hold dear begins to show its age; when we look closer, the fresh faces of the real women of postwar America emerge.

Notes

 CHAPTER ONE

1. Joanne Meyerowitz, "Introduction: Women and Gender in Postwar America, 1945–1960," in *Not June Cleaver: Women and Gender in Postwar America, 1945–1960*, ed. Joanne Meyerowitz (Philadelphia: Temple University Press, 1994), 4.; Lary May, "Introduction," in *Recasting America: Culture and Politics in the Age of Cold War*, ed. Lary May (Chicago: University of Chicago Press, 1989), 2.

2. Betty Friedan, *The Feminine Mystique* (New York: Norton, 1963); Meyerowitz, "Introduction," 3. Accounts of the impact of Friedan's account can be found in Joanne Meyerowitz, "Beyond the Feminine Mystique: A Reassessment of Postwar Mass Culture, 1946–1958," *Not June Cleaver*, 229–262.

3. See Joel Foreman, introduction to *The Other Fifties: Interrogating Midcentury American Icons*, ed. Joel Foreman (Urbana: University of Illinois Press, 1997), 3–4. Other studies that see the 1950s as the origins of the social movements of the 1960s include Wini Breines, *Young, White, and Miserable: Growing Up Female in the Fifties* (Boston: Beacon Press, 1992); Jackie Byars, *All that Hollywood Allows: Re-Reading Gender in the 1950s Melodrama* (Chapel Hill: University of North Carolina Press, 1991); James Gilbert, *A Cycle of Outrage: America's Reaction to the Juvenile Delinquent in the 1950s* (New York: Oxford University Press, 1986); and Brandon French, *On the Verge of Revolt: Women in American Films of the Fifties* (New York: Ungar, 1978).

4. Leila J. Rupp and Verta Taylor, *Survival in the Doldrums: The American Women's Rights Movement, 1945 to the 1960s* (New York: Oxford University Press, 1987); Joanne Meyerowitz, "Sex, Gender, and the Cold War Language of Reform," in *Rethinking Cold War Culture*, ed. Peter Kuznick and James Gilbert (Washington, DC: Smithsonian Institute Press, 2001), 106–123; Eugenia Kaledin, *Mothers and More: American Women in the 1950s* (Boston: Twayne, 1984), 41.

5. Breines, *Young, White, and Miserable*, 127–166.

6. Lewis A. Erenberg, "Things to Come: Swing Bands, Bebop, and the Rise of a Postwar Jazz Scene," in *Recasting America*, 221–245.

7. See John D'Emilio and Estelle B. Freedman, *Intimate Matters: A History of Sexuality in America* (New York: Harper & Row, 1988), especially 288–295; Jane Sherron De Hart, "Containment at Home: Gender, Sexuality, and National Identity in Cold War America," in *Rethinking Cold War Culture*, 124–155; and Lillian Faderman, *Odd Girls and Twilight Lovers: A History of Lesbian Life in Twentieth-Century America* (New York: Columbia University Press, 1991).

8. Richard Flacks, *Youth and Social Change* (Chicago: Markham Publishing, 1971), cited in Breines, *Young, White, and Miserable*, 133–134; George Lipsitz, "Land of a Thousand Dances: Youth, Minorities, and the Rise of Rock and Roll," in *Recasting America*, 267–284. See also De Hart, "Containment at Home," and Paul Goodman, *Growing Up Absurd: The Problems of Youth in the Organized Society* (New York: Vintage Books, 1960).

9. See Peter Filene, "'Cold War Culture' Doesn't Say It All," in *Rethinking Cold War Culture*, 156–174; Barbara Ehrenreich, *The Hearts of Men: American Dreams and the Flight from Commitment* (New York: Doubleday/Anchor, 1983); and William H. Whyte, *The Organizational Man* (New York: Simon and Schuster, 1956).

10. While many writers exercise considerable license in describing the beginnings of wrestling, Gerald W. Morton and George M. O'Brien persuasively argue that it is impossible to accurately date its origin in *Wrestling to Rasslin: Ancient Sport to American Spectacle* (Bowling Green, OH: Bowling Green State University Popular Press, 1985). For more complete accounts of the history of wrestling, see chapter 1 in particular. Also see Charles Morrow Wilson, *The Magnificent Scufflers: Recalling the Great Days When America Wrestled the World* (Brattleboro, VT: Stephen Greene Press, 1959); and Graeme Kent, *A Pictorial History of Wrestling* (Middlesex, England: Spring, 1968).

11. Milton MacKaye, "On the Hoof," *Saturday Evening Post*, 14 December 1935, 35.

12. Cf. Kent, *A Pictorial History of Wrestling*, 185.

13. MacKaye, "On the Hoof," 35.

14. Bill Cunningham, "The Bigger They Are—" *Colliers*, 17 December 1932, 40; MacKaye, "On the Hoof," 8.

15. See "Baba & Behemoths," *Time*, 18 May 1936, 54–55, 58; "Wrestling," *Newsweek*, 20 February 1937, 29; and John Lardner, "Who Degrades Whom?" *Newsweek*, 4 December 1944, 92.

16. Morton and O'Brien, *Wrestling to Rasslin*, 46.

17. Ron Powers, *Supertube: The Rise of Television Sports* (New York: Coward-McCann, 1984), 47. See also Joe Jares, *Whatever Happened to Gorgeous George?* (Englewood Cliffs, NJ: Prentice-Hall, 1974, 13. Jares notes that the Olympic Auditorium matches were kinescoped and rebroadcast in fifty-seven markets nationwide. Brooks and Marsh, *The Complete Directory to Prime Time Network Television Shows: 1946–Present*, 7th ed. (New York: Ballantine, 1999). In 1948, ABC, NBC and DuMont each sponsored at least one weekly wrestling program; CBS joined the fray in 1950. See the following chapter for in-depth treatment of this subject.

18. Edythe Farrell, "Lady Wrestlers," *American Mercury*, December 1942, 674. Ted Shane, "Gorgeous George the Wrestler," *American Mercury*, July 1950, 65.

19. "It Pays to Sponsor Television Corn," *Business Week*, 7 October 1950, 25.

20. "It Pays," 7 October 1950, 25.

21. See De Hart, "Containment at Home"; Elaine Tyler May, *Homeward Bound: American Families in the Cold War Era* (New York: Basic Books, 1988); William H. Chafe, *The American Woman: Her Changing Social, Economic, and Political Roles, 1920–1970* (London: Oxford University Press, 1972); and Rupp & Taylor, *Survival*, 6–9.

22. Rupp & Taylor, *Survival*, 13–14; May, *Homeward Bound*, 59; Chafe, *American Woman*, 135.

23. Chafe, *American Woman*, 148.

24. Chafe, *American Woman*, 149.

25. Chafe, *American Woman*, 149.

26. May, *Homeward Bound*, 60–62, 68. Chafe, *American Woman*, 141, 151–65.

27. G. T. Allen, "Eight Hour Orphans," *Saturday Evening Post* 215 (10 October 1942), 20.

28. Chafe, *American Woman*, 146.

29. Rupp & Taylor, *Survival*, 14; Susan M. Hartmann, *The Homefront and Beyond: American Women in the 1940's* (Boston: Twayne Publishers, 1982).

30. Chafe, *American Woman*, 180; Rupp & Taylor, *Survival*, 12–14; Stephanie Coontz, *The Way We Never Were: American Families and the Nostalgia Trap* (New York: BasicBooks, 1992), 159–160.

31. Susan M. Hartmann, "Women's Employment and the Domestic Ideal in the Early Cold War Years," in *Not June Cleaver*, 84–100; Ruth Milkman, *Gender at Work: The Dynamics of Job Segregation by Sex During World War II* (Urbana: University of Illinois Press, 1987); Coontz, *The Way We Never Were*, 160; Chafe, *American Woman*, 176; Andrea S. Walsh, *Women's Film and Female Experience, 1940–1950* (New York: Praeger, 1984). While Walsh does point to the often punishing image of women in 1940s film noir, she equally argues for the redemptive power of the women's depictions in 1940s film, seeing in them evidence of a "nascent feminist consciousness" (197).

32. Mary Beth Haralovich, "Sitcoms and Suburbs: Positioning the 1950s Homemaker," in *Private Screenings: Television and the Female Consumer*, ed. Lynn Spigel and Denise Mann (Minneapolis: University of Minnesota Press, 1992), 111–141. See also Lynn Spigel, *Make Room for TV: Television and the Family Ideal in Postwar America* (Chicago and London: University of Chicago Press, 1992); Byars, *All That Hollywood Allows*.

33. Breines, *Young, White, and Miserable*, 11, 86–95. See also Susan Douglas, *Where the Girls Are: Growing Up Female with the Mass Media* (New York: Times, 1994); and May, *Homeward Bound*.

34. Mary P. Ryan, *Women in Public: Between Banners and Ballots, 1825–1880* (Baltimore: Johns Hopkins University Press, 1990).

35. "American Woman's Dilemma," *Life*, 16 June 1947, 101–112; "The Girls," *Life*, 15 August 1949, 39–40. Other useful and provocative discussions of the construction of femininity in the 1950s include Coontz, *The Way We Never Were*; Breines, *Young, White, and Miserable*; Brett Harvey, *The Fifties: A Women's Oral History* (New York: HarperCollins, 1993); Douglas, *Where the Girls Are*; and Rochelle Gatlin, *American Women Since 1945* (Jackson: University Press of Mississippi, 1987).

36. "Fortune Survey: Women in America," *Fortune*, August 1946, 5–6; cited in Chafe, *American Woman*, 200.

37. See Margaret Marsh, *Suburban Lives* (New Brunswick, NJ: Rutgers University Press, 1990).

⊠ CHAPTER TWO

1. "Gorgeous George," *Newsweek* 32, 13 September 1948, 56.

2. Ron Powers, *Supertube: The Rise of Television Sports* (New York: Coward-McCann, 1984), 47.

3. "Guaranteed Entertainment," *Time* 51, 31 May 1948, 52.

4. Rito Romero v. Gorgeous George, *Wrestling from Hollywood with Dick Lane*, Long Beach Auditorium, Long Beach, CA (Los Angeles: UCLA Film and Television Archive), listed under "Gorgeous George."

5. Bill Fay, "Collier's Sports," *Collier's* 121, 1 May 1948, 6.

6. *Pitt Parade*, Archives of Industrial Society, Hillman Library, University of Pittsburgh, Pittsburgh, PA.

7. *Lou Weiss Presents: Wrestling Night at Hollywood Legion Stadium* (Los Angeles: Mike LeBell video collection, 1941), Video Scrapbook #42,; *Lou Weiss Presents: Wrestling Night at Hollywood Legion Stadium* (1941) UCLA Archive, VA 9716, part 2.

8. Michael Ball, *Professional Wrestling as Ritual Drama in American Popular Culture* (Lewiston, NY: Edwin Mellen, 1990), 52–3.

9. For workers in the wrestling industry, the character of the hero is typically referred to as a "babyface," or often just a "face," while a villain is called a "heel." Audience members, particularly those who cannot distinguish between performers and the characters they play, are described as "marks."

10. Graeme Kent, *A Pictorial History of Wrestling* (Middlesex, England: Spring, 1968), 191–198.

11. Kent, *A Pictoral History of Wrestling*, 191.

12. See Andreas Huyssen, "Mass Culture as Woman: Modernism's Other," in *Studies in Entertainment: Critical Approaches to Mass Culture*, ed. Tania Modleski (Bloomington: Indiana University Press, 1986): 188–207; M. Alison Kibler, *Rank Ladies: Gender and Cultural Hierarchy in American Vaudeville* (Chapel Hill: University of North Carolina Press, 1999); and Ann Douglas, *The Feminization of American Culture* (New York: Knopf, 1977).

13. Bill Cunningham, "The Bigger They Are—," *Collier's* 90, 17 December 1932, 9; Milton MacKaye, "On the Hoof." *Saturday Evening Post* 208, 14 December 1935, 8; Jack Kerouak, "In the Ring," *Atlantic* 221, March 1968, 110–11.

14. Richard Butsch, *The Making of American Audiences: From Stage to Television, 1750–1990* (Cambridge: Cambridge University Press, 2000); Kibler, *Rank Ladies*, 12; Kathy Peiss, *Cheap Amusements: Working Women and Leisure in Turn-of-the-Century New York* (Philadelphia: Temple University Press, 1986); David A. Cook, *A History of Narrative Film*, 4th ed. (New York: W. W. Norton, 2004).

15. Roland Barthes, "The World of Wrestling," in *Mythologies*, trans. Annette Lavers (New York: Noonday, 1972), 15.

16. John Fiske, *Understanding Popular Culture* (Winchester, MA: Unwin Hyman, 1989), 84.

17. Richard Butsch describes the attraction of sensational melodramas in theaters across America, which between the 1870s and 1910s drew audiences that were up to three-quarters female (*American Audiences*, 79). See also Tania Modleski, *Loving With a Vengeance: Mass-Produced Fantasies for Women* (New York: Methuen, 1982) and Helen

W. Papashvily, *All the Happy Endings: A study of the domestic novel in America, the women who wrote it, the women who read it, in the nineteenth century* (New York: Harper & Brothers, 1956).

18. Cf. "Wrestlers," *Ebony*, July 1950, 21–24. Of the 281 male wrestlers featured with biographies in Sid Feder's *Wrestling Fan's Book* (New York: Key, 1953), four African-American men are included: Don Blackman, Jim Claybourne, Jim Mitchel and Woody Strode.

19. Tim Brooks and Earle Marsh. *The Complete Directory to Prime Time Network Television Shows: 1946–Present*, 7th ed. (New York: Ballantine, 1999), 1132.

20. *At Ringside with the "Rasslers" from Hollywood American Legion Stadium*, produced by Jerry Fairbanks, Inc. (St. Paul, MN: Jim Melby Collection), tape number 42.

21. Pierre Bourdieu, *Distinction: A Social Critique of the Judgement of Taste*, trans. R. Nice (Cambridge, MA: Harvard University Press); for more on cultural capital and fandom, see Joli Jensen, "Fandom as Pathology," and John Fiske, The Cultural Economy of Fandom," in Lisa Lewis, ed., *The Adoring Audience: Fan Culture and Popular Media* (London: Routledge, 1992), 9–29 and 30–49.

22. Delores Hall, interview with the author, 6 April 1993, 5–6; Nancy Jacobs, Lillian Beltz, interviews with author, 7 August 1994, 16, 68. Page numbers reference my transcriptions.

23. Ali Pasha v. Mr. Moto, *Wrestling from Hollywood with Dick Lane*, Long Beach Auditorium, Long Beach, CA (Los Angeles: UCLA Film & Television Archive), VA 1758 T.

24. Rito Romero v. Gorgeous George, *Wrestling from Hollywood with Dick Lane*. Long Beach Auditorium, Long Beach, CA (Los Angeles: UCLA Film and Television Archive), listed under "Gorgeous George."

25. *Western Main Event Wrestling* (no location listed), produced by McConkey Artists Corporation. (Los Angeles: UCLA Archive), VA 9714 T.

26. Patricia Mellencamp, "Situation and Simulation: An Introduction to *I Love Lucy*," *Screen* 26, no. 2 (March–April 1985): 31.

27. I use the term *incorporation* here in the Raymond Williams sense, as a move by dominant forces to use the oppositional voices of female fans strategically, reinscribing them within the context of consumption and profit. Raymond Williams, *Marxism and Literature* (London: Oxford University Press, 1975). My thanks to Richard Butsch for pointing out this important argument.

28. Leo Garibaldi v. Wild Red Berry, *Wrestling from Hollywood with Dick Lane*, Long Beach Auditorium, Long Beach, CA (Los Angeles: UCLA Archive), VA 9715 T.

29. My use of the term "gaze" invokes the work of Laura Mulvey in "Visual Pleasure and Narrative Cinema," *Screen* 16, no. 3 (Autumn 1975): 6–18, to describe the mechanism by which a person is made to be the object of erotic desire. While Mulvey and other "semio-psychoanalytic" cinema critics have insisted that the gaze is always masculine, theorists such as Jackie Byars (*All that Hollywood Allows: Rereading Gender in 1950s Melodrama* [Chapel Hill: University of North Carolina Press, 1992]) have challenged that assertion.

30. Kibler, *Rank Ladies*, 52; Miriam Hansen, "Pleasure, Ambivalence, Identification: Valentino and Female Spectatorship," *Cinema Journal* 25, no. 4 (Summer 1986): 6–32.

31. Freddie Blassie v. Baron Michele Leone, *Wrestling from Hollywood with Dick Lane*, Long Beach Auditorium, Long Beach, CA (Los Angeles: UCLA Archive), VA 1760 T.

32. Sandor Szabo and Warren Bockwinkel v. Wild Red Berry and "Sockeye" Jack MacDonald, *Tafon Wrestling*, Hollywood Legion Stadium. (Los Angeles: UCLA Archive), VA 9716.

33. Ali Pasha v. Mr. Moto. *Wrestling from Hollywood with Dick Lane*, Long Beach Auditorium, Long Beach, CA (Los Angeles: UCLA Archive), VA 1758 T.

34. Pat Meehan v. Hans Schnabel, *Wrestling from Hollywood with Dick Lane*, Long Beach Auditorium, Long Beach, CA (Los Angeles, CA: UCLA Archive), listed under "Gorgeous George."

35. Wini Breines, *Young, White, and Miserable: Growing Up Female in the Fifties* (Boston: Beacon, 1992), 110–124.

36. Wild Red Berry v. Leo Garibaldi, *Wrestling from Hollywood with Dick Lane*, Long Beach Auditorium, Long Beach, CA (Los Angeles: UCLA Archive), VA 9715 T.

37. Roy McClarity v. Tony Marino, *Wrestling from War Memorial Auditorium*, Buffalo, NY, circa 1957. (St. Paul, MN: Jim Melby Collection), tape number 1.

38. Andre Drapp v. The Bushman, *At Ringside with the "Rasslers" from Hollywood American Legion Stadium*, produced by Jerry Fairbanks, Inc. (St. Paul, MN: Jim Melby Collection), tape number 42.

39. Freddie Blassie v. Baron Michel Leone, *Wrestling from Hollywood with Dick Lane*, Long Beach Auditorium, Long Beach, CA (Los Angeles, CA: UCLA Archive), VA 1760 T.

40. Marcel Bucette v. Ivan Rasputin, *Wrestling from Chicago*, Marigold Arena. Produced by DuMont Television Network. (Los Angeles: UCLA Archive), VA 9713 T.

41. See *Wrestling from Chicago*, Marigold Arena. (Los Angeles: UCLA Archive), VA 9713 T.

42. The A.C. Nielsen media research company rated *I Love Lucy* among the top three shows in the nation every year between 1951 and 1957, according to Brooks & Marsh, *The Complete Directory*, 1243–45.

⊠ CHAPTER THREE

1. Melvin L. Adelman, *A Sporting Time: New York City and the Rise of Modern Athletics, 1820–70* (Urbana: University of Illinois Press, 1986), 269.

2. Steven A. Riess, *Sport in Industrial America, 1850–1920* (Wheeling, IL: Harlan Davidson, 1995), 29.

3. Harry Heath, Jr. and Louis Gelfand, *How to Cover, Write and Edit Sports* (Ames: Iowa State University Press, 1951), 7–8; Edwin Emery, *The Press in America: An Interpretive History of the Mass Media*, 3rd Edition (Englewood Cliffs, NJ: Prentice Hall, 1972).

4. See Riess, *Sport*; Ademan, *A Sporting Time*.

5. See Riess, *Sport*; Robert McChesney, "Media Made Sport: A History of Sports Coverage in the United States," *Media, Sports, and Society*, ed. Lawrence Wenner (Newbury Park, CA: Sage, 1989), 49–69; and Frank L. Mott, *American Journalism, A History: 1690–1960*, 3rd ed. (New York: MacMillan, 1962).

6. J. Michael Kenyon, "The Difficulty with 'History,'" *Wrestling As We Liked It* 1, no. 63, 20 December 1996.

7. See Bill Cunningham, "The Bigger They Are—," *Collier's*, 17 December 1932, 9, 39–40; Milton MacKaye, "On the Hoof," *Saturday Evening Post*, 14 December 1935,

8–9, 35–40; and Westbrook Pegler, "Are Wrestlers People?" *Esquire*, January 1934, reprinted in *Esquire*, October 1974: 284–85, 397.

8. Sam Boal, "Big Boom in the Grunt and Groan Business," *New York Times Magazine*, 20 November 1949, 24. Ted Shane, "Gorgeous George The Wrestler," *American Mercury*, July 1950, 65.

9. Shane, "Gorgeous George The Wrestler," 69; "Wrestlers," *Ebony*, July 1950, 21; C. L. "Steve" McPherson and Oren Arnold, "What Gives in Rasslin'," *Collier's*, 29 October 1949, 76; John Kobler, "Where Grandma Can Yell 'Bum,'" *Cosmopolitan*, December 1953, 126; "It Pays to Sponsor Television Corn," *Business Week*, 7 October 1950, 25.

10. My discussion of this topic is informed by Gaye Tuchman, *Making News: A Study in the Construction of Reality* (New York: Free Press, 1978), whose work on media and news framing helped to establish the field.

11. Frank M. Entman, "Cascading Activation: Contesting the White House's Frame after 9/11," *Political Communication* 20 (October 2003): 415–432. Italics in original.

12. For more on framing, see Shanto Iyengar, *Is Anyone Responsible?: How Television Frames Political Issues* (Chicago: University of Chicago Press, 1991); Frank M. Entman, "Framing: Toward Clarification of a Fractured Paradigm," *Journal of Communication* 43, no. 4 (1993): 51–58; and Dietram A. Scheufele, "Framing as a Theory of Media Effects," *Journal of Communication* 49, no. 1 (1999): 103–122.

13. Frank de Blois, "Lo, The Lady Wrestling Fan!" *TV Guide*, 11 September 1954, 18–19.

14. Pierre Bourdieu, *Distinction: A Social Critique of the Judgement of Taste*, trans. R. Nice (Cambridge, MA: Harvard University Press, 1984), 173.

15. Bourdieu, *Distinction*, 487–488.

16. Bourdieu, *Distinction*, 190.

17. Cf. John Fiske, *Understanding Popular Culture* (Boston: Unwin Hyman, 1989).

18. John Fiske, *Television Culture* (London: Methuen, 1985), 18.

19. Boal, "Big Boom," 24–31.

20. A. J. Liebling, "A Reporter at Large: From Sarah Bernhardt to Yukon Eric," *New Yorker*, 13 November 1954, especially 142–149. Liebling's fondness for boxing, demonstrated frequently in the pages of the *New Yorker*, no doubt further contributed to his sardonic reportage of professional wrestling. Still, his keen observations offer valuable pearls of data.

21. Liebling, "A Reporter at Large," 149.

22. Ann Gray, *Video Playtime: The Gendering of a Leisure Technology* (London: Routledge, 1992). For discussion of radio and television audiences, see also Richard Butsch, *The Making of American Audiences: From Stage to Television, 1750–1990* (Cambridge: Cambridge University Press, 2002).

23. Robert Rice, "Diary of a Viewer," *New Yorker*, 30 August 1947, 50; cited in Dave Berkman, "Long Before Arledge . . . Sports & TV: The Earliest Years: 1937–1947—as Seen by the Contemporary Press," *Journal of Popular Culture* 22 (Fall 1988): 57–8.

24. "It Pays," *Business Week*, 26.

25. Kobler, "Where Grandma Can Yell 'Bum,'" 126.

26. De Blois, "Lo, The Lady Wrestling Fan!" 19.

27. Fiske, *Understanding Popular Culture*, 89.

28. Shane, "Gorgeous George The Wrestler," 71.

29. "Behind the Scenes," *Look*, 9 March 1954, 9; De Blois, "Lo, The Lady Wrestling Fan!" 18.

30. While it might be thought that Hatpin Mary was a plant, in the employ of the wrestling promoter, my interviews with wrestlers and announcers such as Bill Cardille (9 August 1994) suggest otherwise. It is more than likely that women such as Hatpin Mary, Ringside Rosie of Pittsburgh and others were simply dedicated fans who had developed their own ringside personas. While they represented something of a risk to wrestlers, they helped the performers create heat and excite the audience.

31. "DraMATic Stars, Part 2: The Ladies who Grapple for Diamonds and Such," *TV Guide*, 5 May 1951, 20–22; Rex Lardner, "Pity the Poor Wrestler," *Look*, 9 March 1954, 92.

32. Boal, "Big Boom," 24–31.

33. Not surprisingly, the quote betrays the racist attitudes of the time, assuming an exclusively white audience. In fact, African-Americans and Hispanics in particular actively attended wrestling matches, as is detailed in chapter 5. See "Wrestlers," *Ebony*, July 1950, 21–24; "Negro Wrestlers," *Ebony*, May 1962: 43–46; Gereon Zimmermann, "Rocca The Magnificent," *Look*, 14 August 1962, 59–64.

34. De Blois, "Lo, The Lady Wrestling Fan!" 19.

35. De Blois, "Lo, The Lady Wrestling Fan!" 19.

36. Elaine Tyler May, *Homeward Bound: American Families in the Cold War Era* (New York: Basic Books, 1988). See also Susan J. Douglas, *Where the Girls Are: Growing Up Female with the Mass Media* (New York: Times Books, 1994).

37. Alfred C. Kinsey, Wardell Pomeroy, and C. E. Martin, *Sexual Behavior in the Human Female* (Philadelphia: W.B. Saunders Co, 1953), 344. For a discussion of women and accusations of frigidity, see May, *Homeward Bound*; and Wini Breines, *Young, White, and Miserable: Growing Up Female in the Fifties* (Boston: Beacon Press, 1992), 112–113.

38. Breines, *Young, White, and Miserable*, 88.

39. Peter Biskind, *Seeing is Believing: How Hollywood Taught Us to Stop Worrying and Love the Fifties* (New York: Pantheon, 1983); Breines, *Young, White, and Miserable*, 102.

40. Douglas, *Where the Girls Are*, 71. Marty Jezer, *The Dark Ages: Life in the United States, 1945–1960* (Boston: South End Press, 1982), 247, points out that the use of sex appeal in movie posters, never more than 50 percent before World War II, jumped to 71 percent in 1951 (cited in Breines, *Young, White, and Miserable*, 228).

41. The Chippendales are one of many popular all-male dance revues. See Clarissa Smith, "Shiny Chests and Heaving G-Strings: A Night Out with the Chippendales," *Sexualities* 5 (February 2002): 67–89; and Paula L. Dressel and David Peterson, "Gender Roles, Sexuality and the Male Strip Show: The Structuring of Sexual Opportunity," *Sociological Focus* 15 (April 1982): 151–162.

42. Kobler, "Where Grandma Can Yell 'Bum,'" 126.

43. De Blois, "Lo, The Lady Wrestling Fan!" 18; Boal, "Big Boom," 30.

44. "DraMATic Stars, Part 1: How Nature Boy Struck it Rich," *TV Guide*, 5 May 1951, 5–7.

45. Boal, "Big Boom," 30.

46. John D'Emilio and Estelle B. Freedman, *Intimate Matters: A History of Sexuality in America* (New York: Harper & Row, 1988), 333.

47. De Blois, "Lo, The Lady Wrestling Fan!" 19; McPherson and Arnold, "What Gives in Rasslin'," 76.

48. Kobler, "Where Grandma Can Yell 'Bum,'" 126.

49. Boal, "Big Boom," 24–5.

50. "It Pays," *Business Week*, 25.

51. Fiske offers a persuasive discussion of what he sees as the inadequacies of the "safety valve" argument—which would diffuse the challenge to power such actions or pleasures represent—in chapter 1 of *Reading the Popular*.

52. My use here of the terms "place," "space," "strategy" and "tactic" are informed by the arguments of Michel de Certeau, *The Practice of Everyday Life*, trans. S. Rendall (Berkeley: University of California, 1984), especially 36–37. The powerful, he argued, always operate from their own place of power, a base of operations from which they can identify targets or threats, and devise strategies for dealing with them. On the other hand, he argued, the weak do not control their own place of operation, and as such must carve out temporary spaces within the place occupied by the powerful. It does so through the use of tactics: fleeting, calculated actions which take advantage of whatever opportunities present themselves. While the weak never confront the powerful directly, nonetheless the actions of the weak are always "within the enemy's field of vision." This is a useful means of understanding the actions of female fans of wrestling, challenging a patriarchal system that wishes to suppress them.

53. "The Last Word," *Cosmopolitan*, February 1954, 131.

☒ CHAPTER FOUR

1. Cf. Gerald Morton and George O'Brien, *Wrestling to Rasslin: Ancient Sport to American Spectacle* (Bowling Green, OH: Bowling Green State University Popular Press, 1985), 57.

2. Theodore Peterson, *Magazines in the Twentieth Century* (Urbana: University of Illinois Press, 1964), 45–6; John Tebbel and Mary Ellen Zuckerman, *The Magazine in America, 1741–1990* (New York: Oxford University Press, 1991), 243–45; Frank L. Mott, *American Journalism, A History: 1690–1960*, 3rd ed. (New York: MacMillan, 1962).

3. Tebbel and Zuckerman, *The Magazine*, 244. In his study of the magazine industry in the twentieth century, Peterson (*Magazines in the Twentieth Century*, 45–6) identified two primary factors that account for the health of the magazine industry: the growth in demand for advertisers' goods and services and growth in consumer demand for magazines.

4. Other attempts to duplicate the success of *Sports Illustrated* and launch a successful general interest sports periodical failed during the period. See Peterson, *Magazines in the Twentieth Century*, 364.

5. Tebbel and Zuckerman, *The Magazine*; Robert McChesney, "Media Made Sport: A History of Sports Coverage in the United States," in *Media, Sports, and Society*, ed. Lawrence Wenner (Newbury Park, CA: Sage, 1989), 49–69.

6. While the *Ring* was founded in 1922, its focus was exclusively on boxing until the 1940s. Only the *Wrestling News*, a weekly from Kansas City published by John "Doc" Reed in 1923–24, and the *Grappler*, a four-page weekly published in San Antonio, Texas, in 1933, have surfaced thus far as publications dedicated solely to wrestling. Both appear to have doubled as wrestling programs for local promotions.

7. By all accounts, *Wrestling As You Like It* (WAYLI) was the only wrestling publication to be launched between World War II and 1950. However, the 1950s saw the release of at least nine additional magazines devoted to wrestling, and two additional publications devoted to wrestling and boxing:

Wrestling As You Like It (Sept. 1946–1955)
Boxing and Wrestling (1951–58)
Official Wrestling/N.W.A. Official Wrestling (1951–53)
The Wrestler (1951–?)
Wrestling (1951)
Wrestling & TV Sports (1951–8)
Wrestling USA (1954–55)
Wrestling World (1954–55)
Wrestling Life (1955–64)
Ringside: The Magazine of Wrestling and Boxing (1955/56–?)
Real Ringside (1956–?)
Wrestling Revue (1959–80)

The 1960s were even more successful for wrestling publishers, certainly in terms of longevity: at least four publications—*Wrestling World* (1962–82), *Ring Wrestling* (1963–84), *Inside Wrestling* (1968–80) and the *Wrestler* (1968–80)—were introduced then, all lasting into the 1980s. Other titles also came and went during the period.

8. Though too late to include in this chapter, as I was preparing this manuscript for publication I was alerted to the Jack Pfefer Collection of wrestling materials at the Joyce Sports Research Collection at the University of Notre Dame, which holds a substantial collection of wrestling publications.

9. For purposes of comparison and historical context, I also studied selected issues of the *Ring* during the 1940s and 1950s, along with forty-four issues of six wrestling publications from the 1960s and 1970s. Finally, where appropriate, I also draw on an analysis of fifty event programs published and sold between 1949 and 1961 at wrestling events by promoters in Chicago, New York, Boston, Pittsburgh and Hershey, Pennsylvania.

10. With the increasing complexity of industrial practices in the twentieth century, the house organ became an important means of industrial communication. Mirroring the general rise in the popularity of periodicals, the number of house organs published in the United States rose significantly during and following World War II. A number of factors contributed to this increase, including the gains made by labor unions and the concomitant rise of the labor press, and an increased value placed on public relations by industry (Peterson, *Magazines in the Twentieth Century*, 51).

11. Richard Laermer, "Wrestling Proves a Boon for Publisher," *New York Times*, 19 February 1989, sec. 11. Weston began writing as a columnist for *Ring Magazine* after World War II.

12. Indeed, wrestling magazines have sometimes been described disparagingly as "mark mags," because they are said to target the naïve wrestling fan, thought to be unaware that wrestling is a construction.

13. "Crusader From Lorraine," *Official Wrestling*, April 1951, 12; "A Personal Interview with Lord Pinkerton," *Wrestling*, September 1951, 33; "The Sheik of Araby," *Wrestling Guide*, 24 February 1958, 2.

14. Ted Lewin, interview with author, 30 July 1994, 37; Mel Snyder, "Ring Dust, *Wrestling,* September 1951, 49.

15. Advertisements for nationally known, mainstream products were relatively rare, though they did have an occasional presence. For instance, *Official Wrestling* included full-page advertisements for Blatz Beer, and Chicago's WGN-TV advertised in *WAYLI.* Still, as Morton and O'Brien confirm, the more typical advertising fare included fan paraphernalia, body-building courses, mail-order products and the like. Ads in *Wrestling World* were entirely fan-based, with solicitations for eight-by-ten photos and souvenir calendars offered by the publication itself. *Official Wrestling* often featured ads for mail-order products and services—such as "Rasslers Rub" liniment and "PEPSuL" vitamin supplement—as well as offers for training courses in the new field of television.

16. Cf. Peterson, *Magazines in the Twentieth Century;* Emery, *The Press in America;* McChesney, "Media Made Sport."

17. "A Section For Bobby Soxers," *WAYLI,* 28 April 1949, 2.

18. "Ladies Attend Wrestling Shows," *WAYLI,* 7 July 1949, 8.

19. Sam Muchnick, "A Message." *WAYLI,* 21 April 1951, 7. Emphasis added.

20. Wayne Griffin, "From the Foxhole," *Official Wrestling,* June 1951, 43.

21. Dick Axman, "He Solved the Problem," *WAYLI,* 9 September 1948, 7.

22. John Fiske, *Understanding Popular Culture* (Boston: Unwin Hyman, 1989), 114; Janice Radway, *Reading the Romance: Women, Patriarchy and Popular Literature* (Chapel Hill: University of North Carolina Press, 1984).

23. "His Girl Excited," *WAYLI,* 5 May 1949, 2.

24. Dick Axman, "Behind the Scenes," *WAYLI,* 15 September 1949, 2.

25. "Brilliant Gordon Hessell to Meet Billy Goelz Monday," *WAYLI,* 2 September 1948, 4.

26. "All About Hessell," *WAYLI,* 7 July 1949, 8.

27. "Answering the Mail," *WAYLI,* 2 June 1949, 7.

28. James Barnett, "Wrestling Profile: Verne Gagne," *WAYLI,* 10 June 1950, 2–3.

29. Richard Butsch, *The Making of American Audiences: From Stage to Television, 1750–1990* (Cambridge: Cambridge University Press, 2000), 180. For more on radio and women, see Michele Hilmes, *Radio Voices: American Broadcasting, 1922–1952* (Minneapolis: University of Minnesota Press, 1997).

30. See photos of Ralph Garibaldi ("Well Liked," *WAYLI,* 2 September 1948, 2); Fred Kohler (Fred Kohler, "The Technique of Wrestling," *WAYLI,* 2 September 1948, 5); Billy Goelz and Pierre LaBelle ("Fans to Hail LaBelle in Bout with Goelz Wednesday Nite," *WAYLI,* 14 October 1948, 3); Don Eagle ("Don Eagle Club for Kids," *WAYLI,* 28 April 1949, 2); and Walter Palmer ("No Heat Wave Worry," *WAYLI,* 5 May 1949, 2).

31. "Answering the Mail," *WAYLI,* 2 June 1949, 7.

32. "Lone Eagle to Stalk Benito in Marigold Gardens—Sat.," *WAYLI,* 25 November 1950, 4.

33. F. Valentine Hooven, III, *Beefcake: The Muscle Magazines of America, 1950–1970* (Cologne: Taschen, 1995).

34. "Men at Work," *Official Wrestling,* April 1951, 36–39; "Women at Work," *Official Wrestling,* April 1951, 40–41.

35. "Crusader From Lorraine," *Official Wrestling,* April 1951, 12–13.

36. "Rough, Tough and WOW!" *Official Wrestling,* April 1951, 14–17.

37. "Beefcake," *Official Wrestling*, April 1951, 20–23. This balance continued through the first five issues: the September 1951 issue of *Official Wrestling* featured another pair of pictorial features, entitled "Pindown Gals" and "Pindown Boy" (*Official Wrestling*, September 1951, 18–20), the name a play on both "pinup girls" and the ultimate goal in wrestling, pinning one's opponent. The description in the table of contents following the first article read: "Women wrestlers offer competition to pinup girls from Hollywood."

38. "A Woman's Opinion," *WAYLI*, 10 June 1950, 9. The quotes that follow all come from this article.

39. For more on the function of the close-up in soap opera, see Tania Modleski, "The Search for Tomorrow in Today's Soap Opera," *Loving with a Vengeance: Mass Produced Fantasies for Women* (New York: Methuen, 1982); and Fiske, "Gendered Television: Femininity," *Television Culture* London: Methuen, 1987).

40. One of the first regional columns, a single feature entitled "Western Circuit" by Jim Chemi, appeared in 1950. Forty regional columns appeared in the six issues of *WAYLI* I examined published in 1953 and 1954 (24 January 1953; 7 February 1953; 14 March 1953; 21 March 1953; 11 December 1954; 25 December 1954); nineteen of them were written by women.

41. Dorothy Brydges, "San Francisco News," *WAYLI*, 24 January 1953, 5.

42. See Joan Ellis, "Texas Letter," *WAYLI*, 24 January 1953, 10. The column was renamed "Joan's Jottings" in 1954.

43. Joan Ellis, "Joan's Jottings," *WAYLI*, 25 December 1954, 10.

44. Deborah Jones, "Gossip: Notes on Women's Oral Culture," *Women's Studies International Quarterly* 3 (1980): 193–198. See the following chapter for a fuller treatment of the subject.

45. Corry, "His Kind of Woman," *Official Wrestling*, March 1952, 13.

46. Of course it is entirely possible that "Corry" was a male writer masquerading as a woman. The fact that she had to reassure readers that "Corry is a gal herself" suggests that perhaps she doth protest a bit too much.

47. Mary McCauley, "'My Prince Charming' in Rassling Trunks," *Official Wrestling*, April 1952, 22.

48. While female interests were strongly evident through the editorial approach of many wrestling publications, their presence was not unanimously felt. Joe Weider's *Wrestling*, not surprisingly, catered largely to a male readership, in keeping with its underlying mission to sell body-building equipment.

49. "Our Initial Issue," *WAYLI*, 2 September 1948, 2; "Letters Pour In," *WAYLI*, 21 October 1948, 7.

50. Wayne Griffin, "From the Foxhole," *Official Wrestling*, June 1951, 43.

51. "Dick Lane," *Official Wrestling*, August 1951, 30.

52. John Fiske, "The Cultural Economy of Fandom," in *The Adoring Audience: Fan Culture and Popular Media*, ed. Lisa Lewis (London: Routledge, 1992), 30–49. Julie D'Acci, *Defining Women: Television and the Case of Cagney & Lacey* (Chapel Hill: University of North Carolina Press, 1994); C. Lee Harrington and Denise Bielby, *Soap Fans: Pursuing Pleasure and Making Meaning in Everyday Life* (Philadelphia: Temple University Press, 1995).

53. "Answering the Mail," *WAYLI*, 2 June 1949, 7.

54. "Picking Up the Slips," *Official Wrestling*, June 1951, 46; August 1951, 46–47. As I was unable to locate a copy of the second (May 1951) issue of publication, I cannot say

definitively if this feature began with the June issue. However, a letter appearing in the June 1951 issue by E. Rydzik (p. 46) mentioned having just finished reading the first issue of the publication. That the letter did not appear in the second issue lends credence to this argument.

55. "Picking," *Official Wrestling*, June 1951, 46.

56. "Picking," *Official Wrestling*, June 1951, 46.

57. First, more women would have reason to use an initial rather than include their first name, whether for modesty's sake, or to protect their identity from potential ridicule from others in the community for their fandom of wrestling, as such interests were clearly considered unusual by most standards. Second, the writer adopts a position and a writing style consistent with that taken by many female fans, offering effusive support of both *Official Wrestling* and the flamboyant wrestlers it featured.

58. "Picking," *Official Wrestling*, June 1951, 46.

59. Raymond Williams, *Marxism and Literature* (Oxford: Oxford University Press, 1977), 122–23.

60. "Picking," *Official Wrestling*, September 1951, 46; June 1951, 46; April 1952, 46; February 1952, 47.

61. Some letters were likely written by the editors themselves, for the letters both validated editorial decisions and prompted offers of merchandise for sale to readers, such as photographs, magazine subscriptions or back issues. For instance, a letter from Otis Cates, Jr. requesting information on purchasing photographs of his favorite wrestlers was followed by a boxed advertisement offering photos for sale directly from the magazine ("Picking," *Official Wrestling*, August 1951, 47).

62. "Picking," *Official Wrestling*, June 1951, 46.

63. Marriage queries: "Answering the Mail," *WAYLI*, 2 June 1949, 7; "Voice of the Fan," *WAYLI*, 10 June 1950, 4; "Picking," *Official Wrestling*, February 1952, 47.

64. "Voice," *WAYLI*, 10 June 1950, 4.

65. "Voice," *WAYLI*, 10 June 1950, 4.

66. "Picking," *Official Wrestling*, April 1952, 46; "Fan Mail," *WAYLI*, 25 December 1954, 14; See also Jim Blank letter, "Voice," *WAYLI*, 7 February 1953, 15; Bruce Cowill letter, "Picking," *Official Wrestling*, April 1953, 40.

67. "Picking," *Official Wrestling*, August 1951, 47.

68. "Picking," *Official Wrestling*, June 1951, 46; September 1951, 46. See also letters from Florence Brennan and Jeanette Bozanic, March 1952, 47 and February 1954, 31.

69. "Picking," *Official Wrestling*, April 1952, 46.

70. James Barnett, "Notes by J.B.," *WAYLI*, 21 April 1951, 7.

71. Susan E. Cayleff, *Babe Didrikson: The Greatest All-Sport Athlete of All Time* (Berkeley, CA: Conari, 2000); Lois Browne, *Girls of Summer: The Real Story of the All-American Girls Professional Baseball League* (New York: HarperCollins, 1992); Susan K. Cahn, *Coming on Strong: Gender and Sexuality in Twentieth Century Women's Sport* (New York: Free Press, 1994).

72. See letters from Judy Lee Athernon, Barbara Brown, Marion Palmer, Barry Lloyd Penhale, Carol Ann Staib, and H. A. Deaton, plus a letter from Pat Schnee, who ran *Wrestling Ink* (discussed at length in the following chapter) in "Picking Up the Slips," *Official Wrestling*, May 1952, 46–7.

73. Ned Brown, "Fan Clubs of America," *Official Wrestling*, October 1952, 32–36, 42–3, 45.

74. Ned Brown, "Fan Clubs of America," *Official Wrestling*, April 1953, 31–35.

75. Tom Cummins, "Tom Cummins' Page," *WAYLI*, 24 January 1953, 14.

76. "Tom Cummins' Page," *WAYLI*, 24 January 1953, 14; "Fan Club News," *WAYLI*, 7 February 1953, 13; "Cousin El's Mailbox," *Wrestling World*, January 1955, 22.

77. Tom Cummins, "Tom Cummins' Page," *WAYLI*, 24 January 1953, 14; Eleanor Greene, "California Mat Observations, *WAYLI*, 24 January 1953, 6–7; Joan Ellis, "Texas Letter," *WAYLI*, 24 January 1953, 10–11; Dorothy Brydges, "San Francisco News," *WAYLI*, 24 January 1953, 5; Arlene Edwards, "News From Newark," *WAYLI*, 24 October 1953, 9; Barry Lloyd Penhale, "Canadian Wrestling Notes," *WAYLI*, 14 March 1953, 5. See also *WAYLI*, 14 March 1953, 6–7, 11, 13.

78. Dorothy Brydges, "San Francisco News," *WAYLI*, 14 March 1953, 13.

79. Garibaldi Fan Club, "Tom Cummins' Page," *WAYLI*, 24 January 1953, 14; Mercer & Meeker fan clubs, "Fan Club News," *WAYLI*, 7 February 1953, 13; Joan Stuff letter, "Cousin El's Mailbox," *Wrestling World*, January 1955, 21.

80. Cf. Danny Savich fan clubs, Joan Ellis, "Texas Letter;" and Pat O'Connor fan clubs, "Tom Cummins' Page," *WAYLI*, 24 January 1953, 11, 14.

81. Joan Ellis, "Texas Letter," *WAYLI*, 24 January 1953, 11.

82. Thomas Cummins and Joanne Meyers, "Fan Club News," *WAYLI*, 7 February 1953, 13.

☒ Chapter Five

1. For researchers willing to spend money, eBay and used-book websites have made materials like wrestling magazines and memorabilia more accessible.

2. John Tulloch and Henry Jenkins, *Science Fiction Audiences: Watching "Doctor Who" and "Star Trek"* (London: Routledge, 1995), 23.

3. Lawrence Grossberg, "Is There a Fan in the House?: The Affective Sensibility of Fandom," in *The Adoring Audience: Fan Culture and Popular Media*, ed. Lisa Lewis (London: Routledge, 1992), 50–65. For more on definitions of fandom, see Matt Hills, *Fan Cultures* (London: Routledge, 2002) and Joli Jensen, "Fandom as Pathology: The Consequences of Characterization," in *The Adoring Audience*, 9–29.

4. There was no mention of fan clubs in any written histories of professional wrestling covering the period prior to the 1950s. See Walter Armstrong, *Wrestling* (London: Longmans, Green, 1902); Percy Longhurst, *Wrestling* (London: Methuen, 1917); Graeme Kent, *A Pictorial History of Wrestling* (Middlesex, England: Spring, 1968); Gerald Morton and George O'Brien, *Wrestling to Rasslin: Ancient Sport to American Spectacle* (Bowling Green, OH: Bowling Green State University Popular Press, 1985). Nor was there evidence in the mainstream press or commercial wrestling magazines. I surveyed three issues of the *Grappler* 1, no. 4–6, published February 3–17, 1933 in San Antonio, Texas, and selected issues of boxing magazine the *Ring* from 1945–56. "Pierre Returns to Midway Arena to Wrestle Hessel," *WAYLI*, 21 August 1948, 4.

5. *WAYLI*'s fan club column began as "Tom Cummins' Page" on 24 January 1953, 14; the following week it was renamed "Fan Club News," co-authored by Cummins and Joanne Meyers (7 February 1953, 13). *Official Wrestling*'s column, written by editor Ned Brown, was titled "Fan Clubs of America." Begun sometime between May and October

1952, by the latter date it covered nearly seven pages of the fifty-page publication (32–36, 42–3, 45).

6. See Camille Bacon-Smith, *Enterprising Women: Television Fandom and the Creation of Popular Myth* (Philadelphia: University of Pennsylvania Press, 1992); Henry Jenkins, *Textual Poachers: Television Fans and Participatory Culture* (New York: Routledge, 1992); Nancy Baym, *Tune In, Log On: Soaps, Fandom and Online Community* (Thousand Oaks, CA: Sage, 2000); Constance Penley, "Brownian Motion: Women, Tactics, and Technology," in *Techno-Culture*, ed. Constance Penley and Andrew Ross (Minneapolis: University of Minnesota Press, 1991), 135–161; Barbara Ehrenreich, Elizabeth Hess, and Gloria Jacobs, "Beatlemania: Girls Just Want to Have Fun," in *The Adoring Audience*, 84–106; and Stephen Hinerman, "'I'll Be There With You': Fans, Fantasy and the Figure of Elvis," in *The Adoring Audience*, 107–134.

7. "Fan Clubs of America," *Official Wrestling*, April 1953, 31–35; *Wrestling USA*, April 1954, 4, 15; "Wrestling Fan Club Roster," *Wrestling World*, January 1955, 23–24.

8. Information for this section comes from Marilyn Hanson Nelson, interview with the author, 26 August 1994. She also ran fan clubs for Verne Gagne and Pat O'Conner.

9. Stephen Duncombe, *Notes from Underground: Zines and the Politics of Alternative Culture* (London: Verso, 1997), 47. For more on zines, see Fredric Wertham, *The World of Fanzines: A Special Form of Communication* (Carbondale: Southern Illinois University Press, 1973).

10. Verna Powers, *Mimeo Newspapers Can Be Tops* (Minneapolis: National Scholastic Press Assn./Minneapolis University Press, 1964), 4.

11. Diane Devine, *Look for a Star*, October 1960, 1.

12. Pat Schnee, *Wrestling Publicity Ink*, December 1953, 2. Emphasis in the original.

13. Jenkins, *Textual Poachers*, 23.

14. Duncombe, *Notes*, 37. Emphasis in the original.

15. Mabel Stonecipher, *Thunderbolt News*, July 1954, 7. Emphasis in the original.

16. *The 49er Wrestling and Football*, October 1954, 2. Emphasis in the original.

17. Mary Hasley, *Count Billy Varga Fan Club*, Spring 1959, 5.

18. Violet Smith, *Flying Tacklers*, September 1956, 11. Emphasis added.

19. For more on women in the public sphere in the postwar era, see Jane Sherron De Hart, "Containment at Home: Gender, Sexuality, and National Identity in Cold War America," in *Rethinking Cold War Culture*, ed. Peter Kuznick and James Gilbert (Washington, DC: Smithsonian Institution Press, 2001), 124–155; and Susan Lynn, "Gender and Progressive Politics: A Bridge to Social Activism in the 1960s," in *Not June Cleaver: Women and Gender in Postwar America, 1945–1960*, ed. Joanne Meyerowitz (Philadelphia: Temple University Press, 1994), 103–127.

20. Duncombe, *Notes*, 65.

21. John Fiske, *Television Culture* (London: Methuen, 1987), 77–83; Jenkins, *Textual Poachers*, 80–85; Deborah Jones, "Gossip: Notes on Women's Oral Culture," *Women's Studies International Quarterly* 3 (1980): 193–8.

22. Jones, "Gossip," 194–6.

23. In this chapter's excerpts from bulletins, I have retained the original spellings, punctuation and grammar, only acknowledging the most egregious errors for clarity.

24. Betty LaPoint, *Flash*, July 1956, 1, 5.

25. Pat Schnee, *Wrestling Publicity Ink*, December 1953, 16. Emma Gilbert, *Kansas Flash*, March 1957, 3, 4.

26. Emma Gilbert, "Here and There," *Kansas Flash*, March 1957, 7.

27. Violet Smith, *Flying Tacklers*, December 1957, 4.

28. Only two out of the sixteen bulletins I examined did not come with photos. One, *Look for a Star*, featured a large hand-drawn illustration on the cover. The other, the *Flash*, I refer to below. And as the photographs were taped or inserted in issues, rather than published as part of the printing process, there is no way to know whether or not additional photographs were included and taken out by their recipients.

29. Betty LaPoint, *Flash*, March 1957, 2.

30. To cite but one illustration of the elaborate cover art that was common among the bulletins I examined, the second anniversary edition of *Flying Tacklers*, September 1956, featured an illustrated cover printed in red, blue and yellow inks. While color printing was not the norm among the bulletins I studied, elaborate cover art was the rule rather than the exception.

31. As I discuss in the following chapter, sometimes women poached both time and resources from their work environments, using the office machinery and supplies in pursuit of their fan interests.

32. Ferdinand Lundberg, "News-letters: A Revolution in Journalism" *Harper's Magazine*, April 1940, 463–73; Virginia Burke, *Newsletter Writing and Publishing: A Practical Guide* (New York: Columbia University Teachers College Bureau of Publications, 1958); Howard Penn Hudson, *Publishing Newsletters* (New York: Charles Scribner's Sons, 1982).

33. Duncombe, *Notes*, 49.

34. Sam Moskowitz, "The Origins of Science Fiction Fandom: A Reconstruction," in *Science Fiction Fandom*, ed. Joe Sanders (Westport, CT: Greenwood, 1994), 17–36; Harry Warner, Jr. "A History of Fanzines," in *Science Fiction Fandom*, 175. For more on SF and fandom, see Paul Carter, *The Creation of Tomorrow: Fifty Years of Magazine Science Fiction* (New York: Columbia University Press, 1977); Lester del Rey, *The World of Science Fiction: The History of a Subculture, 1926–1976* (New York: Garland, 1980); and Harry Warner Jr., *All Our Yesterdays: An Informal History of Science Fiction Fandom in the Forties* (Chicago: Advent, 1969).

35. Duncombe, *Notes*, 7.

36. For more on the antebellum juvenile press, see Paula Petrik, "The Youngest Fourth Estate: The Novelty Toy Printing Press and Adolescence, 1870–1886," in *Small Worlds: Children and Adolescents in America, 1850–1980*, ed. Elliott West and Paula Petrik (Lawrence: Kansas University Press, 1992), 125–42.

37. "Office Machines: Selling Them through Dealers," *Business Week*, 18 October 1952, 42–44; "What? When? Where? Who? and Why?: A symposium for editors of local-association newsletters," in *National Education Association Journal*, February 1955, 103–4. To offer another example, the minister of the Episcopal Church in Millis, Massachusetts (a small town of 5,000) told me the church made regular use of a ditto machine throughout the 1950s, eventually replacing it with a more expensive mimeo duplicator. As well as being marketed by office supply stores, ditto machines were readily available in the Sears Roebuck catalogue at the time (Rev. Edward T. Dell Jr., interview with author, 14 December 1994).

38. Burke, *Newsletter Writing and Publishing*, 6. See also Catherine Emig, *Bulletins: How to Make Them More Effective* (New York: New York Social Work Publicity Council, 1942), and Irvin Herrmann, *Office Reproduction and Imprinting Methods* (New York: Office Publications Co., 1951). "How-to" pamphlets were also published and distributed by the manufacturers of printing machines, such as the twenty-four-page booklet *How to Plan and Publish a Mimeographed Newspaper*, distributed free of charge by the A. B. Dick Company, cited in Verna Powers, *Mimeo: Newspapers Can Be Tops* (Minneapolis: National Scholastic Press Assn., 1964).

39. Ellen Hunt, *Ringmaster*, 9.

40. Violet Smith, *Flying Tacklers*, September 1956, 8.

41. See Gilbert, *Kansas Flash* 6, March 1957, 7, 9.

42. Jenkins, *Textual Poachers*, 23.

43. Ellen Seiter, Hans Borchers, Gabriele Kreutzner and Eva-Maria Warth, "'Don't treat us like we're so stupid and naïve': Toward an ethnography of soap opera viewers," in *Remote Control: Television, Audiences, and Cultural Power*, ed. Ellen Seiter, Hans Borchers, Gabriele Kreutzner and Eva-Maria Warth (London: Routledge, 1989), 223–247.

44. *Wrestling World*, February 1954, 32; *Wrestling World*, January 1955, 23–4.

45. Hunt, "Just Chatting a Bit with Ellen," *Ringmaster*, circa 1957, 7, 9.

46. I use the term "preferred" reading to invoke the work of Stuart Hall in "Encoding/Decoding," in *Culture, Media, Language*, ed. Stuart Hall, Dorothy Hobson, Andrew Lowe and Paul Willis, (London: Hutchinson, 1980).

47. Carol Holmes, *Publicity for Favorites* 1, no. 2, 1957, 5.

48. Violet Smith, *Flying Tacklers*, September 1956, 8.

49. Michel Foucault describes "effective" history as a localized approach to history that places more emphasis on the vast and potentially contradictory details of everyday life, and which is used in opposition to the "grand narrative" of official history. In "Nietzsche, Genealogy, History," in *The Foucault Reader*, ed. Paul Rabinow (New York: Pantheon, 1984), 76–100.

50. Violet Smith, *Flying Tacklers*, December 1957, 2–3.

51. *Wrestling Publicity Ink*, ed. Pat Schnee, 10. I should note that while Ann used her experience to make an important social point in her column, this story also demonstrates her gullibility. Like many fans, she was what insiders in wrestling would call a "mark." Ann had stumbled "backstage," catching the performer who played "Lord" Carlton en route to his next venue. After not catching on initially, Carlton offered a plausible explanation for the absence of his "valet."

52. Diane Devine, *Look for a Star*, October 1960, 1. Emphasis in the original.

53. E.J. Hobsbawm, *Primitive Rebels* (Manchester: Manchester University Press, 1959). Cited in Duncombe, *Notes*, 175–176.

⬚ CHAPTER SIX

1. Carol Holmes Verdu, interview with author, 4 August 1994, 16a. Page number references in the endnotes below reflect my transcript pagination. I have used italics and other literary means of emphasis in an attempt to replicate verbal emphases used by the speaker. All are derived from the speaker unless specifically noted.

2. I mailed postcards to 307 addresses. The postcard queried:
Are you the person named on this card?

I'm writing because many years ago your name appeared in a wrestling fan magazine as an active fan of professional wrestling. I am researching and writing a book on pro wrestling's many female fans in the post–WW II years, and would like to interview fans who were active in the 1940s and '50s. If you are interested in sharing some of your memories, would like more information about my research, or know someone who was a fan then who might participate, please contact me at this address. . . .

3. Anecdotal evidence from mail-order-business operator Edward T. Dell Jr., interview with author, 14 December 1994. These were not the only source of respondents. One interviewee yielded two additional, equally devoted women fans of roughly the same age and one equally interested spouse. I met another eventual contributor to the project—and my first interview opportunity—on a hotel shuttle bus in Los Angeles. A chance conversation about our respective tasks at UCLA led to a discussion of television and finally to my ongoing wrestling research, prompting her to reveal a long-standing interest dating back to her adolescent years in the 1950s. Other respondents emerged from discussions and queries on the internet. In the process, one initial respondent to my mailing died before I could interview her, and her daughter, also a dedicated wrestling fan (though of a later era), withdrew from sight. A second woman who initially responded later declined to be interviewed.

4. Marilyn Hanson Nelson, interview with author, 26 August 1994, 6.

5. Both Carol and her mother Ruth Holmes began fan clubs for wrestlers in the 1950s, for Leon Graham and Jackie Nichols, respectively; Carol participated in national fan club conventions, and both Carol and her mother garnered press attention for their efforts along the way. Carol's fandom eventually led her to experience a different side of the business, when she married wrestler Oscar "Crusher" Verdu at the age of twenty-one (she is now divorced). For more on the press attention Carol and her mother received, see "Sponsoring Honoraries is Not Job for Folks Who Love Leisure," *Columbus Star*, 6 September 1958, 14.

6. Verdu, 11a.

7. Elizabeth Mackey (pseudonym), interview with the author conducted via the internet, 31 August 1993 through 27 January 1994.

8. In our later conversations, some question as to her father's fandom (or lack thereof) emerged. Elizabeth's nephew was a regular weekend house guest in the 1950s and remembered both parents watching wrestling on Saturday nights. This suggests that Elizabeth's father did not initially share in his wife's fandom and may have evolved as a wrestling fan over time, following his spouse's interest in the genre.

9. Nancy L. Jacobs, Lillian Beltz, Barbara Serasto, Tom Serasto, interview with author, 7 August 1994, 16.

10. Delores Hall, interview with author, 6 April 1993.

11. Hall, 17, 2.

12. Nelson, 25.

13. Nelson, 24.

14. For additional title and career information on Red Bastien—and other retired professional wrestlers and industry workers—see Scott Teal, "Red Bastien," *Whatever*

Happened To . . . ? December 1993, 10 (published by Scott Teal, P.O. Box 2781, Hendersonville, TN 37077).

15. Red Bastien, interview with author, 17 December 1994, 6.

16. Hall, 16.

17. A "carpenter" is a wrestler whose role is to advance the career of his or her opponent.

18. Tom Burke, interview with the author, 29 October 1993, 5–6.

19. Jacobs, 12.

20. Verdu, 8a.

21. Bastien, 10.

22. Hall, 16.

23. Verdu, 7.

24. Lillian Beltz, 16.

25. Verdu, 54b.

26. Bastien, 9.

27. For more on Ted Lewin's career as a wrestler, see his autobiographical book *I Was a Teenage Professional Wrestler* (New York: Orchard Books, 1993).

28. Ted Lewin, interview with author, 30 July 1994, 10.

29. Bill Cardille, interview with author, 9 August 1994, 10–12.

30. Cardille, 10–11.

31. Verdu, 1–2b.

32. Jacobs, 41–42.

33. Cardille, 5.

34. Mike LeBell, interview with author, 22 March 1993, 1.

35. Bob Orton Sr., interview with author, 14 December 1994, 2. For more on Orton's career, see *Whatever Happened To . . . ?*, 14–15.

36. Cardille, 5.

37. Kenneth Dutton, *The Perfectible Body* (London: Cassell, 1995), 253.

38. See Jackie Stacey, *Stargazing: Hollywood Cinema and Female Specatorship* (London: Routledge, 1994); Fred Vermorel and Judy Vermorel, *Starlust: The Secret Life of Fans* (London: W. H. Auden, 1985); Clarissa Smith, "Shiny Chests and Heaving G-Strings: A Night Out with the Chippendales," *Sexualities* 5, no. 1 (2002): 67–89.

39. Nelson, 27.

40. Verdu, 1b.

41. Lewin, 11.

42. Verdu, 16a.

43. Jacobs, 42.

44. Cardille, 25.

45. DeAnn K. Gauthier and Craig J. Forsyth, "Buckle Bunnies: Groupies of the Rodeo Circuit," *Deviant Behavior* 21 (July 2000), 349–365.

46. R. W. Creamer, *The Legend Comes to Life* (New York: Simon & Schuster, 1974), cited in George Gmelch and Patricia San Antonio, "Groupies and American Baseball," *Journal of Sport & Social Issues* 22 (February 1998), 32–45.

47. Cardille, 17.

48. Cardille, 22.

49. Gmelch and San Antonio, "Groupies and American Baseball," 37.

50. Lewin, 9.

51. Lewin, 11.

52. Bastien, 8.

53. Jacobs, 16.

54. Frank De Blois, "Lo, The Lady Wrestling Fan!" *TV Guide*, 11 September 1954, 18–19; John Kobler, "Where Grandma Can Yell 'Bum,'" *Cosmopolitan* 135, December 1953, 120–127; Jacobs, 38.

⊠ CHAPTER SEVEN

1. Carol Dell, telephone interview with author, 24 August 2004.

2. See Raymond Williams' discussion of mobile privatization in *Television: Technology and Cultural Form* (New York: Schocken, 1975); Margaret Marsh, *Suburban Lives* (New Brunswick, NJ: Rutgers University Press, 1990).

3. Marilyn Hanson Nelson, interview with author, 26 August 1994.

4. Susan Douglas, *Where the Girls Are: Growing Up Female with the Mass Media* (New York: Times, 1994).

5. I use the term "gaze" specifically to invoke and question the 1970s film notion of spectatorship and the gaze being entirely male. For more on the gaze, see Laura Mulvey, "Visual Pleasure and Narrative Cinema," *Screen* 16, no. 3 (Autumn 1975): 6–18. For a critique of the use of psychoanalytic theory in issues of spectatorship, see Jackie Byars, *All That Hollywood Allows: Re-Reading Gender in the 1950s Melodrama* (Chapel Hill: The University of North Carolina Press, 1991).

6. My thanks to Kathy Newman at Carnegie Mellon University for suggesting this important insight.

7. *Wrestling Life* continued publication through 1964. Other titles include *Boxing Illustrated/Wrestling News* (1959–), *Wrestling Revue* (1959–73), *Wrestling World* (not related to the previous title, 1962–82), *Ring Wrestling* (1963–84), *Inside Wrestling* (1968–80), and the *Wrestler* (1968–80).

8. For a sampling of the scholarly work on these shows and their fans, see Ien Ang, *Watching Dallas: Soap Opera and the Melodramatic Imagination* (London: Methuen, 1985); Julie D'Acci, *Defining Women: Television and the Case of Cagney & Lacey* (Chapel Hill: University of North Carolina Press, 1994); Rhonda V. Wilcox and David Lavery, eds. *Fighting the Forces: What's at Stake in "Buffy the Vampire Slayer"* (Lanham, MD: Rowman & Littlefield, 2002).

Bibliography

Books and Articles

Adelman, Melvin L. *A Sporting Time: New York City and the Rise of Modern Athletics, 1820–70*. Urbana: University of Illinois Press, 1986.

Allen, G. T. "Eight Hour Orphans." *Saturday Evening Post*, 10 October 1942: 20.

"American Woman's Dilemma." *Life*, 16 June 1947: 101–112.

Ang, Ien. *Watching Dallas: Soap Opera and the Melodramatic Imagination*. London: Methuen, 1985.

Armstrong, Walter. Wrestling. London: Longmans, Green, 1902.

Atkinson, Michael. "Fifty Million Viewers Can't Be Wrong: Professional Wrestling, Sports-Entertainment and Mimesis." *Sociology of Sport Journal* 19 (2002): 47–66.

"Baba & Behemoths." *Time*, 18 May 1936: 54–55, 58.

Bacon-Smith, Camille. *Enterprising Women: Television Fandom and the Creation of Popular Myth*. Philadelphia: University of Pennsylvania Press, 1992.

Ball, Michael. *Professional Wrestling as Ritual Drama in American Popular Culture*. Lewiston, NY: Edwin Mellen, 1990.

Barthes, Roland. *Mythologies*. Translated by Annette Lavers. New York: Noonday, 1972.

Baym, Nancy. *Tune In, Log On: Soaps, Fandom and Online Community*. Thousand Oaks, CA: Sage, 2000.

"Behind the Scenes." *Look*, 9 March 1954: 9.

Berkman, Dave. "Long Before Arledge . . . Sports & TV: The Earliest Years: 1937–1947—as Seen by the Contemporary Press." *Journal of Popular Culture* 22 (Fall 1988): 49–62.

Biskind, Peter. *Seeing is Believing: How Hollywood Taught Us to Stop Worrying and Love the Fifties*. New York: Pantheon, 1983.

Boal, Sam. "Big Boom in the Grunt and Groan Business." *New York Times Magazine*, 20 November 1949, 24–31.

Bourdieu, Pierre. *Distinction: A Social Critique of the Judgement of Taste*. Translated by R. Nice. Cambridge, MA: Harvard University Press, 1984.

Breines, Wini. *Young, White, and Miserable: Growing Up Female in the Fifties*. Boston: Beacon Press, 1992.

Brooks, Tim, and Earle Marsh. *The Complete Directory to Prime Time Network Television Shows: 1946–Present*, 7th ed. New York: Ballantine, 1999.

Browne, Lois. *Girls of Summer: The Real Story of the All-American Girls Professional Baseball League*. New York: HarperCollins, 1992.

Burke, Virginia M. *Newsletter Writing and Publishing: A Practical Guide*. New York: Columbia University Teachers College Bureau of Publications, 1958.

Butsch, Richard. *The Making of American Audiences: From Stage to Television, 1750–1990*. Cambridge: Cambridge University Press, 2002.

Byars, Jackie. *All That Hollywood Allows: Re-Reading Gender in the 1950s Melodrama*. Chapel Hill: University of North Carolina Press, 1991.

Cahn, Susan K. *Coming on Strong: Gender and Sexuality in Twentieth Century Women's Sport*. New York: Free Press, 1994.

Carter, Paul. *The Creation of Tomorrow: Fifty Years of Magazine Science Fiction*. New York: Columbia University Press, 1977.

Cayleff, Susan E. *Babe Didrikson: The Greatest All-Sport Athlete of All Time*. Berkeley, CA: Conari, 2000.

Chafe, William H. *The American Woman: Her Changing Social, Economic, and Political Roles, 1920–1970*. New York: Oxford University Press, 1972.

Cook, David A. *A History of Narrative Film*, 4th ed. New York: W. W. Norton, 2004.

Coontz, Stephanie. *The Way We Never Were: American Families and the Nostalgia Trap*. New York: BasicBooks, 1992.

Creamer, R. W. *The Legend Comes to Life*. New York: Simon & Schuster, 1974.

Cunningham, Bill. "The Bigger They Are——." *Collier's*, 17 December 1932: 9, 39–40.

D'Acci, Julie. *Defining Women: Television and the Case of Cagney & Lacey*. Chapel Hill: University of North Carolina Press, 1994.

D'Emilio, John, and Estelle B. Freedman. *Intimate Matters: A History of Sexuality in America*. New York: Harper & Row, 1988.

De Blois, Frank. "Lo, The Lady Wrestling Fan!" *TV Guide*, 11 September 1954: 18–19.

De Certeau, Michel. *The Practice of Everyday Life*. Translated by S. Rendall. Berkeley: University of California Press, 1984.

De Hart, Jane Sherron. "Containment at Home: Gender, Sexuality, and National Identity in Cold War America." In *Rethinking Cold War Culture*, ed. Peter Kuznick and James Gilbert. Washington, DC: Smithsonian Institute Press, 2001, 124–155.

Dell, Chad. "'Lookit that Hunk of Man!': Subversive Pleasures, Female Fandom, and Professional Wrestling." In *Theorizing Fandom: Fans, Subculture and Identity*, ed. Cheryl Harris and Alison Alexander. Cresskill, NJ: Hampton, 1998.

Del Rey, Lester. *The World of Science Fiction: The History of a Subculture, 1926–1976.* New York: Garland, 1980.

Douglas, Ann. *The Feminization of American Culture.* New York: Knopf, 1977.

Douglas, Susan J. *Where the Girls Are: Growing Up Female with the Mass Media.* New York: Times Books, 1994.

"DraMATic Stars, Part 1: How Nature Boy Struck it Rich." *TV Guide*, 5 May 1951: 5–7.

"DraMATic Stars, Part 2: The Ladies who Grapple for Diamonds and Such." *TV Guide*, 5 May 1951: 20–22.

Dressel, Paula L., and David Peterson. "Gender Roles, Sexuality and the Male Strip Show: The Structuring of Sexual Opportunity." *Sociological Focus* 15 (April 1982): 151–162.

Duncombe, Stephen. *Notes from Underground: Zines and the Politics of Alternative Culture.* London: Verso, 1997.

Dutton, Kenneth. *The Perfectible Body.* London: Cassell, 1995.

Ehrenreich, Barbara, Elizabeth Hess, and Gloria Jacobs. "Beatlemania: Girls Just Want to Have Fun." In *The Adoring Audience: Fan Culture and Popular Media*, ed. Lisa Lewis. London: Routledge, 1992, 84–106.

Ehrenreich, Barbara. *The Hearts of Men: American Dreams and the Flight from Commitment.* New York: Doubleday/Anchor, 1983.

Emery, Edwin. *The Press in America: An Interpretive History of the Mass Media*, 3rd ed. Englewood Cliffs, NJ: Prentice Hall, 1972.

Emig, Catherine. *Bulletins: How to Make Them More Effective.* New York: NY Social Work Publicity Council, 1942.

Entman, Frank M. "Framing: Toward Clarification of a Fractured Paradigm." *Journal of Communication* 43, no. 4 (1993): 51–58.

——. "Cascading Activation: Contesting the White House's Frame after 9/11." *Political Communication* 20 (October 2003): 415–432.

Erenberg, Lewis A. "Things to Come: Swing Bands, Bebop, and the Rise of a Postwar Jazz Scene." In *Recasting America: Culture and Politics in the Age of Cold War*, ed. Lary May. Chicago: University of Chicago Press, 1989, 221–245.

Faderman, Lillian. *Odd Girls and Twilight Lovers: A History of Lesbian Life in Twentieth-Century America.* New York: Columbia University Press, 1991.

Farrell, Edythe. "Lady Wrestlers." *The American Mercury*, December 1942: 674–680.

Fay, Bill. "Collier's Sports." *Collier's*, 1 May 1948: 6.

Feder, Sid. *Wrestling Fan's Book*, 2nd ed. New York: Key, 1953.

Filene, Peter. "'Cold War Culture' Doesn't Say It All." In *Rethinking Cold War Culture*, ed. Peter Kuznick and James Gilbert. Washington, DC: Smithsonian Institute Press, 2001, 156–174.

Fiske, John. *Television Culture.* London: Methuen, 1987.

——. *Reading the Popular.* Boston: Unwin Hyman, 1989.

——. *Understanding Popular Culture.* Boston: Unwin Hyman, 1989.

——. "The Cultural Economy of Fandom." In *The Adoring Audience: Fan Culture and Popular Media*, ed. Lisa Lewis. London: Routledge, 1992: 30–49.

Flacks, Richard. *Youth and Social Change*. Chicago: Markham Publishing, 1971.

Foreman, Joel. "Introduction." In *The Other Fifties: Interrogating Midcentury American Icons*, ed. Joel Foreman. Urbana: University of Illinois Press, 1997: 1–23.

"Fortune Survey: Women in America." *Fortune*, August 1946: 5–6.

Foucault, Michel. "Nietzsche, Genealogy, History." In *The Foucault Reader*, ed. Paul Rabinow. New York: Pantheon, 1984: 76–100.

French, Brandon. *On the Verge of Revolt: Women in American Films of the Fifties*. New York: Ungar, 1978.

Friedan, Betty. *The Feminine Mystique*. New York: Norton, 1963.

Gatlin, Rochelle. *American Women Since 1945*. Jackson: University Press of Mississippi, 1987.

Gauthier, DeAnn K., and Craig J. Forsyth. "Buckle Bunnies: Groupies of the Rodeo Circuit." *Deviant Behavior* 21 (July 2000): 349–365.

Gilbert, James. *A Cycle of Outrage: America's Reaction to the Juvenile Delinquent in the 1950s*. New York: Oxford University Press, 1986.

Gmelch, George, and Patricia San Antonio. "Groupies and American Baseball." *Journal of Sport & Social Issues* 22 (February 1998): 32–45.

Goodman, Paul. *Growing Up Absurd: The Problems of Youth in the Organized Society*. New York: Vintage Books, 1960.

"Gorgeous George." *Newsweek*, 13 September 1948: 56.

Gray, Ann. *Video Playtime: The Gendering of a Leisure Technology*. London: Routledge, 1992.

Grossberg, Lawrence. "Is There a Fan in the House?: The Affective Sensibility of Fandom." In *The Adoring Audience: Fan Culture and Popular Media*, ed. Lisa Lewis. London: Routledge, 1992: 50–65.

"Guaranteed Entertainment." *Time*, 31 May 1948: 51–52.

Hall, Stuart. "Encoding/Decoding." In *Culture, Media, Language*, ed. Stuart Hall, Dorothy Hobson, Andrew Lowe and Paul Willis. London: Hutchinson, 1980, 128–138.

Hansen, Miriam. "Pleasure, Ambivalence, Identification: Valentino and Female Spectatorship." *Cinema Journal* 25, no. 4 (Summer 1986): 6–32.

Haralovich, Mary Beth. "Sitcoms and Suburbs: Positioning the 1950s Homemaker." In *Private Screenings: Television and the Female Consumer*, ed. Lynn Spigel and Denise Mann. Minneapolis: University of Minnesota Press, 1992: 111–141.

Harrington, C. Lee, and Denise Bielby. *Soap Fans: Pursuing Pleasure and Making Meaning in Everyday Life*. Philadelphia: Temple University Press, 1995.

Hartmann, Susan M. *The Homefront and Beyond: American Women in the 1940's*. Boston: Twayne Publishers, 1982.

———. "Women's Employment and the Domestic Ideal in the Early Cold War Years." In *Not June Cleaver: Women and Gender in Postwar America, 1945–1960*, ed. Joanne Meyerowitz. Philadelphia: Temple University Press, 1994: 84–100.

Harvey, Brett. *The Fifties: A Women's Oral History*. New York: HarperCollins, 1993.

Heath, Harry, Jr., and Louis Gelfand. *How to Cover, Write and Edit Sports*. Ames: Iowa State University Press, 1951.

Herrmann, Irvin. *Office Reproduction and Imprinting Methods*. New York: Office Publications Co., 1951.

Hills, Matt. *Fan Cultures*. London: Routledge, 2002.

Hilmes, Michele. *Radio Voices: American Broadcasting, 1922–1952*. Minneapolis: University of Minnesota Press, 1997.

Hinerman, Stephen. "'I'll Be There With You': Fans, Fantasy and the Figure of Elvis." In *The Adoring Audience: Fan Culture and Popular Media*, ed. Lisa Lewis. London: Routledge, 1992, 107–134.

Hobsbawm, E. J. *Primitive Rebels*. Manchester: Manchester University Press, 1959.

Hooven, F. Valentine, III. *Beefcake: The Muscle Magazines of America, 1950–1970*. Cologne: Taschen, 1995.

Hudson, Howard Penn. *Publishing Newsletters*. New York: Charles Scribner's Sons, 1982.

Huyssen, Andreas. "Mass Culture as Woman: Modernism's Other." In *Studies in Entertainment: Critical Approaches to Mass Culture*, ed. Tania Modleski. Bloomington: Indiana University Press, 1986: 188–207.

"It Pays to Sponsor Television Corn." *Business Week*, 7 October 1950: 25–26.

Iyengar, Shanto. *Is Anyone Responsible?: How Television Frames Political Issues*. Chicago: University of Chicago Press, 1991.

Jares, Joe. *Whatever Happened to Gorgeous George?* Englewood Cliffs, NJ: Prentice-Hall, 1974.

Jenkins, Henry. *Textual Poachers: Television Fans and Participatory Culture*. New York: Routledge, 1992.

——. "'Never trust a snake': WWF wrestling as masculine melodrama." In *Out of bounds: Sports, media, and the politics of identity*, ed. Aaron Baker and Todd Boyd. Bloomington: Indiana University Press, 1997, 48–78.

Jensen, Joli. "Fandom as Pathology." In *The Adoring Audience: Fan Culture and Popular Media*, ed. Lisa Lewis. London: Routledge, 1992, 9–29.

Jezer, Marty. *The Dark Ages: Life in the United States, 1945–1960*. Boston: South End Press, 1982.

Jones, Deborah. "Gossip: Notes on Women's Oral Culture." *Women's Studies International Quarterly* 3 (1980): 193–98.

Kaledin, Eugenia. *Mothers and More: American Women in the 1950s*. Boston: Twayne Publishers, 1984.

Kent, Graeme. *A Pictorial History of Wrestling*. Middlesex, England: Spring, 1968.

Kenyon, J. Michael. "The Difficulty with 'History,'" *Wrestling As We Liked It* 1, no. 63, December 20, 1996.

Kerouak, Jack. "In the Ring." *Atlantic Monthly*, March 1968: 110–11.

Kibler, M. Alison. *Rank Ladies: Gender and Cultural Hierarchy in American Vaudeville*. Chapel Hill: University of North Carolina Press, 1999.

Kinsey, Alfred C., Wardell Pomeroy, and C. E. Martin, *Sexual Behavior in the Human Female*. Philadelphia: W.B. Saunders Co, 1953.

Kobler, John. "Where Grandma Can Yell 'Bum.'" *Cosmopolitan*, December 1953: 120–127.

Laermer, Richard. "Wrestling Proves a Boon for Publisher." *New York Times*, 19 February 1989, sec. 21: 21.

Lardner, John. "Who Degrades Whom?" *Newsweek*, 4 December 1944: 92.

Lardner, Rex. "Pity the Poor Wrestler." *Look*, 9 March 1954: 86–92.

Lewin, Ted. *I Was a Teenage Professional Wrestler*. New York: Orchard Books, 1993.

Liebling, A. J. "A Reporter at Large: From Sarah Bernhardt to Yukon Eric." *New Yorker*, 13 November 1954: 132–149.

Lipsitz, George. "Land of a Thousand Dances: Youth, Minorities, and the Rise of Rock and Roll." In *Recasting America: Culture and Politics in the Age of Cold War*, ed. Lary May. Chicago: University of Chicago Press, 1989: 267–284.

Longhurst, Percy. *Wrestling*. London: Methuen, 1917.

Lundberg, Ferdinand. "News-letters: A Revolution in Journalism." *Harper's Magazine*, April 1940: 463–73.

Lynn, Susan. "Gender and Progressive Politics: A Bridge to Social Activism in the 1960s." In *Not June Cleaver: Women and Gender in Postwar America, 1945–1960*, ed. Joanne Meyerowitz. Philadelphia: Temple University Press, 1994, 103–127.

MacKaye, Milton. "On the Hoof." *The Saturday Evening Post*, 14 December 1935: 8–9, 35–40.

Marsh, Margaret. *Suburban Lives*. New Brunswick, NJ: Rutgers University Press, 1990.

May, Elaine Tyler. *Homeward Bound: American Families in the Cold War Era*. New York: Basic Books, 1988.

May, Lary. Introduction to *Recasting America: Culture and Politics in the Age of Cold War*, ed. Lary May. Chicago: University of Chicago Press, 1989: 1–16.

Mazer, Sharon. *Professional Wrestling: Sport and Spectacle*. Jackson: University Press of Mississippi, 1998.

McChesney, Robert. "Media Made Sport: A History of Sports Coverage in the United States." In *Media, Sports, and Society*, ed. Lawrence Wenner. Newbury Park, CA: Sage, 1989: 49–69.

McPherson, C. L. "Steve," and Oren Arnold. "What Gives in Rasslin'." *Collier's*, 29 October 1949: 30–31, 75–76.

Mellencamp, Patricia. "Situation and Simulation: An Introduction to 'I Love Lucy.'" *Screen* 26, no. 2 (March–April, 1985): 30–40.

Meyerowitz, Joanne. "Introduction: Women and Gender in Postwar America, 1945–1960." In *Not June Cleaver: Women and Gender in Postwar America, 1945–1960*, ed. Joanne Meyerowitz. Philadelphia: Temple University Press, 1994, 1–16.

——. "Beyond the Feminine Mystique: A Reassessment of Postwar Mass Culture, 1946–1958." In *Not June Cleaver: Women and Gender in Postwar America, 1945–1960*, ed. Joanne Meyerowitz. Philadelphia: Temple University Press, 1994: 229–262.

——. "Sex, Gender, and the Cold War Language of Reform." In *Rethinking Cold War Culture*, ed. Peter Kuznick and James Gilbert. Washington, DC: Smithsonian Institute Press, 2001: 106–123.

Milkman, Ruth. *Gender at Work: The Dynamics of Job Segregation by Sex During World War II*. Urbana: University of Illinois Press, 1987.

Modleski, Tania. *Loving with a Vengeance: Mass Produced Fantasies for Women*. New York: Methuen, 1982.

Morton, Gerald W., and George M. O'Brien. *Wrestling To Rasslin: Ancient Sport to American Spectacle*. Bowling Green, OH: Bowling Green State University Popular Press, 1985.

Moskowitz, Sam. "The Origins of Science Fiction Fandom: A Reconstruction." In *Science Fiction Fandom*, ed. Joe Sanders. Westport, CT: Greenwood, 1994: 17–36.

Mott, Frank L. *American Journalism, A History: 1690–1960*, 3rd ed. New York: MacMillan, 1962.

Mulvey, Laura. "Visual Pleasure and Narrative Cinema." *Screen* 16, no. 3 (Autumn 1975): 6–18.

"Negro Wrestlers." *Ebony*, May 1962: 43–50.

"Office Machines: Selling Them through Dealers." *Business Week*, 18 October 1952: 42–44.

Papashvily, Helen W. *All the Happy Endings: A study of the domestic novel in America, the women who wrote it, the women who read it, in the nineteenth century*. New York: Harper & Brothers, 1956.

Pegler, Westbrook. "Are Wrestlers People?" *Esquire*, January 1934; reprinted in *Esquire*, October 1974: 284–85, 397.

Peiss, Kathy. *Cheap Amusements: Working Women and Leisure in Turn-of-the-Century New York*. Philadelphia: Temple University Press, 1986.

Penley, Constance. "Brownian Motion: Women, Tactics, and Technology." In *Techno-Culture*, ed. Constance Penley and Andrew Ross. Minneapolis: University of Minnesota Press, 1991: 135–161.

Peterson, Theodore. *Magazines in the Twentieth Century*. Urbana: University of Illinois Press, 1964.

Petrik, Paula. "The Youngest Fourth Estate: The Novelty Toy Printing Press and Adolescence, 1870–1886." In *Small Worlds: Children and Adolescents in America, 1850–1980*, ed. Elliott West and Paula Petrik. Lawrence: Kansas University Press, 1992: 125–42.

Powers, Ron. *Supertube: The Rise of Television Sports*. New York: Coward-McCann, 1984.

Powers, Verna. *Mimeo: Newspapers Can Be Tops*. Minneapolis: National Scholastic Press Assn., 1964.

Radway, Janice. *Reading the Romance: Women, Patriarchy and Popular Literature*. Chapel Hill: University of North Carolina Press, 1984.

Rice, Robert. "Diary of a Viewer." *New Yorker*, 30 August 1947: 50.

Riess, Steven A. *Sport in Industrial America, 1850–1920*. Wheeling, IL: Harlan Davidson, 1995.

Rupp, Leila J., and Verta Taylor. *Survival in the Doldrums: The American Women's Rights Movement, 1945 to the 1960s*. New York: Oxford University Press, 1987.

Ryan, Mary P. *Women in Public: Between Banners and Ballots, 1825–1880*. Baltimore: Johns Hopkins University Press, 1990.

Scheufele, Dietram A. "Framing as a Theory of Media Effects." *Journal of Communication* 49, no. 1 (1999): 103–122.

Seiter, Ellen, Hans Borchers, Gabriele Kreutzner and Eva-Maria Warth. "'Don't treat us like we're so stupid and naïve': Toward an ethnography of soap opera viewers." In

Remote Control: Television, Audiences, and Cultural Power, ed. Ellen Seiter, Hans Borchers, Gabriele Kreutzner and Eva-Maria Warth. London: Routledge, 1989: 223–247.

Shane, Ted. "Gorgeous George The Wrestler." *American Mercury*, July 1950: 65–69.

Smith, Clarissa. "Shiny Chests and Heaving G-Strings: A Night Out with the Chippendales." *Sexualities* 5, no. 1 (2002): 67–89.

Spigel, Lynn. *Make Room for TV: Television and the Family Ideal in Postwar America.* Chicago: University of Chicago Press, 1992.

"Sponsoring Honoraries is Not Job for Folks Who Love Leisure." *Columbus Star*, 6 September 1958: 14.

Stacey, Jackie. *Stargazing: Hollywood Cinema and Female Spectatorship.* London: Routledge, 1994.

Teal, Scott. "Red Bastien." *Whatever Happened To . . . ?* December 1993: 10.

Tebbel, John, and Mary Ellen Zuckerman. *The Magazine in America, 1741–1990.* New York: Oxford University Press, 1991.

"The Girls." *Life*, 15 August 1949: 39–40.

Tuchman, Gaye. *Making News: A Study in the Construction of Reality.* New York: Free Press, 1978.

Tulloch, John, and Henry Jenkins. *Science Fiction Audiences: Watching "Doctor Who" and "Star Trek."* London: Routledge, 1995.

Vermorel, Fred, and Judy Vermorel. *Starlust: The Secret Life of Fans.* London: W. H. Auden, 1985.

Walsh, Andrea S. *Women's Film and Female Experience, 1940–1950.* New York: Praeger, 1984.

Warner, Harry, Jr. *All Our Yesterdays: An Informal History of Science Fiction Fandom in the Forties.* Chicago: Advent, 1969.

——. "A History of Fanzines." In *Science Fiction Fandom*, ed. Joe Sanders. Westport, CT: Greenwood, 1994: 175–180.

Wertham, Fredric. *The World of Fanzines: A Special Form of Communication.* Carbondale: Southern Illinois University Press, 1973.

"What? When? Where? Who? and Why?: A symposium for editors of local-association newsletters." *National Education Association Journal*, February 1955: 103–4.

Whyte, William H. *The Organizational Man.* New York: Simon and Schuster, 1956.

Wilcox, Rhonda V., and David Lavery, editors. *Fighting the Forces: What's at Stake in "Buffy the Vampire Slayer."* Lanham, MD: Rowman & Littlefield, 2002.

Williams, Raymond. *Television: Technology and Cultural Form.* New York: Schocken, 1975.

——. *Marxism and Literature* Oxford: Oxford University Press, 1977.

Wilson, Charles Morrow. *The Magnificent Scufflers: Recalling the Great Days When America Wrestled the World.* Brattleboro, VT: Stephen Greene Press, 1959.

"Wrestlers." *Ebony*, July 1950: 21–24.

"Wrestling." *Newsweek*, 20 February 1937: 29.

Zimmermann, Gereon. "Rocca The Magnificent." *Look*, 14 August 1962: 59–64.

Wrestling Magazine Articles

"Answering the Mail." *Wrestling As You Like It*, 2 June 1949, 7.

Axman, Dick. "He Solved the Problem." *Wrestling As You Like It*, 9 September 1948, 7.

———. "Behind the Scenes." *Wrestling As You Like It*, 15 September 1949, 2.

Barnett, James. "Wrestling Profile: Verne Gagne." *Wrestling As You Like It*, 10 June, 1950, 2–3.

———. "Notes by J.B." *Wrestling As You Like It*, 21 April 1951, 7.

"Beefcake." *Official Wrestling*, April 1951, 20–23.

"Brilliant Gordon Hessell to Meet Billy Goelz Monday." *Wrestling As You Like It*, 2 September 1948, 4.

Brown, Ned. "Fan Clubs of America." *Official Wrestling*, October 1952, 32–36, 42–3, 45.

———. "Fan Clubs of America." *Official Wrestling*, April 1953, 31–35.

Brydges, Dorothy. "San Francisco News." *Wrestling As You Like It*, 24 January 1953, 5.

———. "San Francisco News." *Wrestling As You Like It*, 14 March 1953, 13.

Chemi, Jim. "The Western Circuit." *Wrestling As You Like It*, 10 June 1950, 10.

Corry, "His Kind of Woman." *Official Wrestling*, March 1952, 13.

"Cousin El's Mailbox." *Wrestling World*, January 1955, 21–22.

"Crusader From Lorraine." *Official Wrestling*, April 1951, 12–13.

Cummins, Tom. "Tom Cummins' Page." *Wrestling As You Like It*, 24 January 1953, 14.

"Dick Lane." *Official Wrestling*, August 1951, 30.

"Don Eagle Club for Kids." *Wrestling As You Like It*, 28 April 1949, 2.

Edwards, Arlene. "News from Newark." *Wrestling As You Like It*, 24 October 1953, 9.

Ellis, Joan. "Texas Letter." *Wrestling As You Like It*, 24 January 1953, 10–11.

———. "Joan's Jottings." *Wrestling As You Like It*, 11 December 1954, 10.

"Fan Club News." *Wrestling As You Like It*, 7 February 1953, 13.

"Fan Mail." *Wrestling As You Like It*, 11 December 1954, 14.

"Fans to Hail LaBelle in Bout with Goelz Wednesday Nite." *Wrestling As You Like It*, 14 October 1948, 3.

Greene, Eleanor. "California Mat Observations. *Wrestling As You Like It*, 24 January 1953, 6–7.

Griffin, Wayne. "From the Foxhole." *Official Wrestling*, June 1951, 43.

"His Girl Excited." *Wrestling As You Like It*, 5 May 1949, 2.

Kohler, Fred. "The Technique of Wrestling." *Wrestling As You Like It*, 2 September 1948, 5.

"Ladies Attend Wrestling Shows." *Wrestling As You Like It*, 7 July 1949, 8.

"Letters Pour In." *Wrestling As You Like It*, 21 October 1948, 7.

"Lone Eagle to Stalk Benito in Marigold Gardens—Sat." *Wrestling As You Like It*, 25 November 1950, 4.

McCauley, Mary. "'My Prince Charming' in Rassling Trunks." *Official Wrestling*, April 1952, 22.

"Men at Work." *Official Wrestling*, April 1951, 36–39.

Muchnick, Sam. "A Message." *Wrestling As You Like It*, 21 April 1951, 7.

"No Heat Wave Worry." *Wrestling As You Like It*, 5 May 1949, 2.

"Our Initial Issue." *Wrestling As You Like It*, 2 September 1948, 2.

Penhale, Barry Lloyd. "Canadian Wrestling Notes." *Wrestling As You Like It*, 14 March 1953, 5.

"Personal Interview with Lord Pinkerton. A," *Wrestling*, September 1951, 33.

"Picking Up the Slips." *Official Wrestling*, June 1951, 46.

"Picking Up the Slips." *Official Wrestling*, August 1951, 46–47.

"Picking Up the Slips." *Official Wrestling*, September 1951, 46.

"Picking Up the Slips." *Official Wrestling*, February 1952, 47.

"Picking Up the Slips." *Official Wrestling*, March 1952, 47.

"Picking Up the Slips." *Official Wrestling*, April 1952, 46–47.

"Picking Up the Slips." *Official Wrestling*, May 1952, 46–47.

"Picking Up the Slips." *Official Wrestling*, April 1953, 40.

"Picking Up the Slips." *Official Wrestling*, February 1954, 31.

"Pindown Boy." *Official Wrestling*, September 1951, 20.

"Pindown Gals." *Official Wrestling*, September 1951, 18–19.

"Rough, Tough and WOW!" *Official Wrestling*, April 1951, 14–17.

"Section for Bobby Soxers, A." *Wrestling As You Like It*, 28 April 1949, 2.

"Sheik of Araby, The." *Wrestling Guide*, 24 February 1958, 2.

Snyder, Mel. "Ring Dust, *Wrestling*." September 1951, 49.

"Voice of the Fan." *Wrestling As You Like It*, 10 June 1950, 4.

"Voice of the Fan." *Wrestling As You Like It*, 7 February 1953, 15.

"Well Liked." *Wrestling As You Like It*, 2 September 1948, 2

"A Woman's Opinion." *Wrestling As You Like It*, 10 June 1950, 9.

"Women at Work." *Official Wrestling*, April 1951, 40–41.

Yetter, Earle F. "Eastern News." *Wrestling As You Like It*, 27 November 1953, 5, 9.

Film and Television Resources

"Ali Pasha v. Mr. Moto." *Wrestling from Hollywood with Dick Lane*, Long Beach Auditorium, Long Beach, CA. Los Angeles: UCLA Film & Television Archive, VA 1758 T.

"Andre Drapp v. The Bushman." At *Ringside with the "Rasslers" from Hollywood American Legion Stadium*, (1950) produced by Jerry Fairbanks, Inc. St. Paul, MN: Jim Melby Collection, tape number 42.

At *Ringside with the "Rasslers" from Hollywood American Legion Stadium*, (1950) produced by Jerry Fairbanks, Inc. St. Paul, MN: Jim Melby Collection, tape number 42.

"Freddie Blassie v. Baron Michele Leone." *Wrestling from Hollywood with Dick Lane*, Long Beach Auditorium, Long Beach, CA. Los Angeles: UCLA Film & Television Archive, VA 1760 T.

"Leo Garibaldi v. Wild Red Berry." *Wrestling From Hollywood with Dick Lane*, Long Beach Auditorium, Long Beach, CA. Los Angeles: UCLA Film & Television Archive, VA 9715 T.

Lou Weiss Presents: Wrestling Night at Hollywood Legion Stadium (1941) Video Scrapbook #42, Mike LeBell video collection.

Lou Weiss Presents: Wrestling Night at Hollywood Legion Stadium (1941) Los Angeles: UCLA Film & Television Archive, VA 9716, part 2.

"Marcel Bucette v. Ivan Rasputin." *Wrestling from Chicago*, Marigold Arena, Chicago, IL. Produced by DuMont Television Network. Los Angeles: UCLA Film & Television Archive, VA 9713 T.

"Pat Meehan v. Hans Schnabel." *Wrestling from Hollywood with Dick Lane*, Long Beach Auditorium, Long Beach, CA. Los Angeles: UCLA Film & Television Archive, listed under "Gorgeous George."

Pitt Parade, Archives of Industrial Society, Hillman Library, University of Pittsburgh, Pittsburgh, PA.

"Rito Romero v. Gorgeous George." *Wrestling from Hollywood with Dick Lane*, Long Beach Auditorium, Long Beach, CA. Los Angeles: UCLA Film & Television Archive, listed under "Gorgeous George."

"Roy McClarity v. Tony Marino." *Wrestling from War Memorial Auditorium*, Buffalo, NY, circa 1957. St. Paul, MN: Jim Melby Collection, tape number 1.

"Sandor Szabo and Warren Bockwinkel v. Wild Red Berry and "Sockeye" Jack MacDonald." *Tafon Wrestling*, Hollywood Legion Stadium. Los Angeles: UCLA Film & Television Archive, VA 9716.

Western Main Event Wrestling from Hollywood, (195-) produced by McConkey Artists Corporation. Los Angeles: UCLA Film & Television Archive, VA 9714 T.

"Wild Red Berry v. Leo Garibaldi." *Wrestling From Hollywood with Dick Lane*, Long Beach Auditorium, Long Beach, CA. Los Angeles: UCLA Film & Television Archive, VA 9715 T.

Wrestling from Chicago, Marigold Arena. Los Angeles: UCLA Film & Television Archive, VA 9713 T.

Fan Club Bulletins

Devine, Diane, editor. *Look for a Star* (October 1960). Red McKim International Fan Club: Springfield, MO.

Gilbert, Emma, editor. *Kansas Flash*. no. 6 (March 1957). Richard "Dick" Brown Fan Club: Wichita, KS.

Hasley, Mary, editor. *Count Billy Varga Fan Club*. no. 9 (Spring 1959). Marietta, OH.

Hawkins, Pat, editor. *Go Gon'ya!* (July 1959). Verne Gagne International Fan Club: Washington, DC.

Holmes, Carol, editor. *Publicity for Favorites* 1, no. 2 (1957). Columbus, OH.

LaPoint, Betty, editor. *Flash* 3, no. 6 (July 1956). Johnny Barend Fan Club bulletin: Saratoga Springs, NY.

Patterson, Vera, editor. *Sonora Flash* 1, no. 2 (January 1955). The Enrique and Ramon Torres Fan Club: Alameda, CA.

Schnee, Pat, editor. *Wrestling Publicity Ink* 1, no. 1 (December 1953). Dayton, OH.

Smith, Violet, editor. *Flying Tacklers*. no. 8 (September 1956). Wilbur Snyder International Fan Club: Meadowlands, PA.

——, editor. *Flying Tacklers* 2, no. 4 (December 1957). Wilbur Snyder International Fan Club: Meadowlands, PA.

——, editor. *Flying Tacklers* 2, no. 6. (June 1958). Wilbur Snyder International Fan Club: Meadowlands, PA.

——, editor. *The Darling of the Mat* 2, no. 1 (August 1961). Judy Grable Fan Club: Meadowlands, PA.

Stonecipher, Mabel, editor. *Thunderbolt News* 1, no. 1 (July 1954). Roland Meeker Fan Club: Benicia, CA.

——, editor. *Etchings on Etchison* 1, no. 3 (September 1954). Ronnie Etchison Fan Club: Benicia, CA.

——, editor. *The 49er Wrestling and Football* 1, no. 1 (October 1954). Art Michalik Fan Club Bulletin: Benicia, CA.

Stuff, Joan, and Ellen Hunt, editors. *Ringmaster* (1957). Miller Brothers Fan Club: Mansfield, OH and Ogden, IL.

Interviews with Author

Bastien, Red. 17 December 1994. Telephone.

Beltz, Lillian. 7 August 1994. Pittsburgh.

Burke, Tom. 29 October 1993. Springfield, Massachusetts.

Cardille, Bill. 9 August 1994. Pittsburgh.

Dell, Rev. Edward T. Jr. 14 December 1994. Telephone.

Dell, Carol. 24 August 2004. Telephone.

Hall, Delores. 6 April 1993. Los Angeles.

Jacobs, Nancy L. 7 August 1994. Pittsburgh.

LeBell, Mike. 22 March 1993. Telephone.

Lewin, Ted. 30 July 1994. Telephone.

Mackey, Elizabeth (pseudonym). 31 August 1993–27 January 1994. Conducted via the internet.

Muchnick, Sam. 9 September 1993. Telephone.

Nelson, Marilyn Hanson. 26 August 1994. Red Oaks, Iowa.

Orton, Bob, Sr. 14 December 1994. Telephone.

Sammartino, Bruno. 9 August 1994. Telephone.

Serasto, Barbara. 7 August 1994. Pittsburgh.

Serasto, Tom. 7 August 1994. Pittsburgh.

Verdu, Carol Holmes. 4 August 1994. Columbus, Ohio.

Index